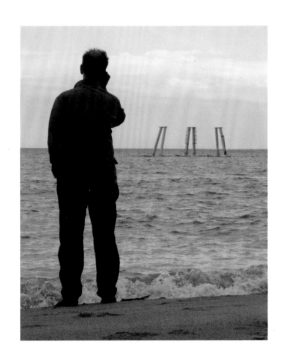

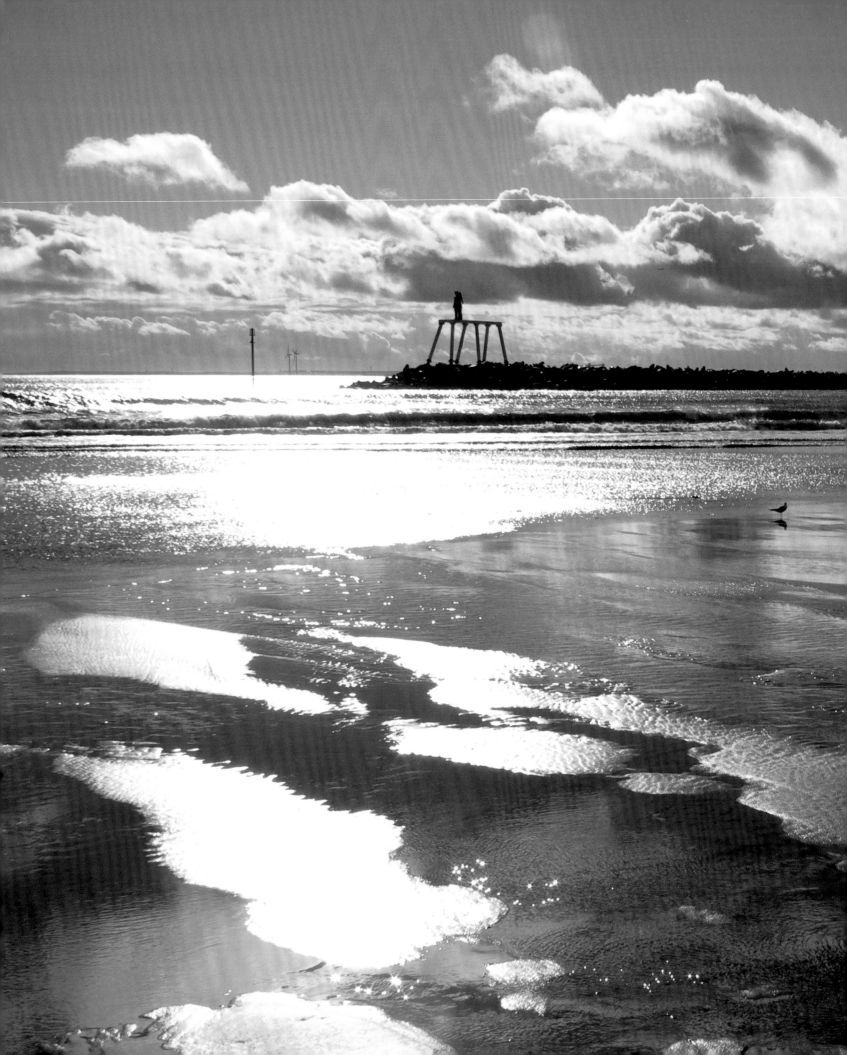

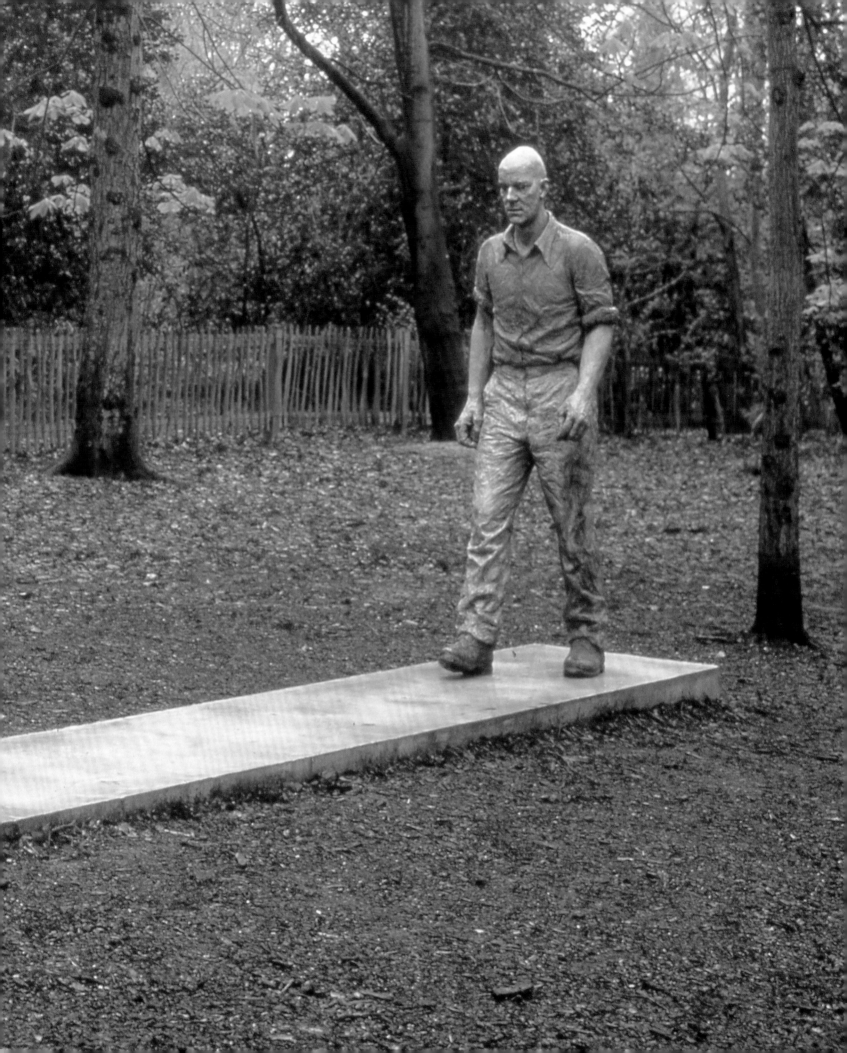

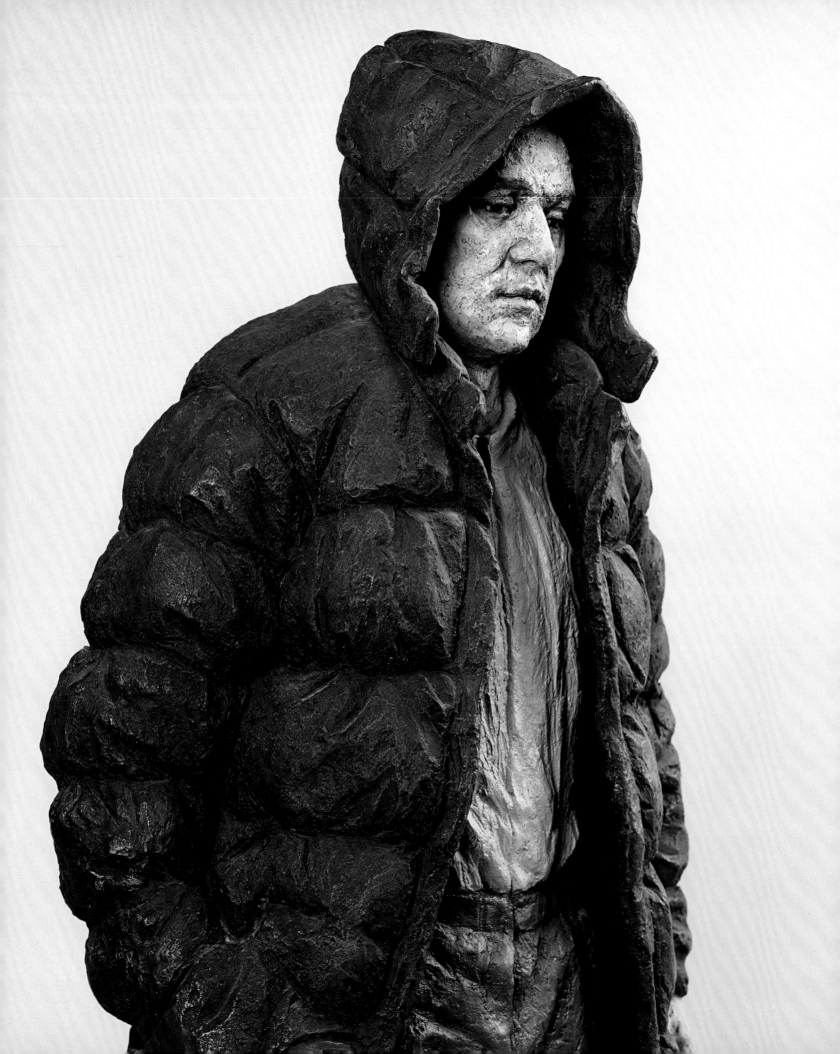

SEAN HENRY

TOM FLYNN

Scala Publishers in association with Osborne Samuel Gallery

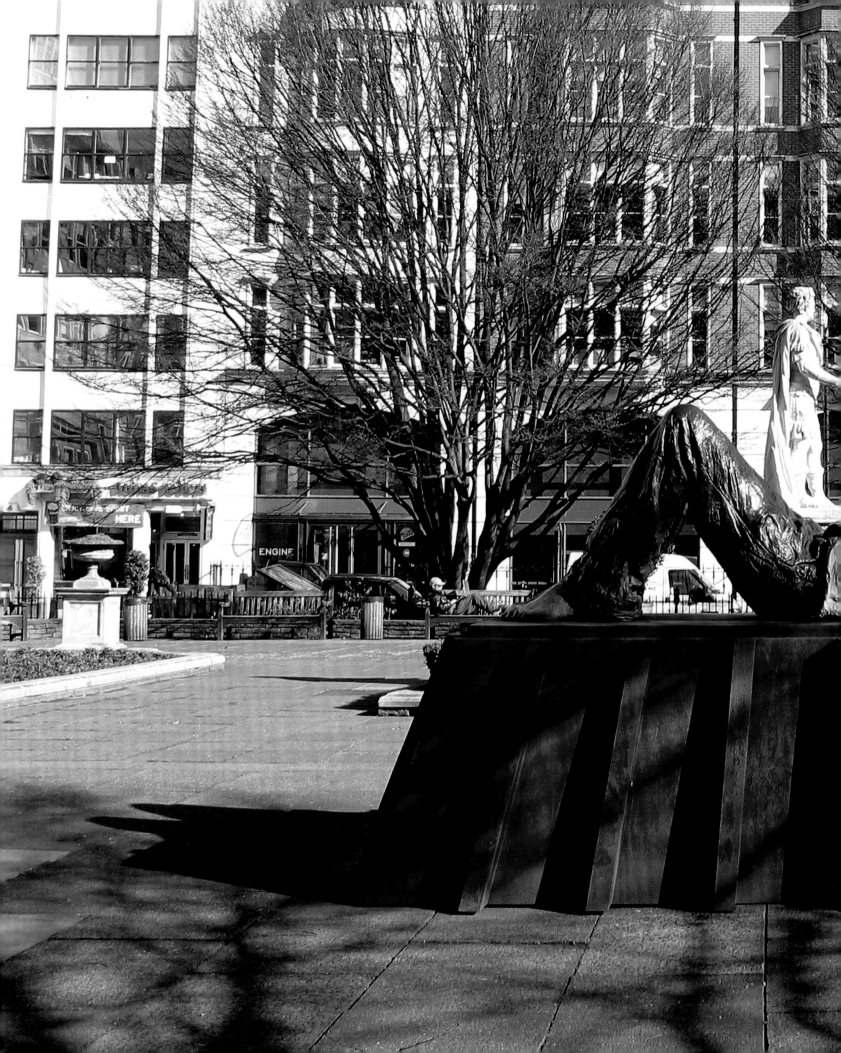

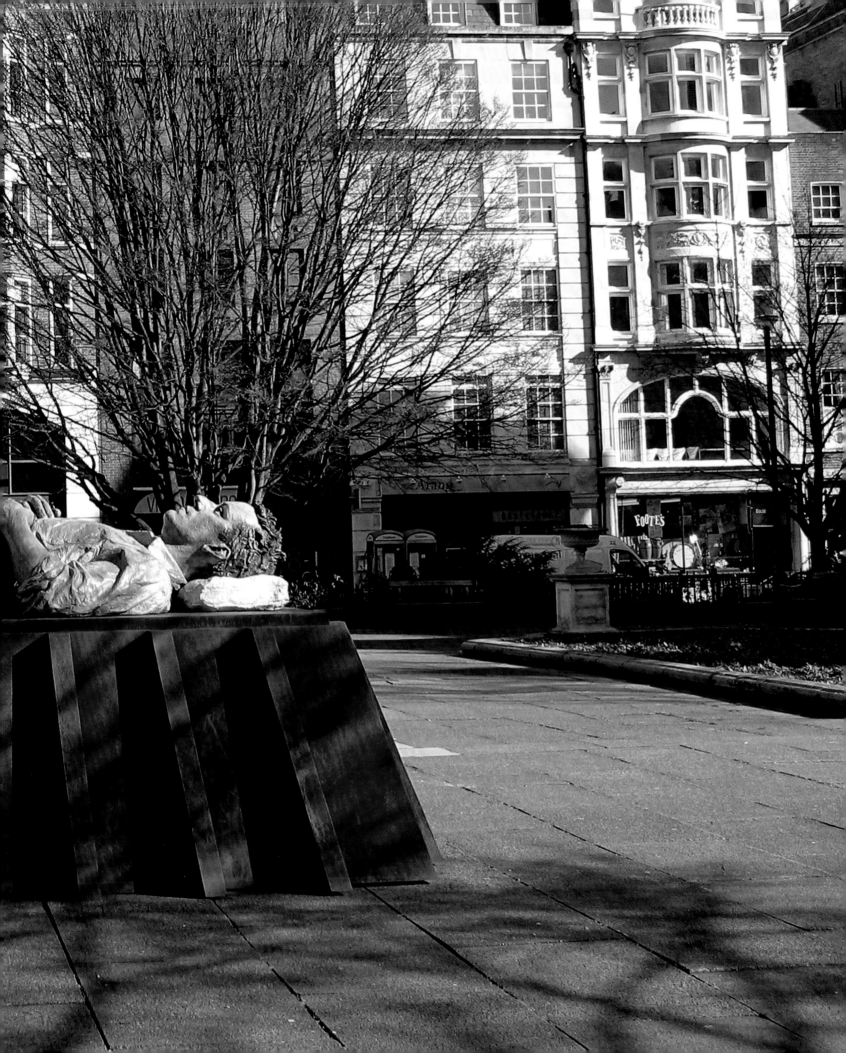

This edition © Scala Publishers Ltd, 2008
Works by Sean Henry © Sean Henry Ltd
Text © Tom Flynn

First published in 2008 by Scala Publishers
in association with Osborne Samuel Gallery

Scala Publishers Ltd
Northburgh House
10 Northburgh Street
London EC1V 0AT, UK
www.scalapublishers.com

Osborne Samuel Ltd
23a Bruton Street
London W1J 6QG
www.osbornesamuel.com

www.seanhenry.com

Paperback ISBN: 978-1-85759-541-3
Hardback ISBN: 978-1-85759-573-4

Designed by Peter Willberg
Edited by Oliver Craske
Production Director: Tim Clarke
Printed in Singapore

10 9 8 7 6 5 4 3 2 1

Dimensions of works are given as height by width; or, for
sculptures and installations, as height by width by depth

Page 1: Sean Henry at Newbiggin Bay, Northumberland,
UK, during construction of Couple, 2007
Pages 2–3: Couple in Newbiggin Bay, Northumberland,
UK, 2007
Pages 4–5: Walking Man, Holland Park, London, 2000
Pages 6–7: Meeting Place at Paddington Central,
London, 2003
Page 8: The Duke of Milan, 1999
Pages 10–11: Catafalque in Golden Square, Soho,
London, 2005
Pages 14–15: Man with Potential Selves at Le Meridien
(The Cumberland) Hotel, Marble Arch, London, 2004
Pages 20–21: Detail of the artist's studio wall, London,
2008
Pages 46–47: The artist's studio at Great Western Studios,
London, 2006
Pages 70–71: Henry painting Couple, Liverpool, 2007
Pages 86–87: Solo exhibition at Forum Gallery, New York,
2006, showing Great Western Man, You're Not the Same
and Woman (Being Looked At)
Pages 112–113: Aerial photograph of Newbiggin Bay,
Northumberland, 2007
Pages 158–159: Couple, Newbiggin Bay, at dawn,
November 2007

CONTENTS

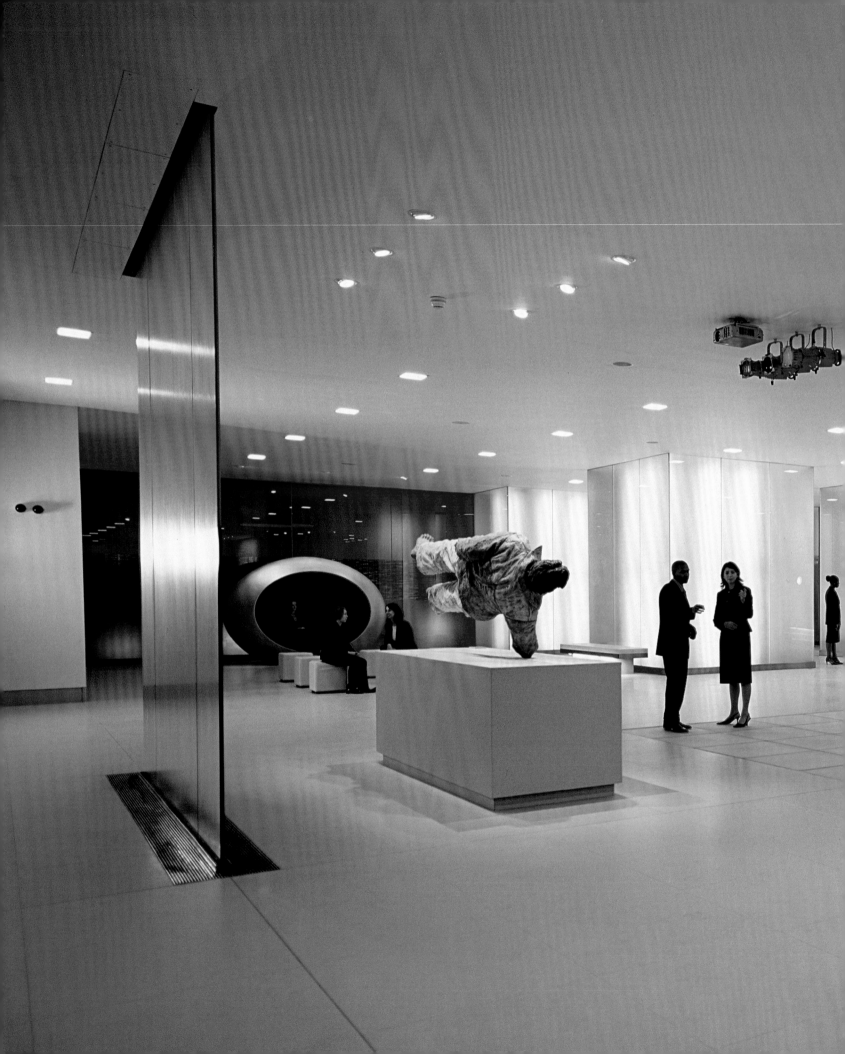

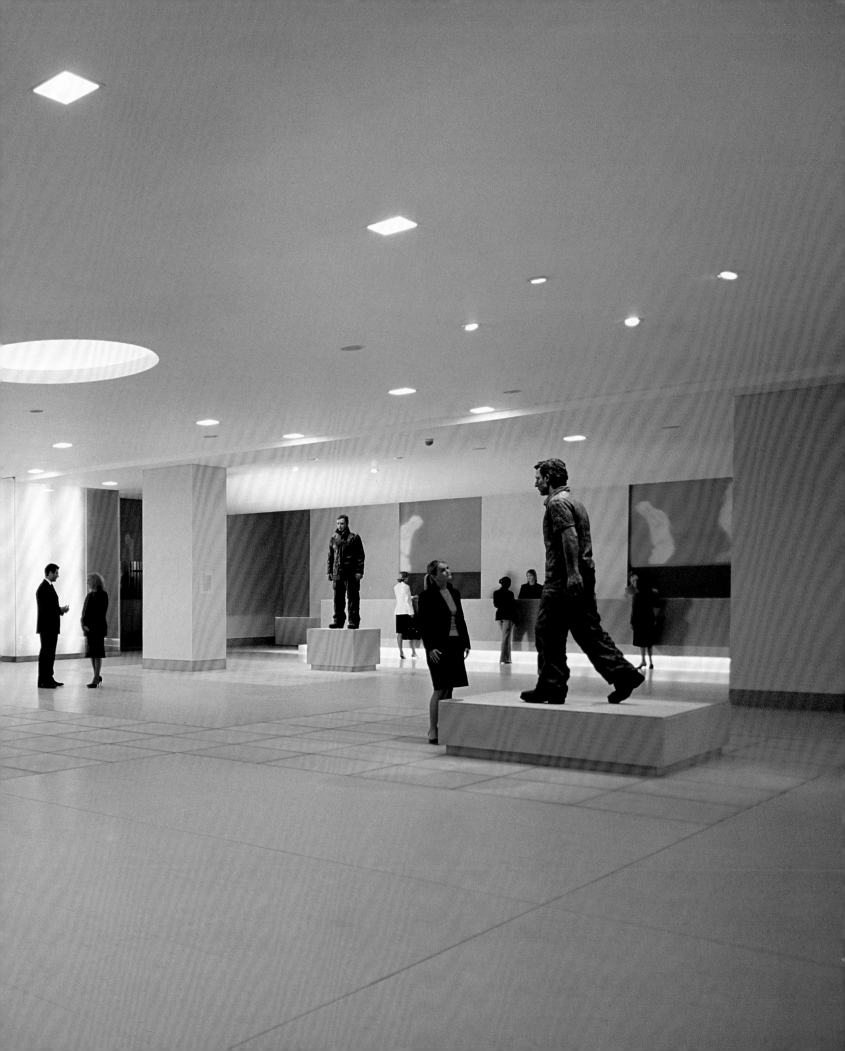

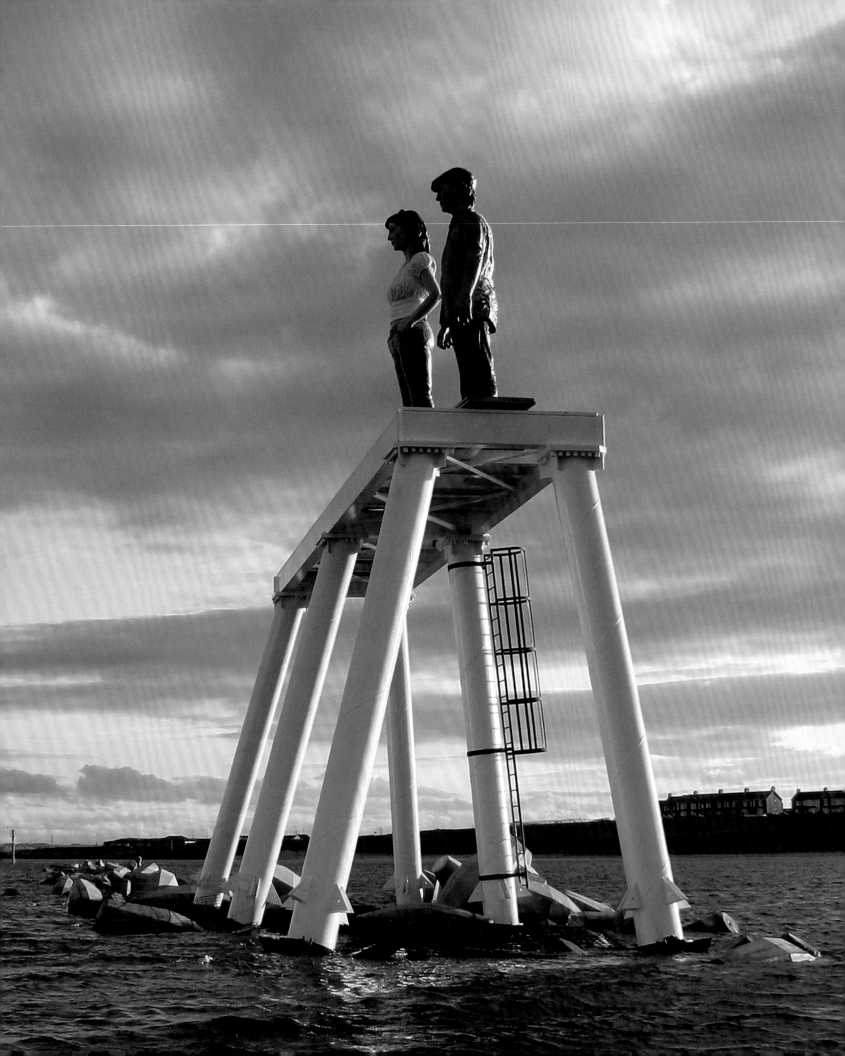

INTRODUCTION

A man and woman stand impassively on a raised platform 300 metres off the Northumberland coast, gazing at the horizon, seemingly oblivious to the grey gauze of chill autumn rain rolling in off the North Sea and the tide swelling below them. It is difficult to make out their ages, details of their clothing, or any other distinguishing features. From a distance they are anonymous, vulnerable and alone. We feel a strong sense of identification with these figures as they brave the unforgiving northern weather to confront the sublime power of the sea.

This is Sean Henry's *Couple*, a 13-metre-high painted bronze sculpture installed in August 2007 on a new breakwater in Newbiggin Bay at Newbiggin-by-the-Sea on England's North East coast (see fig.1). It is Britain's first permanent offshore sculpture and Henry's most ambitious public commission to date.

For centuries, the residents of Newbiggin have stood on the dockside during storm conditions, praying for the safe return of the cobles – the traditional, single-masted, flat-bottomed fishing boats that still ply their trade off the North East coast. Henry's figures pay subtle homage to that aspect of Newbiggin's social history while avoiding the quaint regionalism that might have resulted from a more literal response to the town's seafaring heritage.

Like the stepped plaza leading up to Eduardo Chillida's abstract *Wind Combs* on the rugged Basque coast of San Sebastián, the pier on which *Couple* stands is an integral part of Henry's overall design concept. The pier anchors the work into the landscape, creating a visually arresting silhouette against the skyline.

As with most of Henry's open-air sculptures, *Couple* has no fixed meaning, but derives much of its resonance from its ambient surroundings. Standing out at sea, framed by the natural world, the figures are as fluid and shifting as the elements, suggesting an infinite range of moods as the weather changes around them. According to the time of day and the prevailing conditions, you might encounter them bathed in celestial light, shrouded in mist, or pummelled by turbulent waves and gale force winds.

Since the arrival of *Couple*, Newbiggin-by-the-Sea has been transformed from a charming but undistinguished seaside village into something of a cultural destination, an exponential rise in visitor numbers testifying to the regenerative power of contemporary art.

Over the past ten years, Sean Henry has won a broad international reputation as one of Britain's most gifted sculptors. His celebration of the heroic nature of ordinary working men and women has resonated with collectors around the world and his work is now

Fig.1 *Couple* 2007

represented in numerous outdoor public locations, as well as in museums, sculpture parks and private collections.

The decision to commission him to create the work in Newbiggin reflects Henry's proven ability to translate into larger-scale projects in public arenas the same powerful resonance that his smaller works achieve in more intimate interior environments.

His first foray into a public outdoor space came in 2000 when he contributed work to the group exhibition *Bronze* in London's Holland Park. As a result of this exhibition, his *Walking Man* (1998) remains a permanent fixture in the park.

In 2001, Henry's first solo show at London's Berkeley Square Gallery led to *Trajan's Shadow* being installed in Berkeley Square, the first contemporary work ever shown there. In 2003, Henry's major three-figure piece *Man with Potential Selves* (2000) – first shown in *Sculpture at Goodwood* – was acquired by the city of Newcastle upon Tyne and permanently installed in Grainger Street in the city centre. Shortly after, his *Catafalque* (2003) was displayed in Canary Wharf in the City of London, which led to its acquisition by the Seven Bridges Foundation in New York State.

The success of such high-profile installations serves to emphasise the powerful social qualities inherent in Henry's large-scale figure sculpture. Much of his work is richly ambiguous. On the one hand his figures communicate a certain melancholy and a sense of yearning, and yet they also foster empathy and a feeling of connectedness in the viewer, which perhaps explains why the artworks are so effective in public locations.

Alongside the large public commissions, Henry has also been busy in recent years creating interior pieces on a variety of scales that have featured in numerous successful solo shows in Europe and America, and his work continues to be exhibited at leading international art fairs.

In 2008, these two strands of his work came together for the first time in a major installation at the new headquarters of Standard Chartered Bank in the City of London. This book offers us a chance to pause and take stock – to follow the unusual path that Henry has taken and to examine what motivates and inspires his work.

Fig.2 Exhibition installation at Galleri Andersson Sandström, Umeå, Sweden, 2007

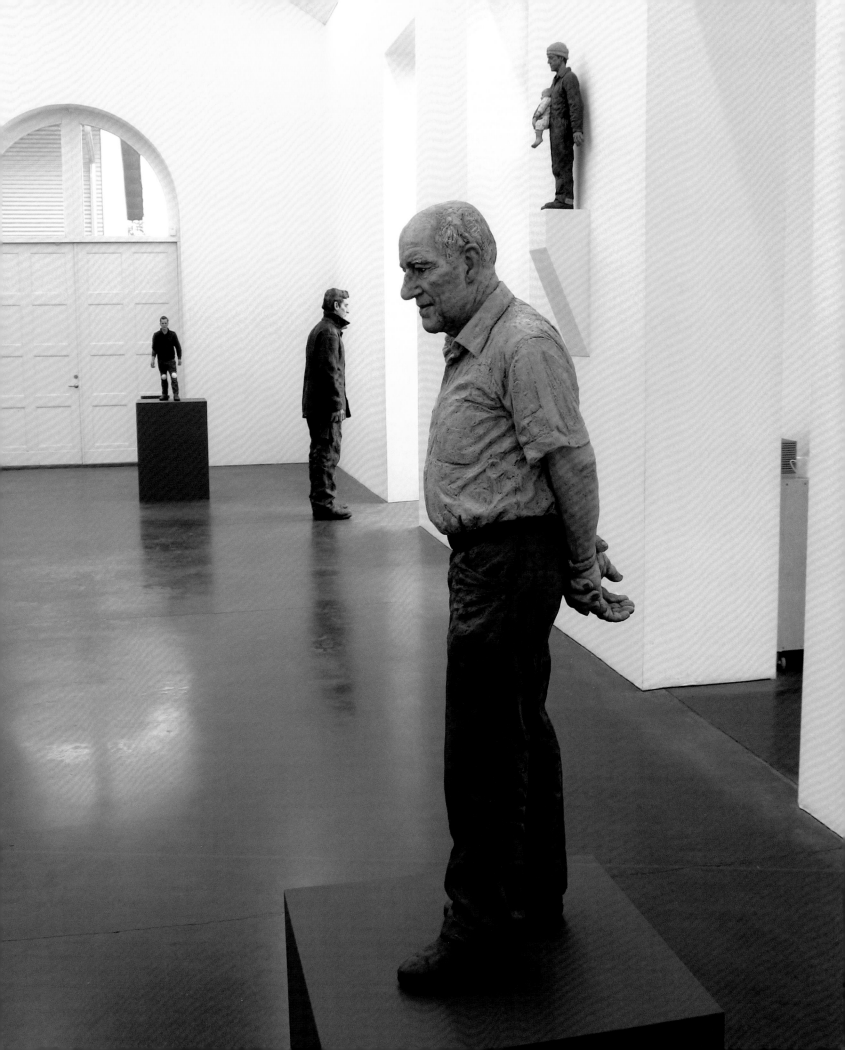

spring

1997

VAN GOGH'S *Postman*
THE PORTRAITS OF JOSEPH ROULIN

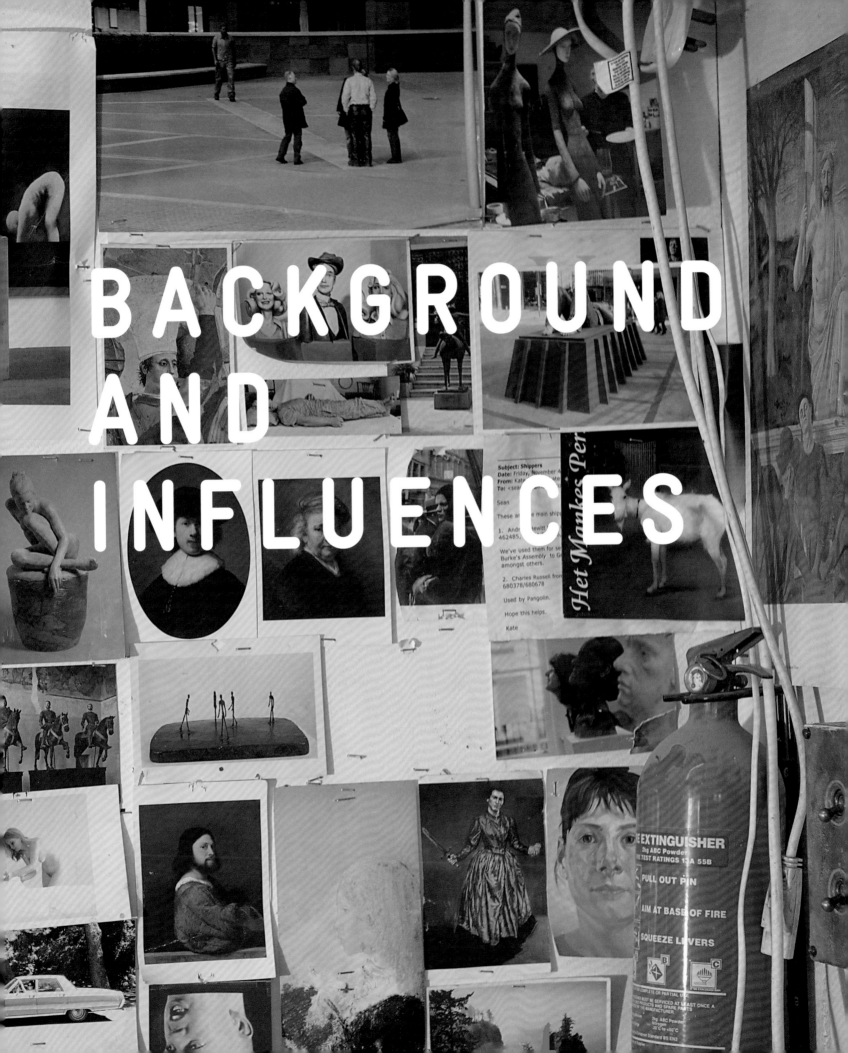

BACKGROUND
AND
INFLUENCES

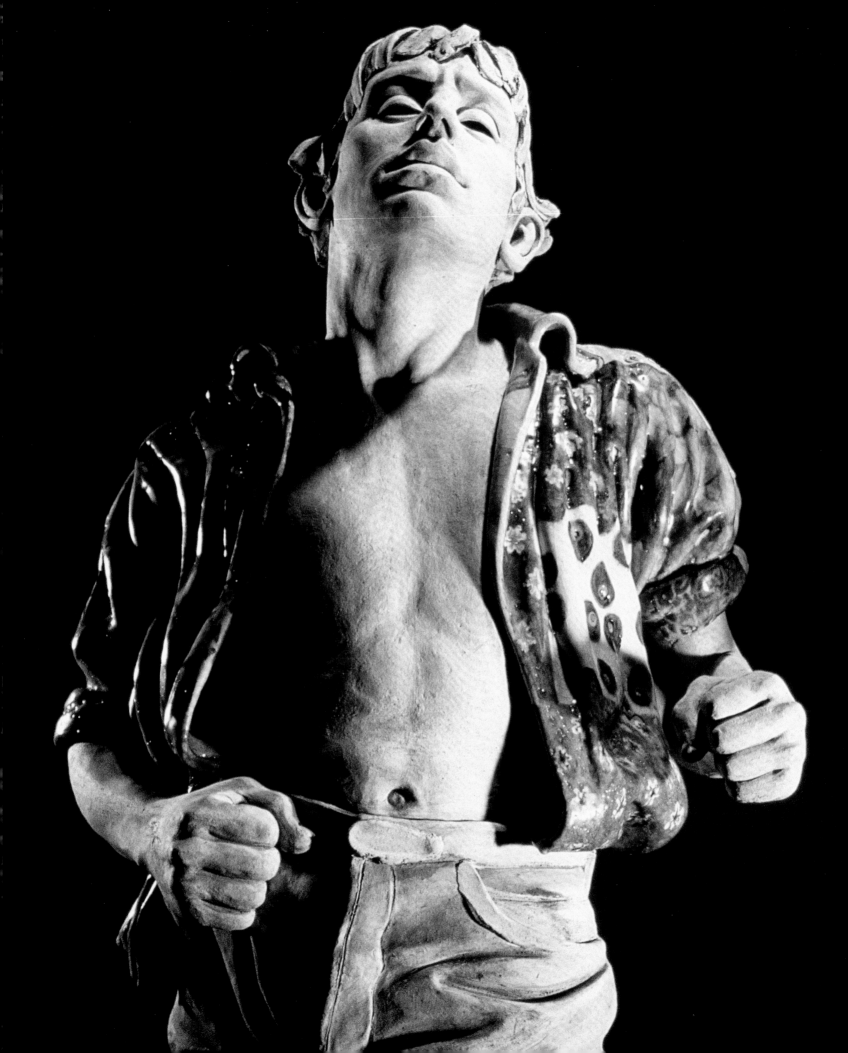

Sean Henry's single figures and multiple-figure groups now occupy private and public locations all over the world. Over the last five years he has won a broad international reputation as one of the most talented British artists of his generation. His most recent projects have confirmed both the scale of his ambition and his ability to conceive and deliver the most complex public commissions. Moreover, Henry has progressed to this point in his career almost entirely single-handedly.

Working from the life model, from photographs and drawings, he constructs his figures in clay before supervising their transmission into bronze. Finally, he paints them himself. One might expect such a painstaking, labour-intensive process to result in a restricted output, but Henry gets more productive as each year passes. In any given month, his working regime embraces drawing, sculpting, both in the round and in low relief, and oil painting, applied not only to his sculpture, but independent works on canvas as well.

Although now established as a sculptor in the fine art tradition, Henry was originally trained as a ceramicist. His ambition within that medium, his determination to push clay beyond the constraints which tradition had imposed upon it, ultimately led him into full-scale bronze sculpture.

Sean Henry was born in Guildford in southern England in 1965, the youngest of four brothers. He became interested in pottery when he was 14, and within a couple of years was making small ceramic hand-built objects which he sold on a local market stall to earn himself extra pocket money. Using the proceeds from this junior cottage industry he bought himself a kiln, an investment in self-sufficiency that was to pay significant dividends in the longer term.

It was during his secondary education at Radley College, a boys' boarding school near Oxford, when Henry's interest in hand-built ceramics really began. He claims he was drawn to pottery – like quite a few of his fellow Radley students – on account of it being the only lesson at the school taught by a woman, Sue Haslam. Henry enjoyed the relative freedom of the school's art rooms and started to develop an ability to model in clay.

In 1983, having left Radley a year early at age 17, and after an interim year completing his A-levels at Guildford Technical College, Henry enrolled at Farnham Art College which at that time had a reputation for the quality of its foundation courses. He remembers this as one of the earliest moments when the parameters of design in which he had been working began to develop into those of fine art. Although he did no clay modelling at all in his year at Farnham, Henry absorbed himself in regular drawing classes. This training gave him new confidence and left him with a set of skills which have subsequently become an important part of his working method.

Fig.3 *And She Said Yes* 1988

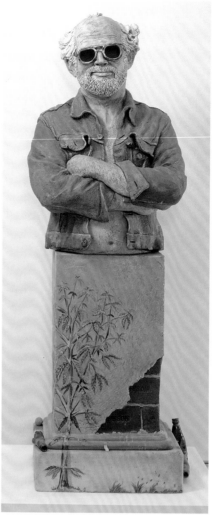

Fig.4 Robert Arneson (1930–92)
General Nuke 1984
Glazed ceramic and bronze on a granite base.
197.5 × 76.2 × 93.3 cm / 77¾ × 30 × 36¾ in
Courtesy of Hirshhorn Museum and Sculpture
Garden, Smithsonian Institution, Gift of Robert
Arneson and Sandra Shannonhouse, 1990

Fig.5 Robert Arneson
California Artist 1982
Stoneware with glazes
173.4 × 69.9 × 51.4 cm / 68¼ × 27½ × 20¼ in
San Francisco Museum of Modern Art
Gift of the Modern Art Council

Sean Henry's single figures and multiple-figure groups now occupy private and public locations all over the world. Over the last five years he has won a broad international reputation as one of the most talented British artists of his generation. His most recent projects have confirmed both the scale of his ambition and his ability to conceive and deliver the most complex public commissions. Moreover, Henry has progressed to this point in his career almost entirely single-handedly.

Working from the life model, from photographs and drawings, he constructs his figures in clay before supervising their transmission into bronze. Finally, he paints them himself. One might expect such a painstaking, labour-intensive process to result in a restricted output, but Henry gets more productive as each year passes. In any given month, his working regime embraces drawing, sculpting, both in the round and in low relief, and oil painting, applied not only to his sculpture, but independent works on canvas as well.

Although now established as a sculptor in the fine art tradition, Henry was originally trained as a ceramicist. His ambition within that medium, his determination to push clay beyond the constraints which tradition had imposed upon it, ultimately led him into full-scale bronze sculpture.

Sean Henry was born in Guildford in southern England in 1965, the youngest of four brothers. He became interested in pottery when he was 14, and within a couple of years was making small ceramic hand-built objects which he sold on a local market stall to earn himself extra pocket money. Using the proceeds from this junior cottage industry he bought himself a kiln, an investment in self-sufficiency that was to pay significant dividends in the longer term.

It was during his secondary education at Radley College, a boys' boarding school near Oxford, when Henry's interest in hand-built ceramics really began. He claims he was drawn to pottery – like quite a few of his fellow Radley students – on account of it being the only lesson at the school taught by a woman, Sue Haslam. Henry enjoyed the relative freedom of the school's art rooms and started to develop an ability to model in clay.

In 1983, having left Radley a year early at age 17, and after an interim year completing his A-levels at Guildford Technical College, Henry enrolled at Farnham Art College which at that time had a reputation for the quality of its foundation courses. He remembers this as one of the earliest moments when the parameters of design in which he had been working began to develop into those of fine art. Although he did no clay modelling at all in his year at Farnham, Henry absorbed himself in regular drawing classes. This training gave him new confidence and left him with a set of skills which have subsequently become an important part of his working method.

Fig.3 *And She Said Yes* 1988

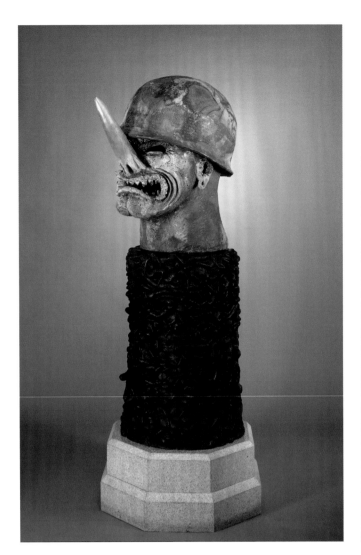

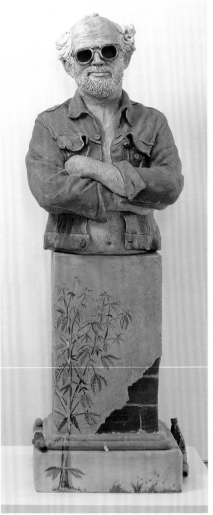

Fig.4 Robert Arneson (1930–92)
General Nuke 1984
Glazed ceramic and bronze on a granite base.
197.5 × 76.2 × 93.3cm / 77¾ × 30 × 36¾ in
Courtesy of Hirshhorn Museum and Sculpture
Garden, Smithsonian Institution, Gift of Robert
Arneson and Sandra Shannonhouse, 1990

Fig.5 Robert Arneson
California Artist 1982
Stoneware with glazes
173.4 × 69.9 × 51.4 cm / 68¼ × 27½× 20¼ in
San Francisco Museum of Modern Art
Gift of the Modern Art Council

The year at Farnham concluded with typical foundation projects – building a bicycle out of wood, and spending three weeks in a tree constructing a human-size nest – but the coursework was ultimately frustrating and Henry decided to go back to clay and the kiln.

In 1984, Henry was accepted onto Bristol Polytechnic's three-year BA ceramics course at Bower Ashton. His tutors at this time included, among others, Walter Keeler, Nicholas Homoky and Mo Jupp. Jupp, a part-time lecturer who criss-crossed the South of England in his van fulfilling teaching assignments at Bristol, Central Saint Martins and Chelsea, was an early advocate of Henry's work. Most of Henry's fellow students at this time hailed from the West Midlands, historically an important centre of industrial ceramic manufacture.

At Bower Ashton the emphasis was placed firmly on what were regarded as the limitless possibilities of teapot design. This was a stimulating enough subject for those seeking careers in the ceramic studios of Stoke-on-Trent and environs, but rather more limiting for Henry whose horizons stretched into the still relatively uncharted territory of large-scale figurative ceramics. 'I didn't really fit in,' he recalls of his time at Bristol. 'It was a 3-D design course and I wanted to make sculpture, but I plugged away, determinedly.'

Perhaps the clearest evidence of how Henry was thinking at this time is provided by his final year thesis, combatively titled 'This is Not a Teapot: A Need for Self Expression', which he submitted in 1987.

If his Bristol tutors had been uncertain as to why Henry had never quite submerged himself in the challenging demands of tableware design, this thesis provided ample explanation. Although completed primarily as a course requirement, Henry's diligently researched account of the development of contemporary American 'Funk Ceramics' also signalled something of his long-term ambitions.

At this time, Funk Ceramics was predominantly a West Coast phenomenon centred principally, although not exclusively, around the Sacramento Valley of Northern California. The leading exponent was Robert Arneson (1930–1992), whose work in the 1960s and 1970s established him as the figurehead of a particular style of socially orientated ceramic sculpture (figs.4–5). Arneson became the principal *agent provocateur* in a battle against a craft tradition which had consigned ceramics to an inferior status below fine art. As David Ryan has noted, 'Few living sculptors have challenged this condescending attitude in a more outrageous, effective manner than Robert Arneson.'[1]

By the time Sean Henry began the Bristol ceramics course in the mid-1980s, schools of large-scale figurative ceramics were flourishing across North America, with prominent exponents in California (Arneson, Viola Frey, Tony Natsoulas, Lisa Reinertson), Ohio (Jack Earl), Wyoming (Terry Kreuzer), Indiana (Joe Rohrman), Washington (Patti Warashina,

Steven McGovney, Anne Perrigo, Marilyn Lysohir), New York (Arthur Gonzalez) and elsewhere. Much of the work being produced at this time was sardonic in content, using varying combinations of humour and satire to convey political or social messages about life in Reagan's America. The unifying element was a shared determination to expand the parameters of ceramics, to rescue it from the ghetto of 'craft' and reclaim it as a viable branch of the fine arts.

The term 'Funk Ceramics' emerged in the late 1960s as shorthand for a deliberately provocative genre that some critics dismissed as 'bad taste'.[2] In his early 'pop' objects and in many of his later large-scale figures, Robert Arneson poked fun at the traditional status of clay as an impoverished, 'second-rate' medium commonly associated with lowly functional objects such as house bricks and tableware. In an effort to elevate figurative ceramics to a higher status he devised a strategy of social and political engagement that would guarantee critical attention. His no-holds-barred approach was deployed to full effect in 1981 in his first significant public commission – a memorial portrait bust of San Francisco mayor George R. Moscone, who had been assassinated in November 1978 along with colleague Harvey Milk by San Francisco supervisor Dan White.

Portrait of George comprised a large head and shoulders bust of Moscone raised on a pedestal inscribed with provocative slogans and emblems referencing the circumstances of Moscone's murder and White's subsequent trial. The work caused an immediate outcry when unveiled at the Moscone Convention Center in December 1981. Following widespread public and media criticism, it was withdrawn from public view.

'I should have known better,' Arneson later remarked. 'I've always avoided public commissions before… but it seemed they were going to be relatively gutsy, that they wanted a Bob Arneson. You see, I'm still naïve.'[3]

Although it failed to win over the public and alienated the political establishment, Arneson's *Portrait of George* succeeded in drawing attention to a radical new genre of large-scale figurative ceramics.

Later that same month, art critic Hilton Kramer penned a review in the *New York Times* attacking Arneson's 'moral smugness… bluster, facetiousness and exhibitionism' and his apparent failure to comprehend the subtleties of true satire. Kramer ascribed these shortcomings to what he saw as the 'spiritual impoverishment' and 'provincialism' of the cultural life of California.[4]

Arneson's response to Kramer, made in the following year, was an ironic self-portrait entitled *Californian Artist* (fig.5). More than any other work, *Californian Artist* reflects Arneson's self-image as art-world refusenik and counter-cultural outsider. With his bare

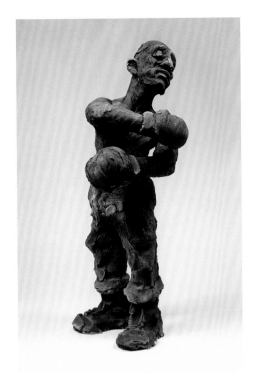 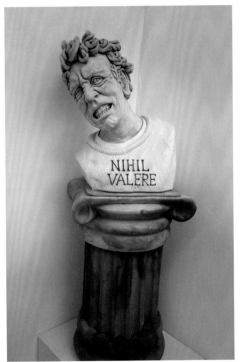

chest, defiantly folded arms, denim jacket and dark glasses (which on closer inspection reveal the clear, blue-glazed interior of a hollow head), *Californian Artist* subverts the antique sculptural tradition of the 'term' – a torso mounted on a pedestal, used to mark boundaries in the ancient world. Arneson's boundary-breaking composition incorporated a *trompe l'oeil* cannabis plant, an empty bottle and an illusionistically modelled chipped stucco base to imply a common or garden brick support beneath. Arneson felt strongly that Californian artists suffered a lack of respect from the East Coast establishment at that time. By presenting back to Kramer a literal representation of how he felt the New York critic had unfairly stereotyped him, Arneson was not only responding to the volleys aimed at him personally, but hitting out on behalf of the broader West Coast artistic community.

These visually noisy interventions into the hitherto genteel realm of ceramics reverberated beyond America and inspired the young Sean Henry to include them in his student thesis at Bristol. After scouring several years of back issues of the leading ceramics magazines and journals in the course of his research, Henry wrote to those ceramic sculptors in Europe and America whose work he most admired. Many responded. By initiating a dialogue, he not only garnered valuable advice and guidance from the most experienced exponents in his chosen medium, he also established a number of lasting friendships.

Fig.6 *She's Gone* 1988 Fig.7 *Nihil Valere* 1986

Henry's work received its first formal recognition at his Bristol degree show, where it was spotted by Anatol Orient, the visionary director of the Anatol Orient Gallery in London's Portobello Road. At that time, Orient was the leading London dealer in fine art ceramics, showing works by Picasso, Hans Coper, Lucy Rie, Kenneth Price, Robert Cooper, Kate Malone, and Jill Crowley, as well as work by up-and-coming new talents such as Henry.

Henry's first show with Anatol Orient included a large glazed ceramic figure of a boxer from his degree show called *Who Am I?* (fig.8). Offered at the then unheard-of price tag of £3000, it immediately sold, indicating that the forward momentum gained by Arneson in America might have a European dimension as well. Spurred on by the market's first significant endorsement of his work, Henry moved into a studio in an old farm building in East Horsley, Surrey. Isolated but affordable, it enabled him to focus on the next stage of his career. However, instead of settling down, in 1989 he seized an opportunity to visit the USA to meet some of the artists with whom he had corresponded while completing his thesis. After a short stopover in New York to see the American Crafts Museum, MoMA, the Frick and other major galleries, Henry flew to Ohio to spend time with the American ceramicist Jack Earl (figs.10–11).

Earl rarely ventured from his Ohio homestead save for rare, brief excursions to New York to deliver work for exhibition. Over time he had developed a highly personal visual vocabulary through which to express his whimsical but always charitable view of his fellow humans – 'ordinary people doing ordinary things', as he put it. To this end he invented a character – 'Bill' – a kind of John Doe whose back stories, often written by Earl himself, spoke of universal hopes and fears. Earl's gentle, non-judgmental observations of his fellow men, his down-home, no nonsense approach to life and art, and his rejection of social pretensions and intellectual posturing, all had a profound impact on the young Henry.

Few works express Earl's brand of rustic spiritualism better than the 27in (69cm) high figure known as *Carrot Finger* (1981; fig.11). Earl gave the work an extended title in the form of a short story or fable about an imaginary acquaintance, a young man who had been born with a carrot for a finger. Although as a boy this mild social impairment elicited jeers from other children, it did not impede the young man's marriage some time later to a local girl with whom Carrot Finger started a family. However, after falling asleep on a grassy hillside one warm day, he woke to find that his finger had been eaten by rabbits. 'He told me he thought it might grow back,' wrote Earl, 'but it didn't.'

On hearing of this strange Freudian fable and the associated work, Henry said at the time: 'The replacement of the young man's forefinger with a large carrot is a subtle human transformation, creating numerous metaphors.' Echoes of Earlian symbolism occasionally

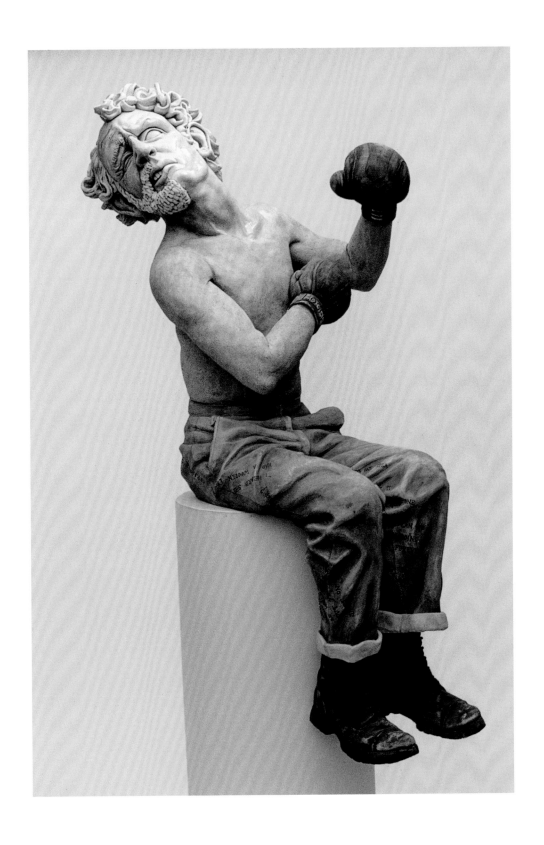

Fig.8 *Who Am I?* 1987

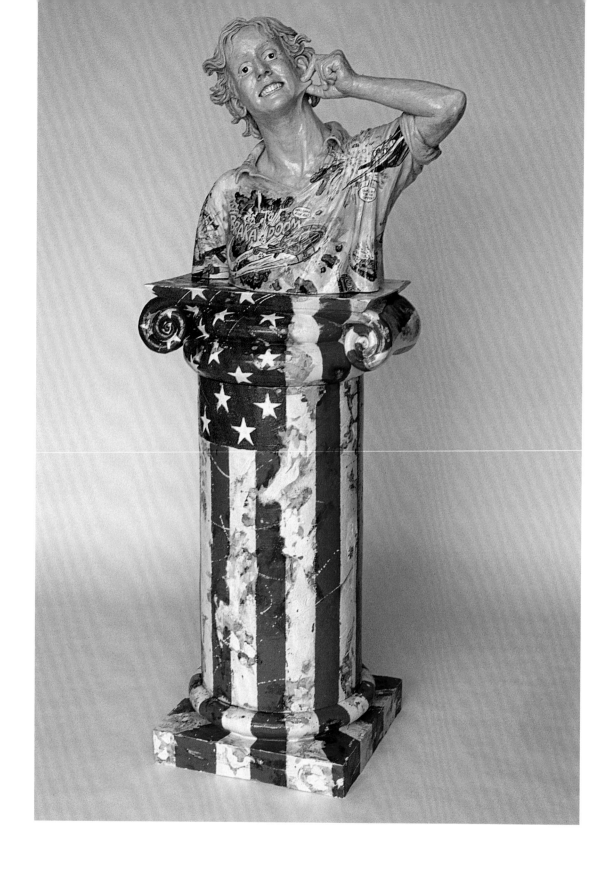

Fig.9 *Yank* 1990

emerged in Henry's own sculpture, particularly in his choice of attributes such as the orange held by the suited figure in *Ben (Ideas Resolved)* of 2001 (see fig.49 on page 81).

From Ohio, Henry traveled to Chico in Northern California at the invitation of two other American ceramicists with whom he'd corresponded while preparing his college thesis. Anthony Natsoulas and Lisa Reinertson had both trained under Arneson at the University of California, Davis in the late 1970s/early 1980s and both were well-established exponents of large-scale figurative ceramics. Henry worked as Natsoulas's assistant for six months, an experience that was to have a lasting impact, not least because it was through Natsoulas that he was first introduced to Robert Arneson.

One of Henry's most significant pieces from this period – *Yank* of 1990 (figs.9, 12) – clearly reveals the influence on his work of Arneson's brand of Funk, albeit an influence absorbed from a distance. The piece, standing 1.98m high, comprises a head and shoulders of a carefree young man mounted on a faux marble classical pedestal decorated with the stars and stripes. The guy's shirt, emblazoned with hand-painted Lichtensteinian comic book imagery – including a US plane downing another in a now all-too familiar 'friendly-fire' scenario – was intended as a protest against the US invasion of Panama under George Bush in 1989. *Yank* also broadly coincided with the outbreak of the first Gulf War of 1990–91, although its satirical edge is subsumed by a cheery pop optimism. The pinching or 'yanking' of the cheek refers more to the influence of the West Coast ceramic school on Henry's own work (as he was pulled in the direction of America) rather than to broader political issues. *Yank* was included in the exhibition *Thirty Ceramic Sculptors* at the Natsoulas Novoloso Gallery in Davis in 1991 alongside works by, among others, Robert Arneson, Tony Natsoulas, Lisa Reinertson, David Gilhooly and Richard Shaw.

In 1990, Henry received a letter from Arneson – who had been impressed after seeing a photograph of Henry's sculpture *Who Am I?* when they first met in 1989 – inviting him to take up the post of Visiting Artist at UC Davis in 1991. Although unpaid, it provided an opportunity for him to deepen his experience in one of the most illustrious and challenging ceramics studios in America.

Set in the flat Sacramento Valley an hour from San Francisco, UC Davis began principally as an agricultural college, but had been offering art courses since 1952. A major in fine art was not established until 1957.[5]

The ceramics department at Davis is housed in a large prefabricated building known by the singularly unromantic name of TB-9 – Temporary Building No.9, erected in the 1920s. Through the late 1950s and early '60s, TB-9 still housed the campus police, a small jail, a post office, specialist libraries and food science research facilities. When Arneson arrived in 1961,

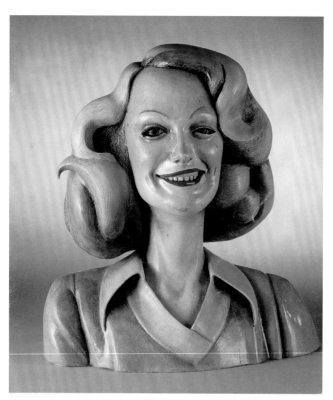

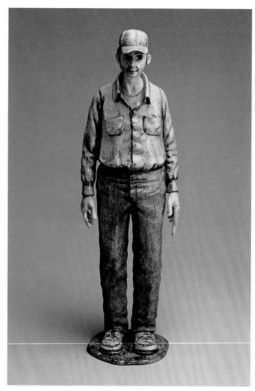

Fig.10 Jack Earl (b. 1934)
Miss Sears, 1940 1982
White earthenware
Handbuilt, glazed, painted
49.5 × 51 × 35.6 / 19½ × 20 × 14 in

Fig.11 Jack Earl
Carrot Finger 1981
Ceramic, china paint
68.6 × 20.3 × 15.2 cm / 27 × 8 × 6 in
Courtesy of The Perimeter Gallery, Chicago
Collection Mrs Karen Johnson Boyd

Fig.12 *Yank* 1990 (detail)

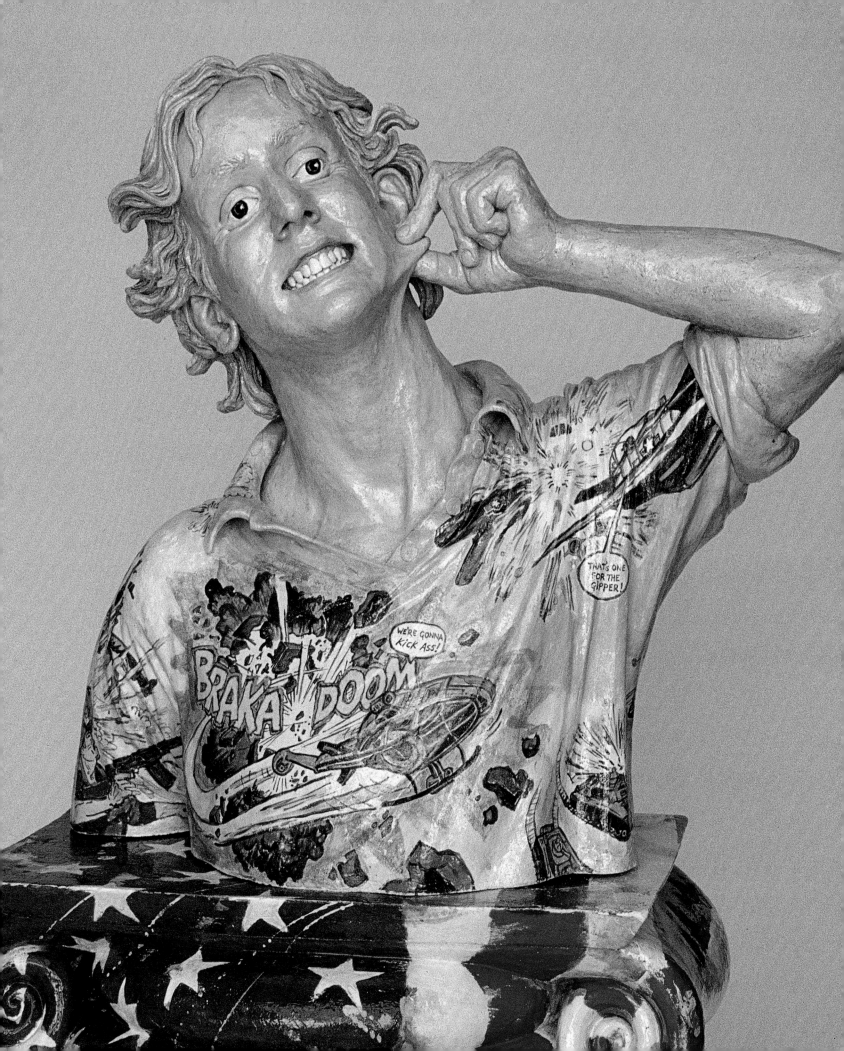

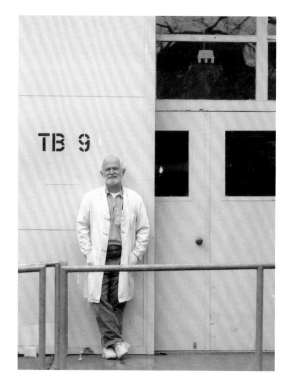

only a small portion of the building was devoted to ceramics studies. However, through the 1960s Arneson gradually expanded his operations and by 1968 his ceramics department had taken over the whole building (fig.13).

From the outset, Arneson placed the emphasis at TB-9 on the fine art potential of ceramics. 'It was real clear in everybody's mind,' Arneson later recalled, 'that it was art and not craft. That's why TB-9 has never had a pottery facility. It was just out of the question. [...] Since we were in the art department we allowed this other sensibility and notion to take hold. [...] We were going to be artists... and that meant you didn't make crafts.'[6] As Bruce Nixon has observed, 'The direction of Californian ceramics – and, by implication, American ceramics – was altered there, within the walls of that long, low, dusty building.'[7]

By the time Henry arrived in 1991, the unprepossessing shed known as TB-9 was internationally acknowledged as the foremost centre for ceramics studies in North America. Among the artists to emerge from TB-9 during the 1960s were Wayne Thiebaud, David Gilhooly, Bruce Nauman, Peter VandenBerge, Arthur Gonzalez, John Buck, Richard Shaw, Lucian Pompili, Deborah Butterfield, Joe Manino, John Roloff and countless others, while the college also benefited from the guidance of resident and guest instructors such as William T. Wiley, Elaine de Kooning and Manuel Neri.

Fig.13 Robert Arneson outside TB-9, University of California, Davis, c.1990

Fig.14 *Hard To Swallow* 1991

Sean Henry's experience in the 'garage' hothouse of TB-9 enabled him to assimilate fully the American Funk persuasion before eventually steering away from it in order to find his own voice.

In return for a half day's teaching at TB-9 each week, Henry had the freedom to push his own work forwards. Arneson, privately battling with cancer, was moving towards semi-retirement. He generously granted Henry access to the kilns and other facilities in which he himself had flourished as artist and educator from the early Sixties onwards. Despite living hand-to-mouth, Henry thrived in the macho ambience of TB-9, working by day and sleeping on friends' floors at night. This catalytic period culminated in 1991 with an exhibition of his work at the Natsoulas Gallery in Davis owned by Tony's brother, John. Entitled *Seven Heads*, in homage to Arneson's eponymous show of the 1970s, the exhibition featured seven ceramic large heads, including a self-portrait and a portrait of another cult pioneer of contemporary American ceramics, Peter Voulkos.[8] The flyer from Arneson's 1970s show had been hanging above the studio door throughout Henry's time at TB-9. 'I saw it every day,' he recalls. 'It seemed pointless to try and avoid the influence.'

Not surprisingly, Arneson's influence was profound, and Henry's work from that time bears close affinities with the older man's work. Doubtless Arneson recognised in Henry the same energy and determination that had helped him put TB-9 on the map in the 1960s. 'Some people have thought that there's a Davis style,' Arneson later remarked, 'but honestly I can't recall one, except that we were always interested in contrariness.'[9]

The early 1990s was a productive period for Henry, at this time still nurturing a contrary stance towards traditional ceramics. Much of his work from this period exploits the vigorous modelling, high glazes and exuberant polychromy of West Coast Funk. However, the figures produced in 1991 begin to betray something of a quirky European sensibility, borrowing the muscular aspects of Arneson's work while eschewing the older man's sledgehammer social agenda. Decals and printed text abound on the surface. Boxing gloves and bare chests form a masculine iconography with which to punch through an alternative to the historically feminised ceramic tradition of teapots and tableware. *Hard To Swallow* (1991) and *Bonjour Monsieur Henri* (1992) extend the fun-poking vein opened by Arneson, while *Refugee* (1990), with its bathroom-tiled pedestal applied with doll figures, subverts the paraphernalia of formal civic portraiture to comment on the threshold status of figurative ceramics (figs.14 –16). But these works also express some of the personal alienation Henry was experiencing at this time as an Englishman abroad, as well as his slight distrust of Californian culture. For example, *Hard to Swallow* (now in the Arizona State Art Museum) was about an outsider being force-fed American flag ice cream on arrival ('love it or leave it' was a common phrase

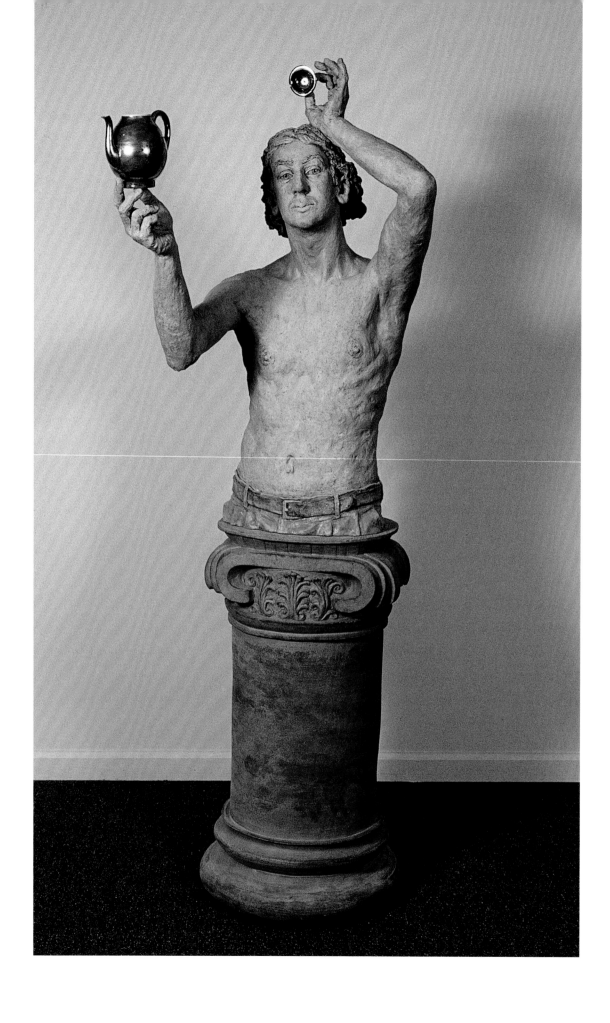

used towards critics of the US in 1991, when the Stars and Stripes were everywhere – on cars, outside houses). *Refugee* was conceived within this flag-waving context as an ironic 'Welcome to America'.

In 1992, Henry swapped studios with a Syrian artist in Paris and spent four months living and working in a first-floor unheated bedroom/kitchen/studio off the rue de Lappe near the Bastille. Here he made a series of life-size ceramic heads inspired by the character busts by the eighteenth-century German sculptor Franz Xaver Messerschmidt (1736–1783). When not working, he made regular visits to the Musée d'Orsay and the Rodin Museum and began to think about European sculpture in contrast to the West Coast art world he had been immersed in.

Returning to England from Paris in 1992, Henry met his future wife Harriet just before an exhibition of his Paris-made sculptures opened in Farnham. Shortly afterwards he received the news of Robert Arneson's death, ending the artist's long struggle with cancer. The following year, still hungry for experience, and keen to avoid the then UK-wide recession, Henry set off for a stay in New Zealand where his one of his brothers was living.

From New Zealand, he moved to Sydney, Australia, where he quickly found a teaching post in the ceramics department at Sydney College of the Arts. Having thus secured access

Fig.15 *Bonjour Monsieur Henri* 1992 Fig.16 *Refugee* 1990

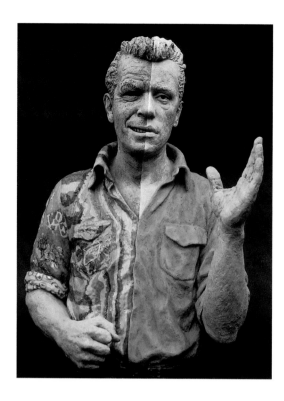

to a studio and a kiln, he spent the next eighteen months making work at home, teaching two days a week, surfing, and touring New South Wales in a 1968 chocolate brown Chrysler Valiant Regal. The beloved Chrysler eventually featured on the invitation to Henry's solo show at the Holdsworth Galleries in Sydney entitled *The Flipside of Dominic Hyde*.

Although largely still under the influence of California, in Sydney Henry started experimenting with painting his clay figures as well as raku-firing large heads. He rented an old Surry Hills studio from Sydney gallerist Rex Irwin, one of Australia's leading dealers in Lucian Freud, Leon Kossoff and Henry Moore. (Henry stills treasures a Freud etching of 'Kai', bought from Irwin around this time, a marker for his increasing awareness of the London School of painting that would exert an influence on his later work.)

Of the pieces dating from the Australian period, *Living with the Past* (fig.17) encapsulates Henry's growing ambivalence towards his earlier glazed work. The Janus-like figure embodies the creative tensions he felt around 1993 as he prepared to slough off the exotic plumage of TB-9 in favour of a more self-contained approach to the figure. *Head of Tom* (fig.18), which also dates from around this time, has a quiet monumentality reminiscent of a Frink head and looks forward to the walking figure from the Holland Park installation of 2000.

Fig.17 *Living with the Past* 1993 Fig.18 *Head of Tom* 1993

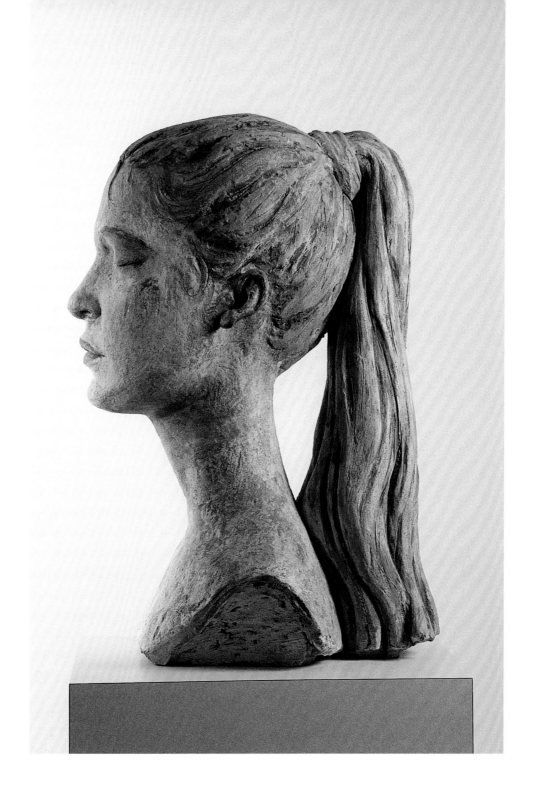

Fig.19 *Camille* 1991

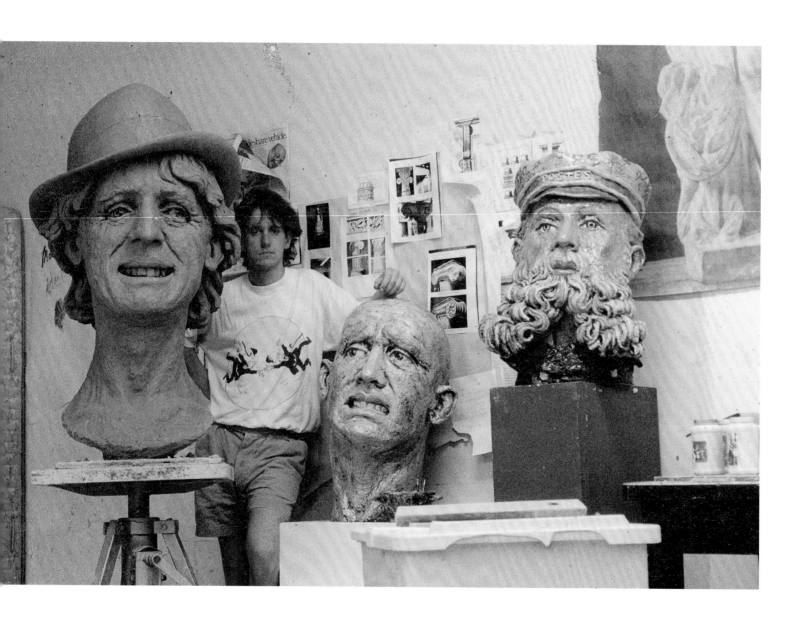

Fig.20 Sean Henry working in Arneson's studio at TB-9 c.1991

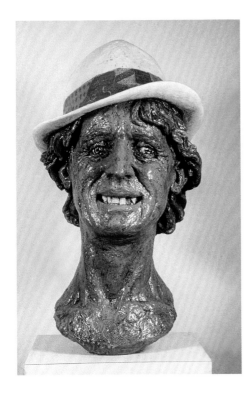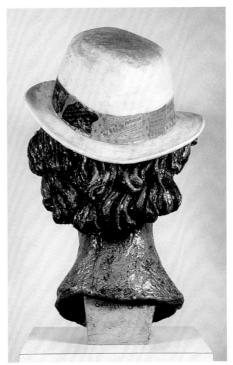

The Boxer, an early acrylic-painted work made in 1993, displays a roughness of modelling that signals a shift in technique which will soon resolve itself into Henry's signature style, while the 34-inch-high standing figure entitled *A Little Wine in the Morning, Some Breakfast at Night* (fig.22) can be regarded as the first of Henry's oil-painted ceramics. In many respects this was a breakthrough piece, signalling the direction in which his work would move after his Australian sojourn.

In 1994, Henry returned to London to find somewhere permanent to live and to take stock. Having shipped back to the UK some of the pieces he had made in America, he now began to look more critically at that body of work. The brash colours and high glazes born out of the carefree California lifestyle suddenly seemed inappropriate in the very different atmosphere of London. This prompted him to refine his technique – 'Some of the big San Francisco ceramic pieces started to look very wrong,' he recalls – 'wrong colours, and too kitsch for the subdued northern light of London.'

It was around this time that Henry stopped applying tight surface detail such as text, buttons and shoelaces to the work, although he continued to reference objects and articles of clothing that had a personal significance for him or that had an element of nostalgia, such as donkey jackets. He saw this as a way of 'calming down, to get to the guts of the figure.'

Fig.21 *Self Portrait in 20 Years Time* 1991

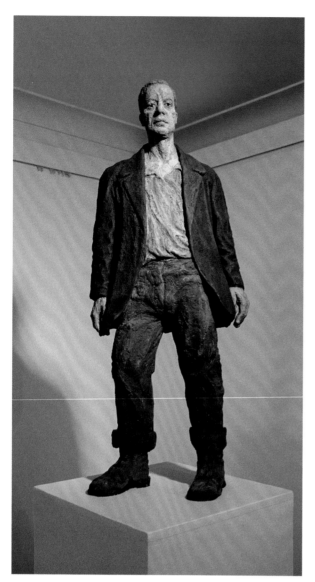
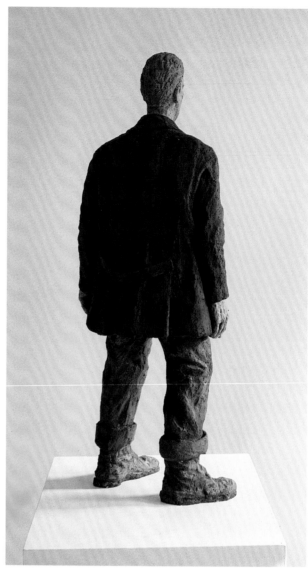

Fig.22 *A Little Wine in the Morning,*
Some Breakfast at Night 1994

Giacometti was a big influence on him at this time as he responded to 'the stillness and the very direct nature of his work.' He also began to feel an affinity with the School of London painters, which manifested itself in a more sober palette and a quiet approach to social realism.

Until this point, Henry's work was principally a response to contemporary social and political stimuli. His work revealed a keen awareness of the long tradition of ceramic making, but art-historical references were yet to appear with any conviction. However, in 1998, Henry was awarded the Villiers David Foundation Prize, granted annually to a British-based artist under the age of 36. Henry – the first sculptor to win the award – used the £8,000 prize money to fund a four-month tour of Italy in 1999. The experience had a profound effect on both his creative outlook and his technique.

Henry is a perceptive people-watcher and acutely sensitive to male and female body language. He registers and stores up the myriad physical reflexes that constitute everyday human behaviour – the absent-minded hand gestures we make when lost in thought, the bored postures we adopt when waiting for a bus or while passively observing the world around us. For Henry the sculptor, these are the components from which to construct a particular kind of ambiguity. He is aware that they reveal not *what* a subject is thinking, but that the subject *is* thinking.

Henry has discovered that a fruitful seam of meaning opens up when certain components we normally associate with realism are either excluded altogether or held in creative tension with more oblique cultural references. Thus he tends to avoid what he considers the extraneous visual noise of wristwatches, spectacles and other personal paraphernalia. On the other hand he is happy to render the word 'Italia' across a zip-front sports jacket in the knowledge that this word alone carries a rich freight of ambivalent allusions, embracing both the historical and the contemporary (see fig.35 on page 60).

In quite a few of Henry's early works he used himself as model, not as a form of obsessive self-analysis in the Arneson mode, but as a vehicle for a personal comment on what it feels like to be alive in the world today.

Although Henry continues to make his objects in clay, once he began translating his work into bronze he effectively liberated himself from the prejudices traditionally levelled at ceramics as 'craft'. As a result he is able to continue engaging with the ceramic tradition, making the work with his hands before painting the finished fired clay, and more often cast bronze works, himself. This arguably saved him from the fate suffered by Arneson who, in the words of Neal Benezra, 'sacrificed risk for didactic whimsy and was unable to achieve the powerful forms that might transcend the fragility of his material.'[10]

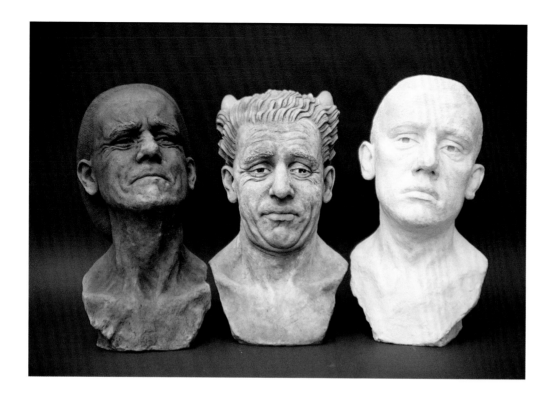

1 David Ryan, director, Des Moines Art Center, in Neal Benezra, *Robert Arneson: A Retrospective* (Des Moines Art Center, February 1986), p.6.

2 Although already coined (in its lower-case form as 'funk') to describe the work of the 1950s Beat generation of West Coast assemblage artists such as Bruce Conner, Ed Kienholz, Bruce Hedrick and others, the term 'Funk Ceramics' was applied to the work of Arneson and his contemporaries following an eponymous exhibition at the University Art Museum, Berkeley in 1967, curated by Peter Selz. See Benezra, *Robert Arneson: A Retrospective*, p.25, n.27.

3 Robert Arneson, quoted in Susan Ager, 'Moscone Sculptor Weary of the Whole Thing', in *San Jose Mercury*, 9 December 1981. (Reference cited in Benezra, *Robert Arneson: A Retrospective*, p.9).

4 Hilton Kramer, 'Ceramic Sculpture and the Taste of California', in *New York Times*, 20 December 1981, pp.31–33.

5 Benezra, *Robert Arneson: A Retrospective*, p.21.

6 Robert Arneson, quoted in *Thirty Years of TB-9: A Tribute to Robert Arneson* (John Natsoulas Gallery Press, 1991), p.24.

7 Bruce Nixon, 'The Impact of TB-9', in *Thirty Years of TB-9*, p.11.

8 Voulkos established the ceramics department at Otis College in Los Angeles in 1954, which trained, among others, Kenneth Price, Billy Al Bengston and John Mason. See Nixon, 'The Impact of TB-9', pp.11–13.

9 Robert Arneson, quoted in *Thirty Years of TB-9*, p.29.

10 Benezra, *Robert Arneson: A Retrospective*, p.29.

Fig.23 *Paris Heads* 1992

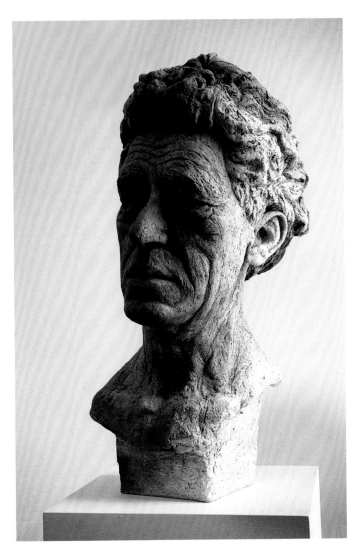
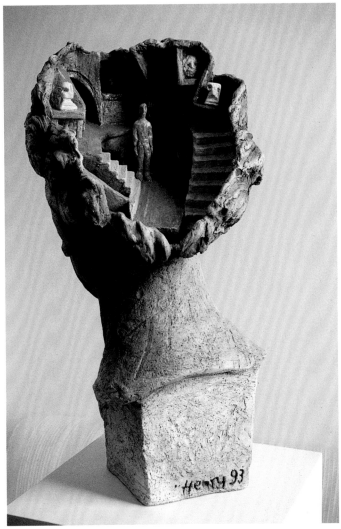

Fig.24 *Portrait of Giacometti* 1993

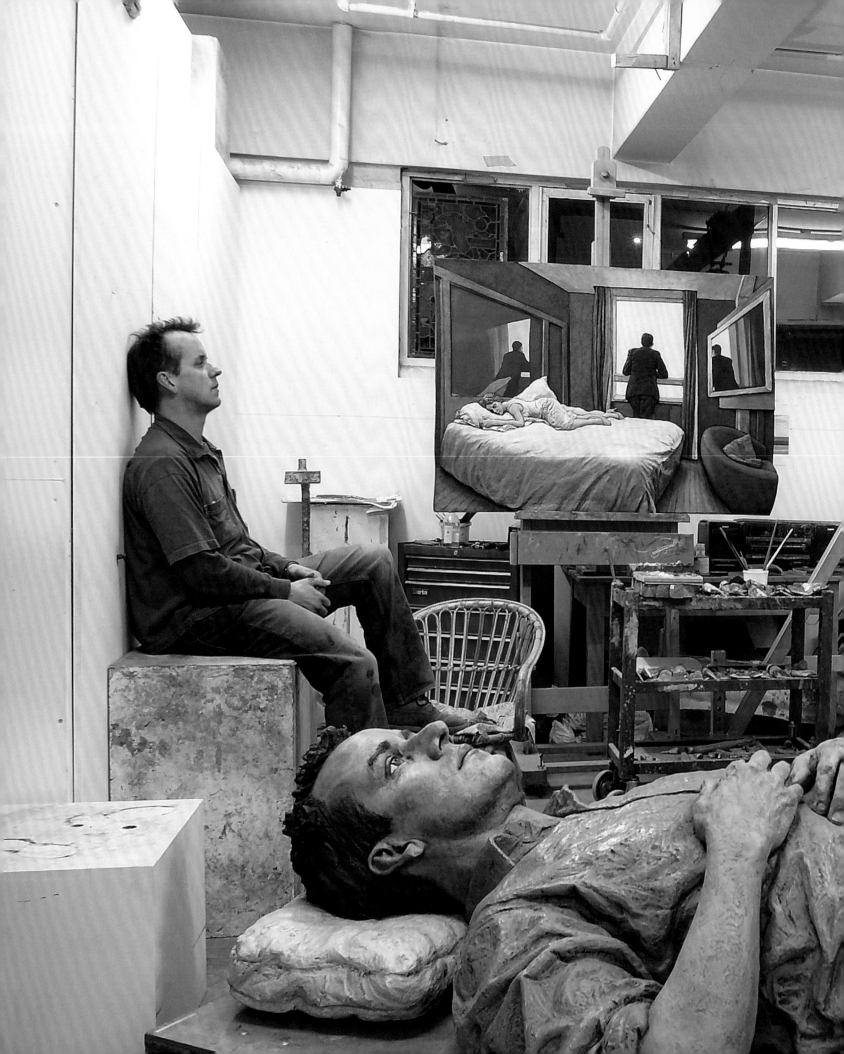

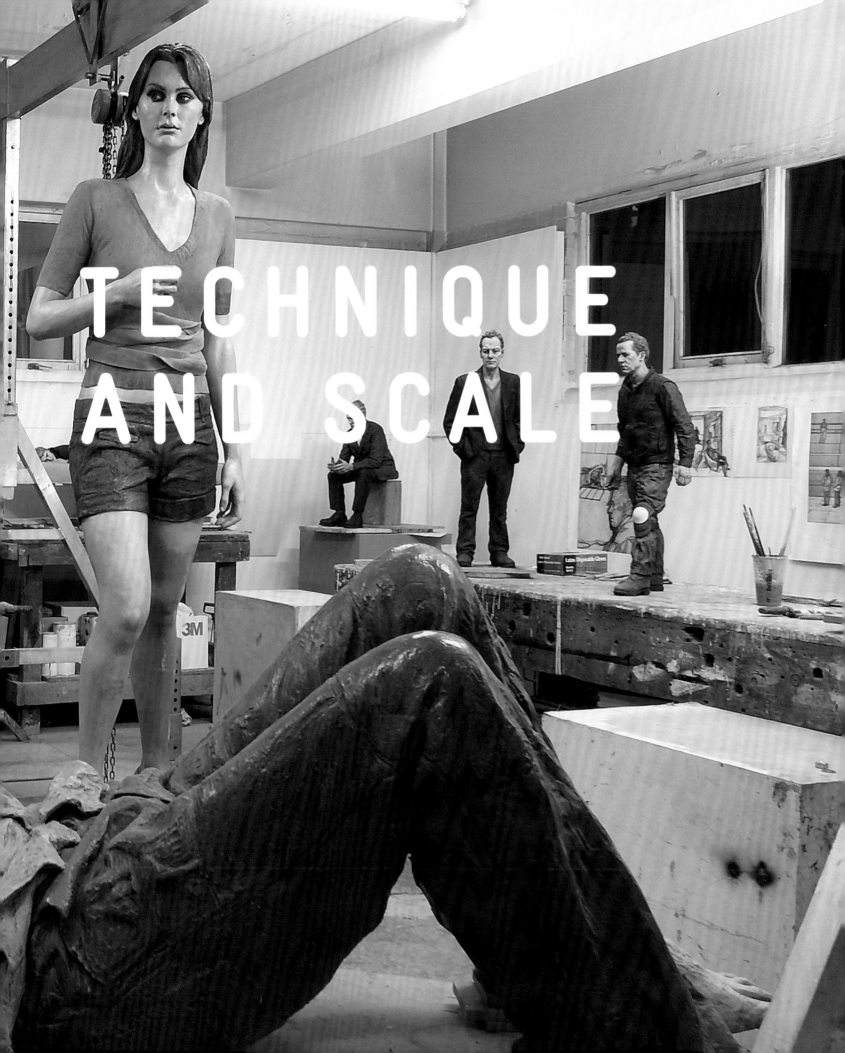

TECHNIQUE AND SCALE

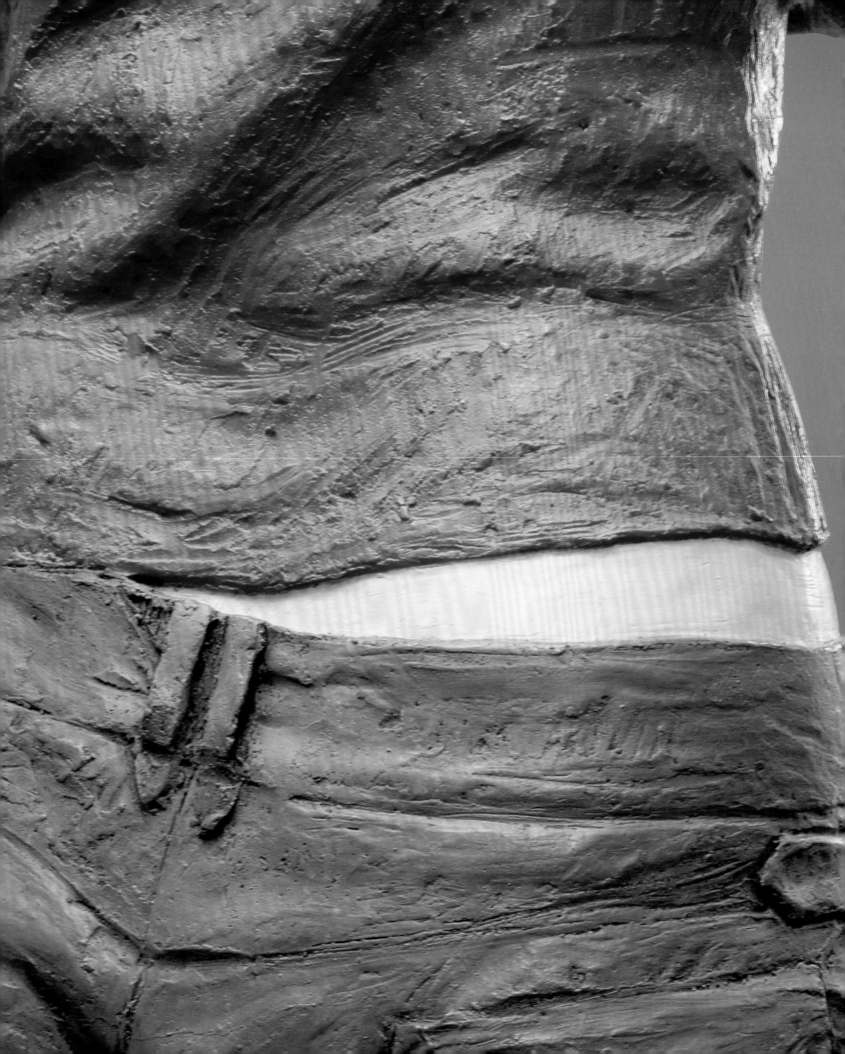

The international success that Sean Henry's work is currently enjoying points up an important aspect of the development of recent British contemporary art and its critical reception. Like many of his counterparts in contemporary realist painting, Henry has progressed his career entirely unswayed by the media attention afforded to the more overtly 'avant-garde' artists of his generation. Realism may not on the surface be the most fashionable route to adopt compared with more experimental modes of art-making, but it has continued to provide its serious practitioners with constant technical and philosophical challenges. For Henry these have centred on a preoccupation with representing the human figure, not only in sculptural terms, for he is first and foremost a sculptor, but also in terms of painting. Henry's work confirms that operating within the parameters of realism does not, as is commonly assumed, imply conservatism; nor does it preclude innovation.

Having come to sculpture via figurative ceramics, Henry arrived almost entirely oblivious of the historical controversy surrounding the colouring of sculpture. This liberated him from the constraints which might otherwise have dimmed his confidence and impeded his progress. Instead, he forged ahead and developed a highly expressive language that fuses strong figurative modelling with a vigorous approach to applied colour. In this way he avoided the 'Tussauds trap' that has dogged polychrome figurative sculpture since the mid-nineteenth century, instead evolving an original approach to the larger-than-life human figure that in recent years has done much to reinvigorate public sculpture.

Despite the ostensible realism of his work, Henry is not primarily concerned with a direct transposition of what he sees. He is more interested in using the figure to get at something beyond physical reality, to express his own experience of existing in the world – 'of trying to make sense of what we're doing and why we're here'. He is fully aware that what he is striving for may ultimately be inexpressible; but, paradoxically, the process of extending himself towards something beyond the straightforward depiction of appearances invests his figures with an almost palpable psychological presence.

Looking across a range of Henry's mature work, certain key aspects of his approach quickly become apparent. His figures are not lifelike. Rarely if ever do they conform to precise human scale, itself a fluid, indeterminate concept.[1] The surface of the work reveals a wealth of evidence of the modelling process – thumbprints, finger marks, striations and incisions (fig.25). His application of colour (he paints his figures in oils) is confident and painterly. He has a preference for seemingly unremarkable subjects and contemporary dress, which he manages to invest with a certain grandeur. His figures are never demonstrative; they are never shown laughing, crying, or speaking; instead they are often caught in the nanosecond between rest and motion. They seem to ponder, to daydream. They exude what the ancient Greeks called *sophrosyne*, or self-control.

Fig.25 *Woman (Being Looked At)* 2006 (detail)

Henry models his figures in clay before having them cast in bronze, after which he paints them in oils. Despite their ostensible realism, when viewed up close the works reveal a looseness of finish in the modelling and painting which announces the figure's hand-made origin. He is not averse to leaving the incisions of a modelling blade unsmoothed or his fingermarks uncorrected. This leaves the surface pitted and swirling with incident. He wants you to see where he's been and how he's made it. The result is an exciting, rugged, visually eventful texture which contributes significantly to our appreciation of the finished object.

The process begins in the studio, usually with the construction of an armature roughly conforming to the desired posture of the figure, which he then builds up in clay. Once the modelling is complete, the work is then either fired or moulded in silicone rubber, before being sent away to the foundry to be cast, first in wax, then finally in bronze. Henry then paints the bronze himself, deriving immense pleasure from negotiating the tension between natural and applied colour – between the light and shade created by modelled surfaces and the highlights and depths provided by pigment from the tube. As with conventional painting on a flat canvas, the paint surface is built up gradually, from ground colours to glazes, to arrive at the desired level of naturalism.

Fig.26 *Man and Dog* 2003 Fig.27 *Nobody's Wedding* 2000

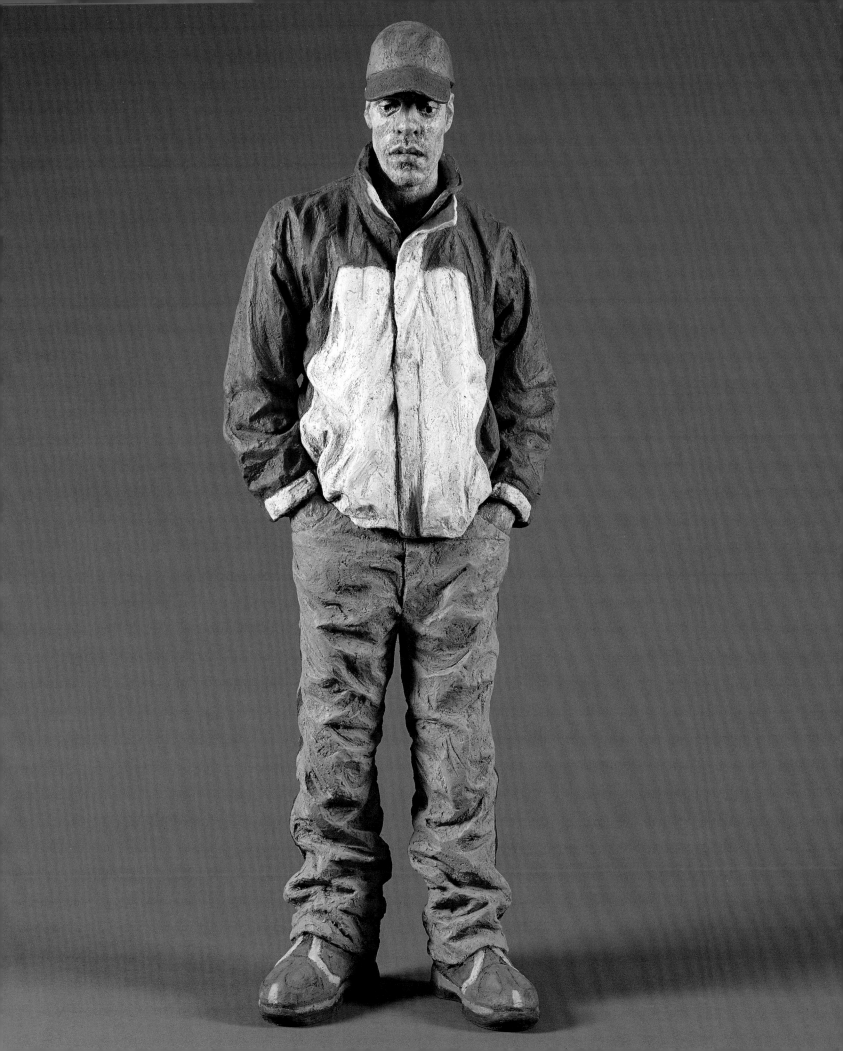

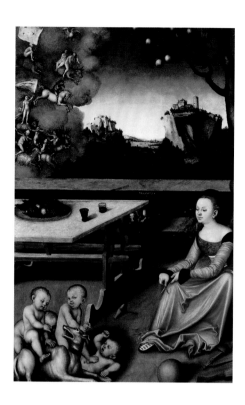

Although primarily a sculptor, bewitched from an early age by the primal pleasure of modelling in clay, Henry also sees himself as a painter, albeit one working mainly on three-dimensional sculptures and relief compositions. He is an accomplished draughtsman, although drawing is not an integral part of his sculptural method but rather a means of recording sensations, solving compositional problems, and memorising material for future use (fig.26).

His occasional forays into relief sculpture represent an opportunity to meld his love of painting with his natural facility at sculptural modelling. One of his most significant works in this medium is *Melancholia*, which exists in two painted versions, one cast aluminium, the other bronze (fig.29). The work derives from *An Allegory of Melancholy* (National Gallery of Scotland, Edinburgh; fig.28), an oil on panel of 1528 by the German Renaissance painter Lucas Cranach (1472–1553) whose work Henry greatly admires.

Into the foreground of a broadly faithful representation of Cranach's domestic interior Henry inserts a contemporary onlooker. In the distance, in place of Cranach's receding Northern European landscape, we glimpse a view of the modern London skyline – more specifically the Great Western Studios where Henry's own studio was then located. Cranach's interior, lent fictive depth by the complex jointed refectory table, offers Henry a pretext for

Fig.28 Lucas Cranach
An Allegory of Melancholy 1528
Private Collection, on loan to the National Gallery
of Scotland, Edinburgh

Fig.29 *Melancholia* 2003

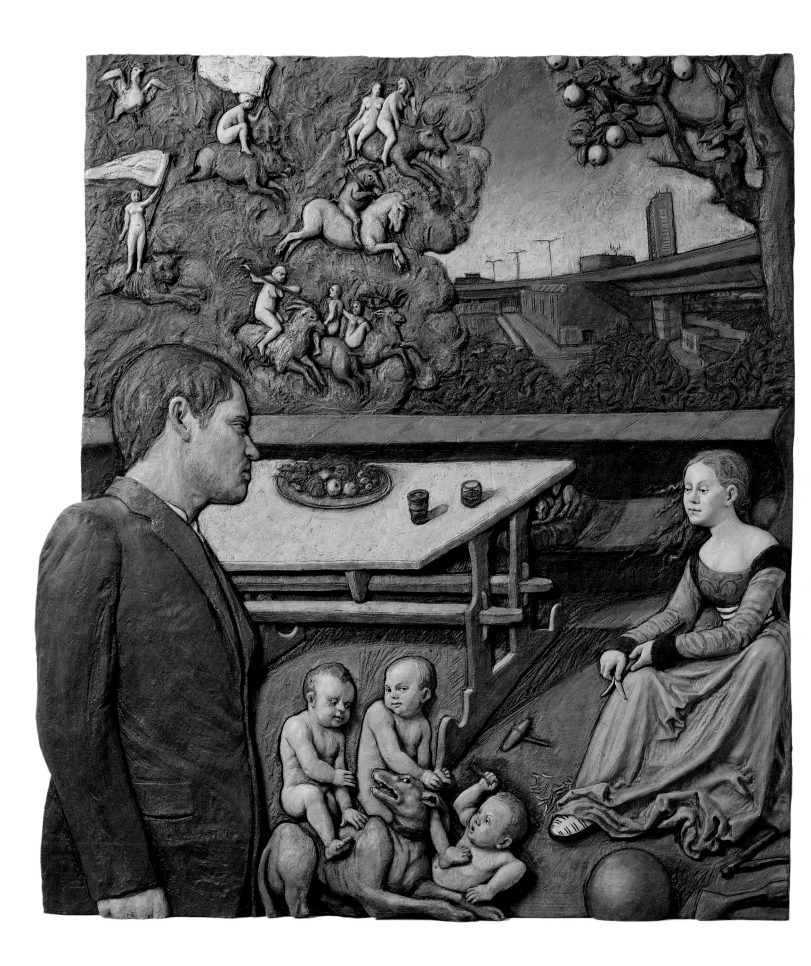

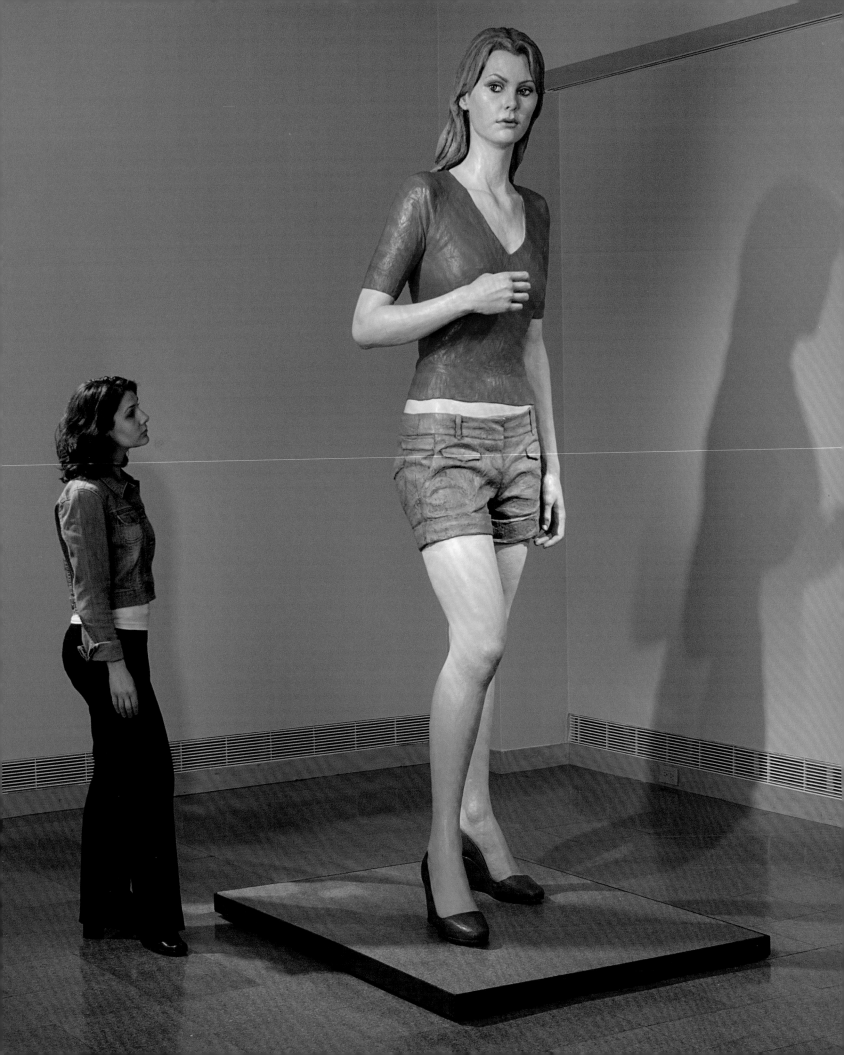

some sculptural sleight of hand in which his relief modelling assumes some of the image's illusionistic burden. In a typically Romantic autobiographical turn, the sixteenth-century interior is segued into Henry's own studio where the artist's female counterpart sits idly whittling a stick as her three children frolic mischievously at her feet. Henry, himself a father of three, has effected a playful elision of artist, onlooker and subject.

Having trained as a ceramicist – first in the UK and later under the guidance of Arneson in America – Henry is experienced in a broad range of media. His early ambition to make his own figurative ceramics more socially significant inevitably led him to reach towards the expanded field of full-scale sculpture. He soon became sensitive to the deeper implications of naturalistic colour and realised that some kind of defamiliarising mechanism was called for in order to counteract the painted figure's default proximity to the model. This need was perhaps made all the more acute given Henry's natural facility at capturing accurate likenesses of his subjects. His solution was to use scale more creatively.

Usually Henry prefers to construct his figures slightly larger than life. This has a distancing effect not dissimilar to that which figures in monochrome marble or bronze have historically achieved, where the very lack of colour 'strikes the first view of the beholder as beings of a different order from himself.'[2] There is an obvious logic here when applied to public sculpture, for which Henry has gained a considerable reputation in recent years. Historically, the larger-than-life figure serves to reduce the viewer in relation to the monument, adding symbolic resonance to those subjects memorialised for heroic deeds or social contributions beyond the normal scale of expectation. The semantics of public sculpture predispose us to equate physical size with achievement. As Susan Stewart has observed, the process of miniaturisation or giganticisation 'tests the relation between materiality and meaning'.[3]

Henry does not scale his figures up purely in response to public commissions. Occasionally, as with *Woman (Being Looked at)* which stands 2.6m tall, he is simply curious as to the visual impact a subject might have if magnified to something like one and a half times human height (fig.30). The process has the effect of making strange what at normal scale would be relatively unremarkable. Henry recalls seeing the subject who inspired this work in a public queue and being immediately struck by her clothing. Somehow he has managed to preserve in the finished work something of what triggered his initial visual curiosity. The British art critic David Sylvester once wrote of how Giacometti sought to crystallize complex feelings about the act of seeing, 'especially about gazing at someone who is gazing back at you.' This was intimately related to Giacometti's formulation of the idea of Existentialist Man. Despite the ostensible familiarity of its everyday subject matter, Henry's work shares

Fig.30 *Woman (Being Looked At)* 2006
Exhibition installation at Forum Gallery, New York

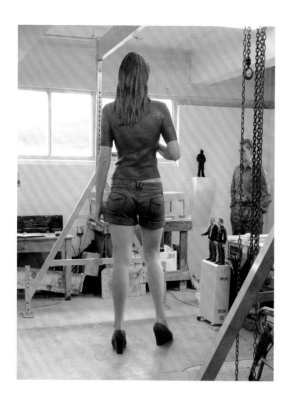

similar concerns. *Woman (Being Looked At)* dramatizes an otherwise unremarkable exchange of glances, the scale of the figure lending an unsettling intensity to the process of looking and being looked at.

Some of Henry's outdoor figures stand in ironic relation to the history of the heroic public monument. His subjects are anonymous, often selected for no good reason other than that they appeal to his own private aesthetic preferences. And yet here they are, immortalized in bronze in the centre of a public precinct or hotel lobby, or standing, sentinel-like, gazing out to sea.

He also produces smaller than life-size figures which engage the viewer in an altogether different interpretative process. Decisions about size are always carefully thought through in order to avoid any connotation of the toy or doll. He generally intends the smaller pieces to be shown on pedestals that raise them to eye level so that when viewed from a distance they give the illusion of being larger than they are. The smaller-scale groups experiment with implied narrative through the introduction of contextual architectural elements to create a tableau. As Axel Olrik has written in the context of folk narrative: 'tableaux scenes frequently convey not a sense of the ephemeral but rather a certain quality of persistence through time. [...] These lingering actions – which also play a large role in sculpture – possess the singular power of being able to etch themselves in one's memory.'[4]

Fig.31 London Studio 2006

Just as scaling up activates a sense of otherness, so scaling down can engender a feeling of empathy with the figure as we enter what seems to be a more private, interior world. This is dramatized to great effect in *Ursula's Dream* (2001; fig.34) in which an unpainted figure of a burly male steals towards a pregnant woman asleep on a bed.

The work takes its inspiration from *The Dream of St. Ursula* (fig.33) by the Venetian Renaissance painter Vittore Carpaccio (*c.*1460–*c.*1526) in the Gallerie dell'Accademia in Venice, which depicts the saint visited in her dreams by an angel who foretells her imminent martyrdom.

Grey tones – or grisaille, to use the proper art-historical term – have traditionally been the easel painter's chosen means of evoking statuary or architectural ornament. Here Henry uses the lack of colour on the male figure to render him as an ethereal, dream-born presence (he is also a noticeably larger scale than the sleeping woman he is approaching). The male figure's oneiric function is somewhat undermined by the stubborn materiality of sculpture and yet his ambivalence in Henry's contemporary take on the subject (is he malevolent or well-intentioned?) adds a layer of dramatic tension. The relatively small scale of the work turns viewer into voyeur, a role reinforced by our unavoidable congruence with the approaching male.

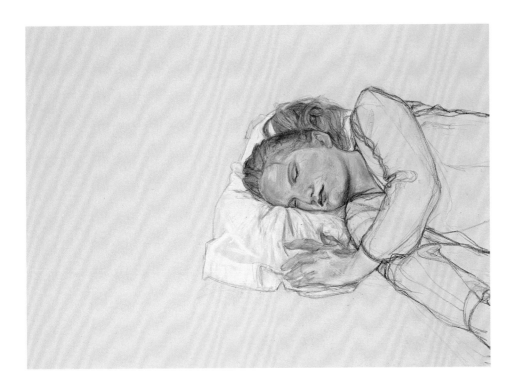

Fig.32 *Ursula* 2001

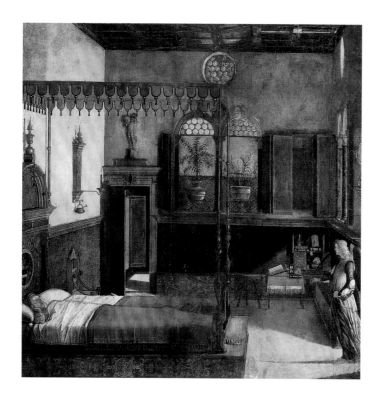

Scale also plays an important function in *Lying Woman* (2005; fig.36), in which a young female sprawls face down on the ground, daydreaming, her child-like position reminiscent of the slumbering Tilda Swinton in Cornelia Parker's 1995 work *The Maybe*. Her clothing – black leather jacket, jeans and boots – is entirely commonplace, prompting us to seek signs of her identity and individuality elsewhere. Henry gravitates to certain social types and has a way of alighting on a particular kind of contemporary dress that speaks meaningfully not just of prevailing fashion, but of the deeper drives that form our identity as citizens of an advanced consumer society. These dress codes often render us more anonymous than we might like to think, which paradoxically allows Henry to tease out a sense of human individuality that transcends clothing and fashion.

Figures lying down are a recurring motif in Henry's work. Sometimes the figure reclines in a trance-like state as in *Lying Woman* discussed above, *Man Lying on his Side* (2000; fig.37), and *Catafalque* (2003; see figs.89–92 on pages 133–136). Occasionally they are shown accompanied by elements that suggest a dream state, as in *Ursula's Dream* and *Lying Man* (1999; fig.39). As Roger Cardinal has noted, 'Dreaming is a quintessential Romantic activity. The fluency and volatility of dreams have traditionally supplied the poetic imagination with images.'[5]

Fig.33 Vittore Carpaccio (*c.1460–c.1526*)
The Dream of St. Ursula 1495
Tempera on canvas
273 × 267 cm / 107½ × 105⅛ in
Galleria dell'Accademia, Venice, Italy / Cameraphoto
Arte Venezia / The Bridgeman Art Library

Fig.34 *Ursula's Dream* 2001

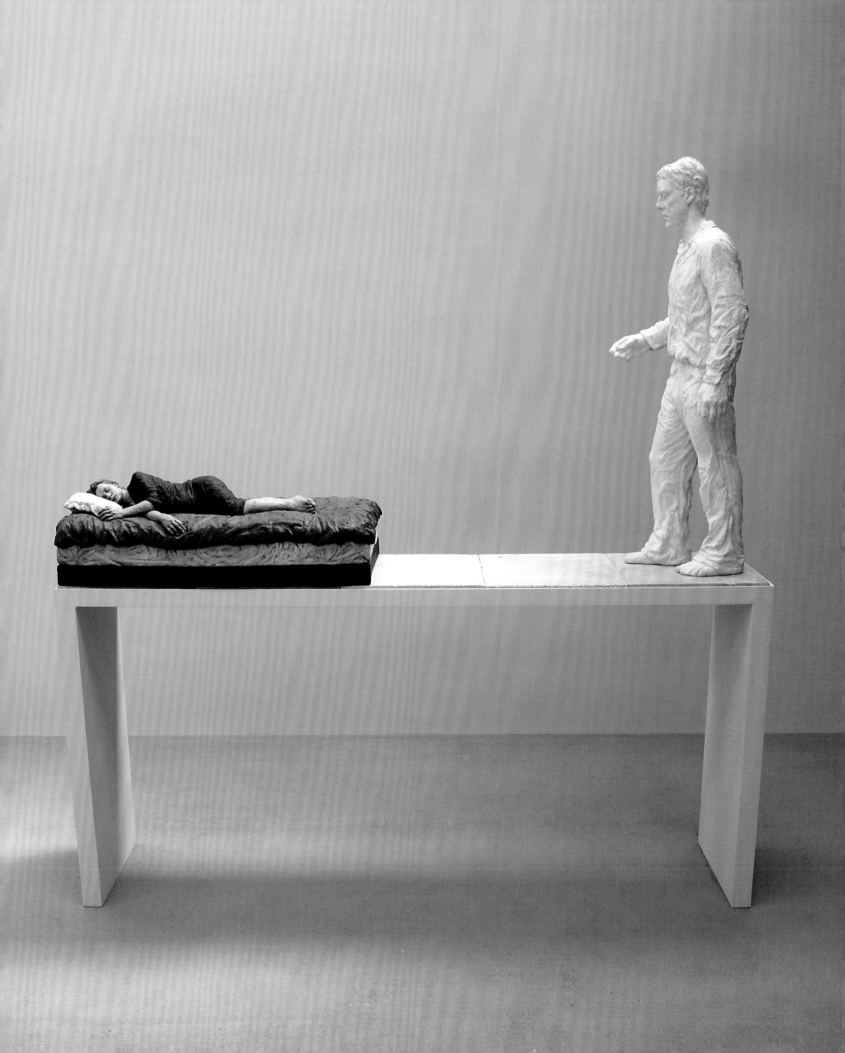

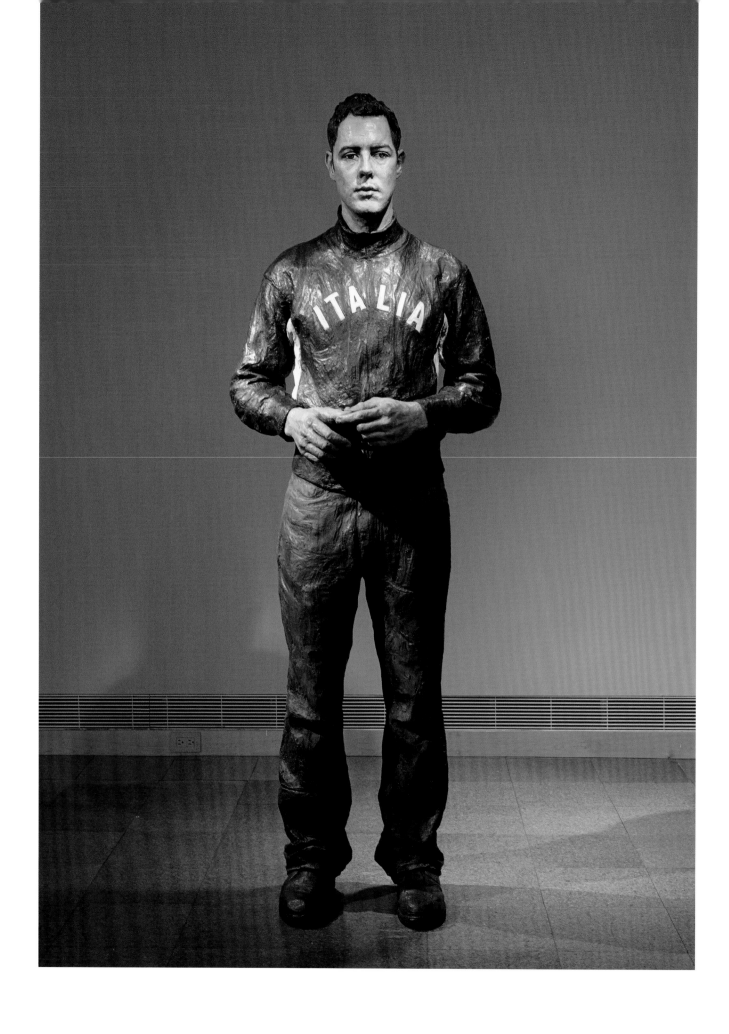

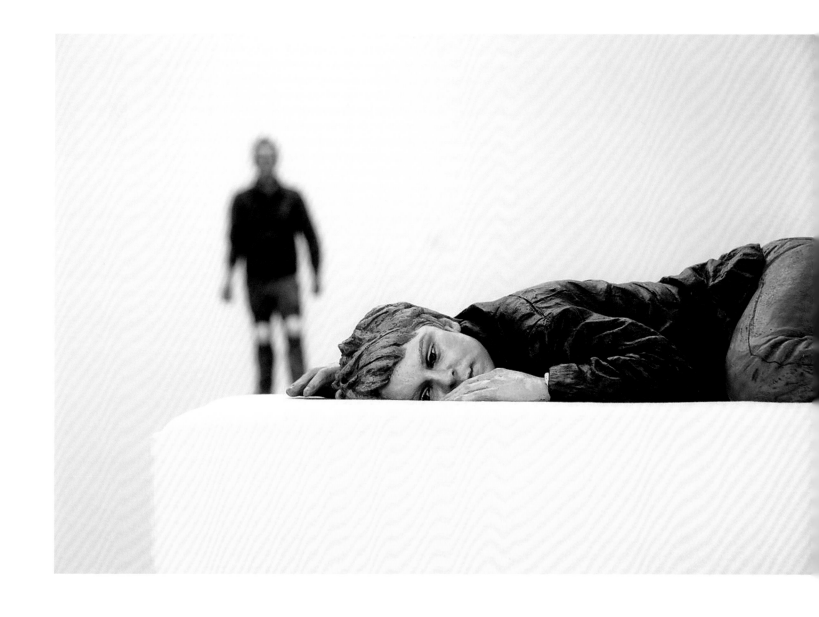

Fig.35 *Italia* 2004 Fig.36 *Lying Woman* 2005

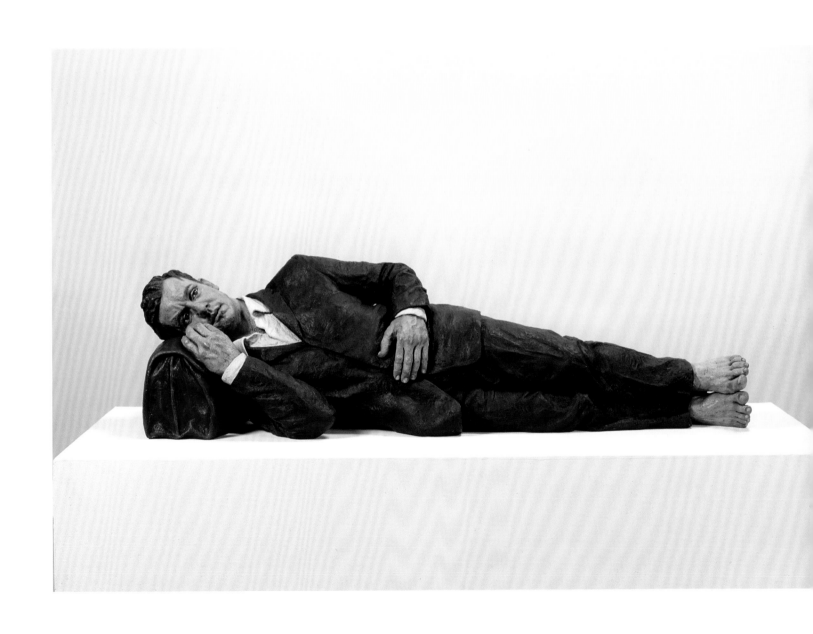

Fig.37 *Man Lying on his Side* 2000 (with detail)

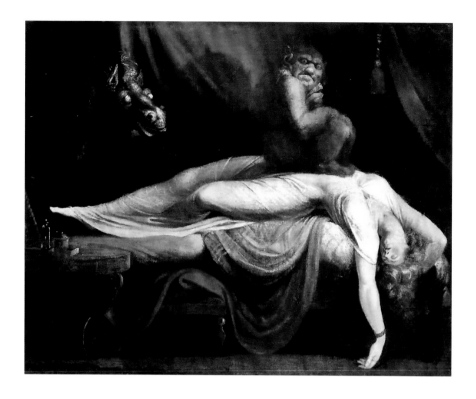

Lying Man shows the artist asleep, barefoot, his head resting on a pillow. Crouching on his chest is a diminutive, younger version of himself dressed in jeans, denim shirt and heavy work boots, gesturing obliquely with one hand as if he has just performed hypnosis on his Brobdingnagian alter ego. This smaller figure – a benign version of the grimacing incubus perched on the sleeping woman in Henry Fuseli's *The Nightmare* (1781; fig.38) – turns his head to one side as though momentarily distracted by the viewer's presence. The figures can be read on a number of levels, most obviously as a symbol of the creative imagination, although it was intended as a personal concept of how the artist's younger self (aged around 20) would 'rate' his older self (aged 35), were they to meet, as in a dream.

A reduced scale was also the preferred format for *Standing Man* (2007; fig.41), for which Henry chose his father as a model. One might interpret the small size of the figure as a symbolic realignment of the natural order, a subversion of the authority exerted by fathers over sons. But a reduction in scale can also elicit affection, a way of expressing a protective instinct. Over time, parents become children again; in some respects our fathers become our sons and our sons assume the role of fathers to us. Henry's *Standing Man* subtly highlights this generational reversal, but even disregarding the familial connection it is supremely successful purely in terms of sensitive observation. The figure stands 42in high, conforming

Fig.38 Henry Fuseli (Johann Heinrich Fussli, 1741–1825)
The Nightmare 1781
Oil on canvas
101.6 × 126.7 cm / 40 × 49⅞ in
Founders Society Purchase with funds from Mr and Mrs
Bert L. Smokler and Mr and Mrs Lawrence A. Fleischman

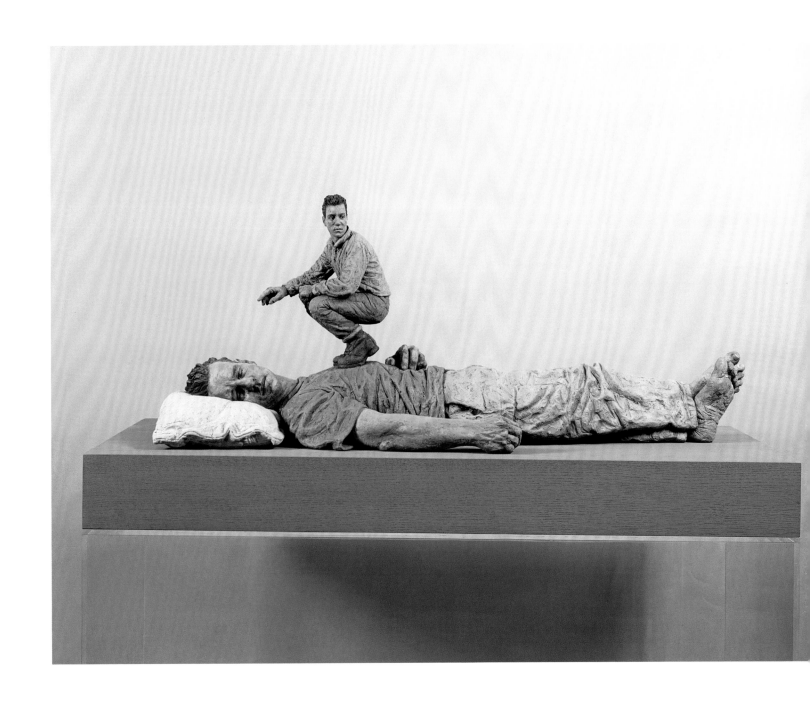

Fig.39 *Lying Man* 1999

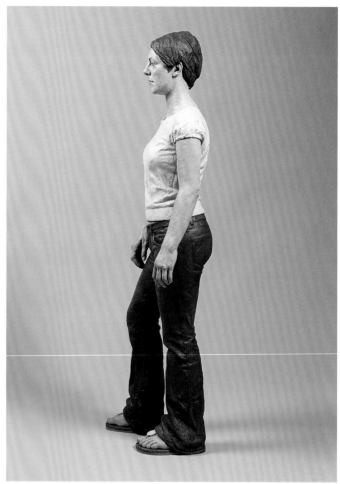

Fig.40 *Sandra (Waiting)* 2003 Fig.41 *Standing Man* 2007

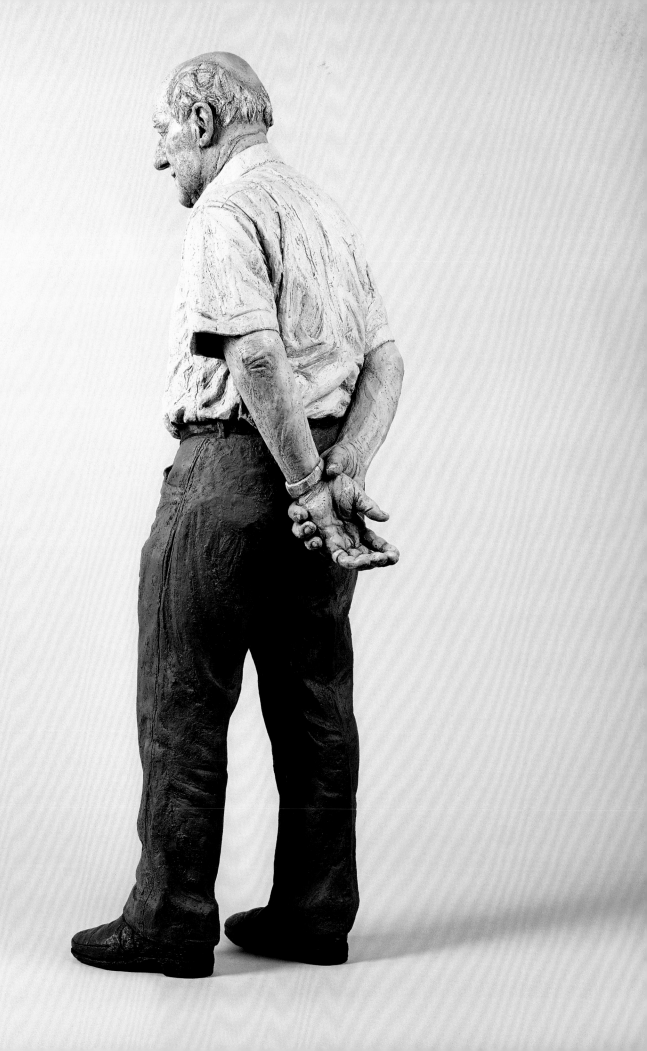

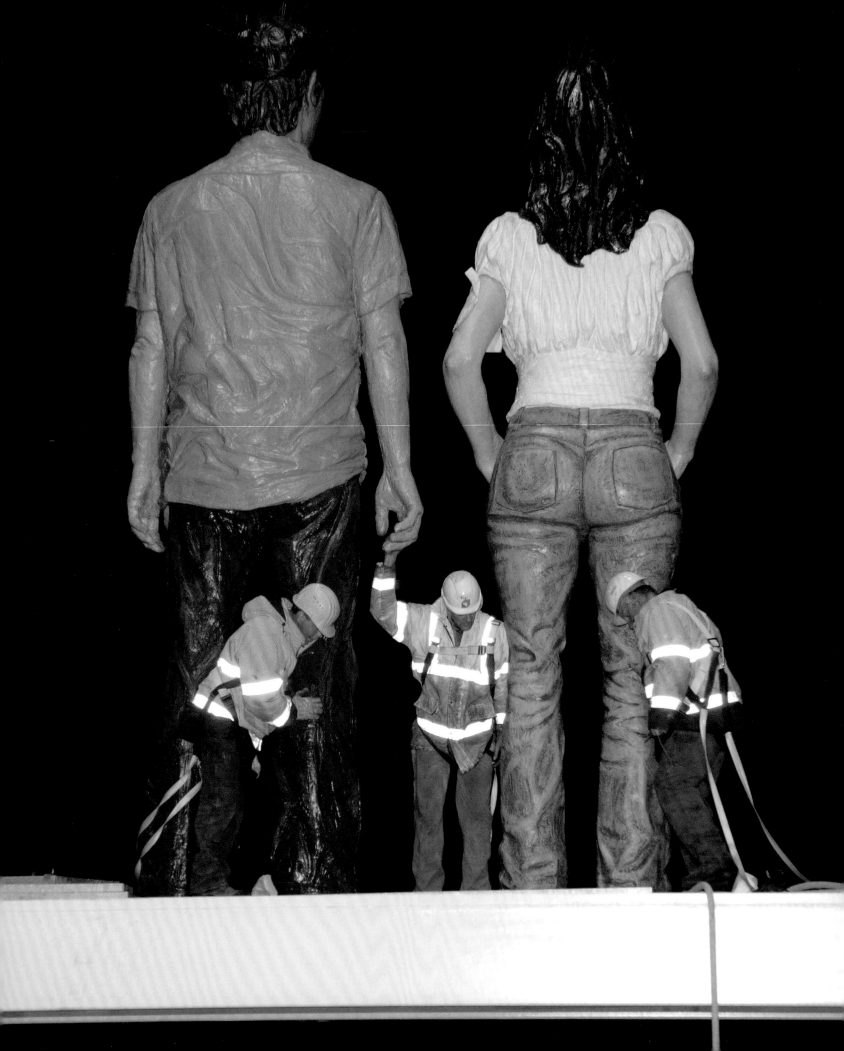

to the ratio of 1: 1.61, i.e. in the golden ratio relative to Henry's own height. 'This scale feels really exciting to me,' Henry says. 'It has weight, but is utterly "other".'

A number of recent projects have taken Henry from the small to the properly gigantic. *Couple* (2007), the offshore sculpture commissioned as part of the £10 million coastal defence project at Newbiggin-by-the-Sea, comprises a pair of 5-metre-high figures of a man and woman standing on a raised platform. The superhuman size of the sculptures is offset by the distance separating the land-based viewer from the sea-based work, so that when seen from the Newbiggin promenade they assume human scale. Interviewed by the BBC in the period leading up to their unveiling, one of the Liverpool foundry workers who helped cast the sculpture offered a telling comment on the psychological effect of the work's colossal size when standing beside it: 'The most fantastic feeling is touching the hand of the man, and you're instantly a three year-old.' This comment finds a visual echo in an advertisement for the dredging company that built the breakwater and supervised the sculpture's installation, the image showing a marine engineer dwarfed by the male figure whose hand he reaches up to hold (fig.42).

An awareness of sculpture's propensity to radically alter the viewer's sense of self is at the heart of Henry's work.

1 Giacometti once remarked to the British art critic David Sylvester that 'life-size' was not an absolute value in sculpture but a concept shifting between the poles of conceptual reality and visual reality. See Dawn Ades, 'Figure and Place: A Context for Five Post-War Artists', in Susan Compton (ed.), *British Art in the 20th Century*, Royal Academy exhibition catalogue (Prestel, 1987), p.74.

2 John Flaxman, *Lectures on Sculpture* (London, 1829), p.178.
3 Susan Stewart, *On Longing: Narratives of the Miniature, the Gigantic, the Souvenir, the Collection* (Duke University Press, 1993), p.57.
4 Axel Olrik, 'Epic Laws of Folk Narrative', in Alan Dundes (ed.), *The Study of Folklore* (Englewood Cliffs, NJ: Prentice-Hall, 1965), p.138, quoted in Stewart, *On Longing*, p.48.

5 Roger Cardinal, 'Night and Dream', in *The Romantic Spirit in German Art*, exhibition catalogue (Scottish National Gallery of Modern Art/Hayward Gallery, 1994), p.194.

Fig.42 *Couple* being installed in Newbiggin Bay, Northumberland, UK at night, 17 August 2007

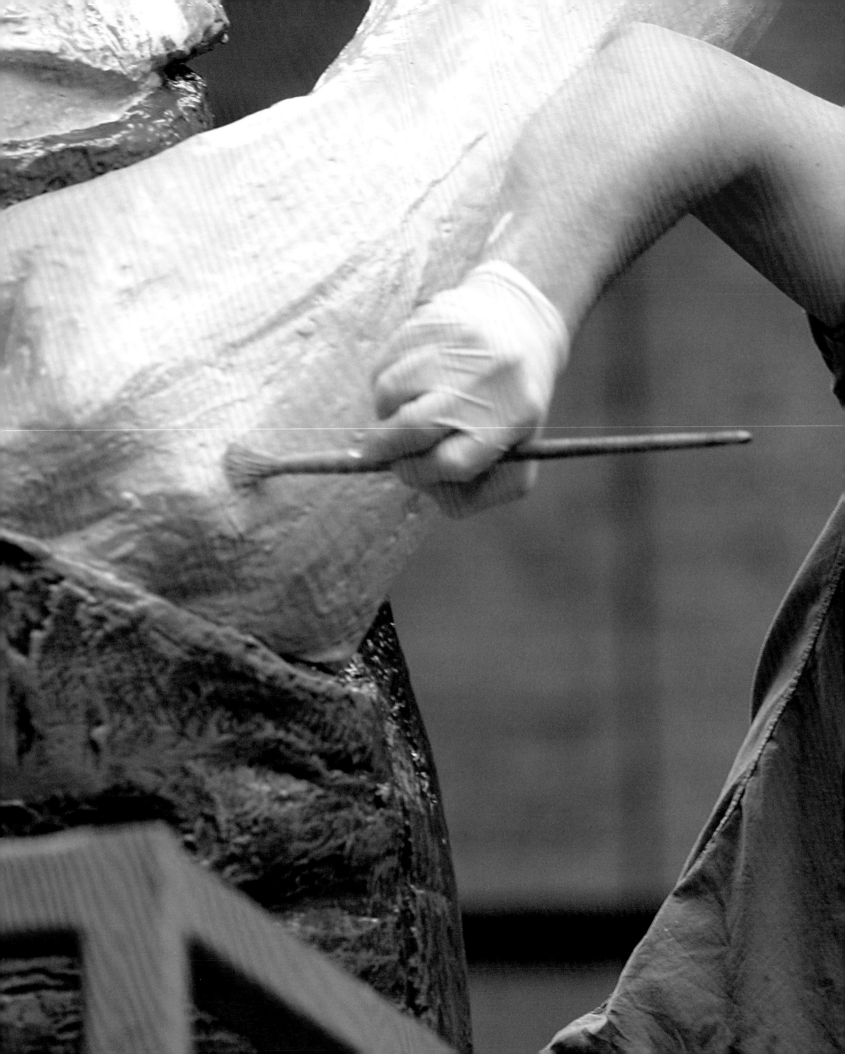

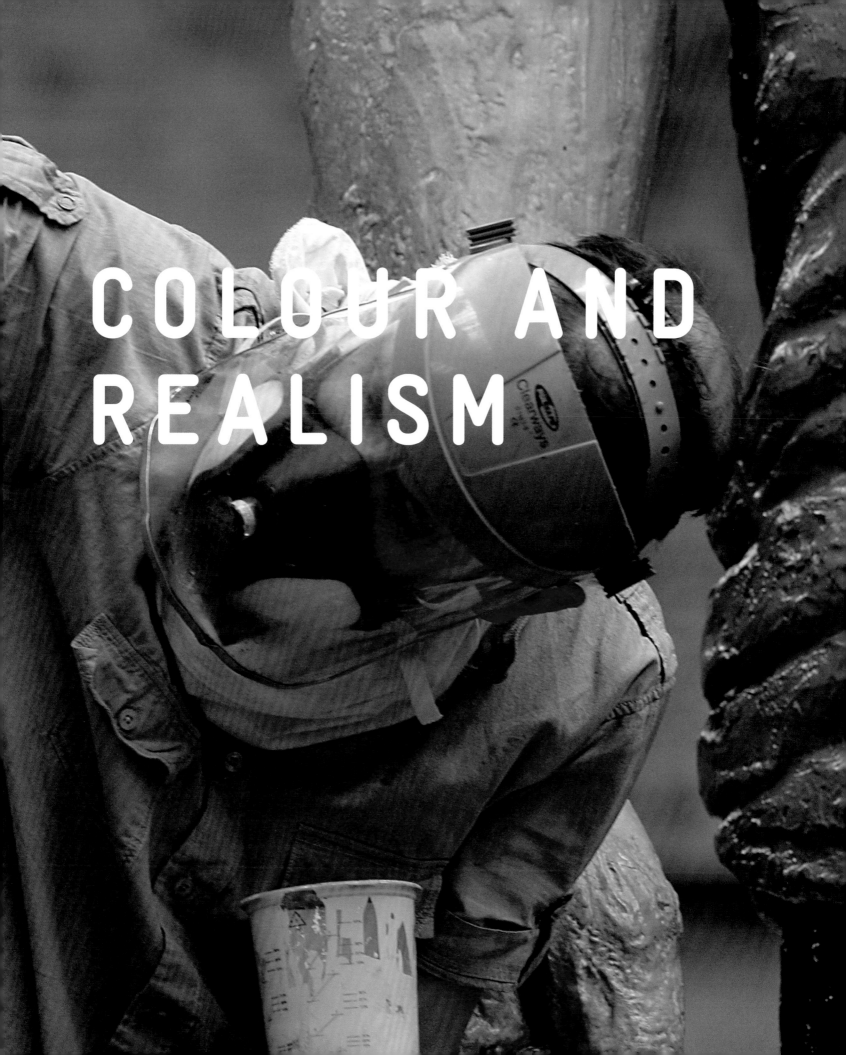

COLOUR AND
REALISM

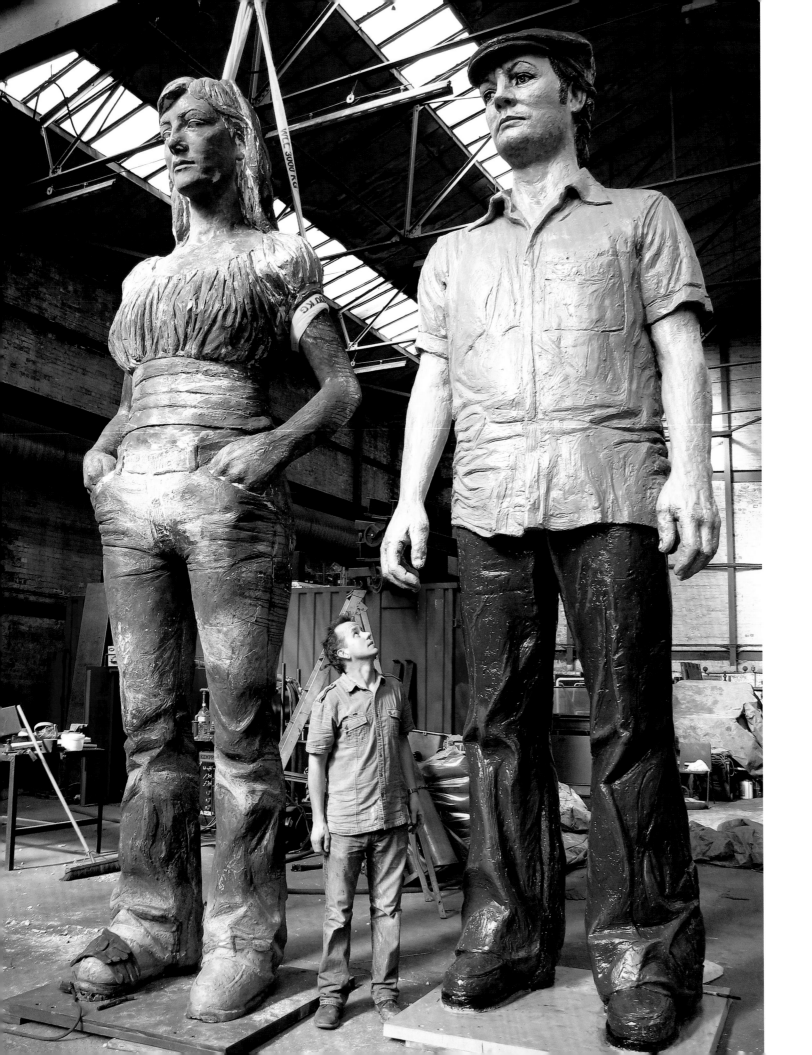

In recent years, British contemporary art has witnessed a resurgence of interest in realism. But while a number of artists continue to explore the possibilities of realism in painting, experiments in sculpture have largely been confined to the ironic appropriation of techniques traditionally associated with waxworks and other forms of 'low' cultural entertainment. The postmodern atmosphere in which many of these tongue-in-cheek interventions were incubated has spared them the negative criticism that greeted early nineteenth-century experiments into polychrome sculpture. Whether they deserve to be treated seriously as sculpture, however, remains a moot point.

Sean Henry has set out on a different path altogether, fusing the disciplines of ceramics with those of sculpture to create a fresh, innovative approach to representing the human figure. Moreover, he has confronted and reinvented on his own terms the traditionally problematic practice of painting the sculpted human form.

Despite irrefutable archaeological evidence that the ancient Greeks painted their sculpture, to a nineteenth-century sensibility such practice was a blatant defiance of prevailing academic wisdom, tantamount to barbarism and moral decay. A distinction was drawn between the natural colour of materials appropriate for use in sculpture and the application of colour through pigments, a practice that invited particularly animated condemnation. A typical attitude was that articulated by Richard Westmacott, professor of the Royal Academy in the 1850s, who remarked that 'it is a remarkable fact that the further we go back towards barbarism in art, or to the infancy of art, the more surely do we meet with coloured sculpture.'[1]

Today, we are more likely to marvel at early instances of the use of colour, perhaps because it has largely disappeared. The discovery in 1974 of the Chinese 'Terracotta Army' of the First Qin Emperor (d.210 BCE) near the modern city of Xi'an in Shaanxi province, revealed yet more evidence of the importance of colour in the sculpture of ancient civilisations. It is easy to appreciate the naturalistic modelling of these highly individuated clay figures, but it requires a leap of imagination to picture the additional impact that realistic colour once imparted to that seven thousand-strong army of standing warriors.

The cult of neoclassical purity – which advocated simple, uncoloured, ideal forms – became so culturally embedded during the nineteenth century that even today its reverberations continue to be felt.[2] But Sean Henry is no historical revivalist. His work is not a *retardataire* experiment in sculptural naturalism, nor is it designed to incite controversy. Indeed, for Henry, a likeness is often subordinate to more important considerations. The way he paints his sculpture is closely connected to, and dependent upon, his modelling technique which, as we have seen, results in the figure declaring its hand-made origin. His aim is not to

Fig.43 Painting *Couple* in Liverpool 2007

produce a counterfeit version of external reality but to evoke psychological presence. Colour is not a prerequisite in this process, as his series of large-scale monochrome portrait heads made in 1992 confirms. In keeping with academic precepts, he knows how to achieve psychological presence through vigorously expressive modelling and his approach to colour complements that process.

Henry loves to paint. He is as likely to opine enthusiastically on some aspect of a Lucas Cranach panel or a Rembrandt canvas he has seen – the way the light falls on a brow or the tip of a nose, for example – as he is to comment on sculpture. In recent years his palette has become more subtle and restrained. He luxuriates in marrying pigments to the natural lights and shades produced by the underlying form.

Henry began his career with few if any aspirations towards being an artist. 'Pottery was a long way from art. God knows why I did it. I never thought of myself as an artist. I just liked making things.'[3]

Ceramics offered a licence to use as much colour as he liked. Since the neoclassical revival of the late-eighteenth century, colour, or its absence, had provided one of the distinguishing characteristics marking the boundary where fine art ended and the decorative or applied arts began. However, having discovered the multiple possibilities of fired clay, Henry, like Robert Arneson before him, was determined to break free of the arbitrary constraints into which figurative ceramics had been forced. As we have seen, these were mainly to do with questions of scale and technique, but the application of colour was another important bone of contention for those wishing to explore the uncertain threshold between large-scale figurative ceramics and sculpture.

By the time he enrolled for the degree course at Bower Ashton campus in Bristol in the mid-1980s, Henry had already begun to refine his aspirations. At that time ceramics was often co-opted into 3-D design, a category quite separate from fine art, which prepared students for the vocational disciplines of industrial manufacture. For Henry, who nurtured hopes for the sculptural potential of figurative ceramics, the 'teapot orientation' of the Bristol degree course ran counter to his instincts and merely helped clarify an alternative direction.

His work at this time began to register the influence of those experimental ceramicists – predominantly American – whose progress he had monitored in leading ceramics magazines while preparing his final-year thesis at Bristol. A typical Henry student work from 1986 – *That's the Fact, Jack* – partakes of the baroque exuberance that characterised much of the Funk ceramics emerging from Arneson's Californian workshop at that time (fig.44). Indeed it was chiefly the American new wave that provided Henry with the justification for such vibrant polychrome decoration, whether hand-painted or applied as under-glaze transfers. His

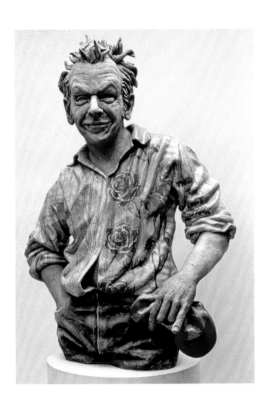

awareness of a broader art-historical tradition of colouring large-scale sculpture was at this point scant – 'I was too impatient to get bogged down in art history and art-historical references when I was in my twenties,' he recalls.[4]

The year 1998 marked a turning point in Henry's career when he was awarded the Villiers-David Foundation Prize and used the award money to embark on his four-month tour of Italy the following spring. As with the many British artists who undertook the Grand Tour during the eighteenth and nineteenth centuries, Italy had a profound effect on Henry's creative outlook. Unsurprisingly, the experience expanded his art-historical horizons, but perhaps the most significant outcome was an increased sensitivity towards the long tradition of polychrome sculpture, particularly as applied to works of religious devotion. 'It was a confidence-builder,' he says, 'to come across ancient works and realise again and again that they had been painted… and it dawned on me the amount of work made over the centuries that fitted into my aesthetic.'[5]

Italy also affected his attitude to his own technique. 'It opened my eyes to the quality of finish, for example, on the newly-revealed underpainting on a crucifix from the twelfth century and so after months of exposure to historical Italian work I came back and thought,

Fig.44 *That's the Fact, Jack* 1986

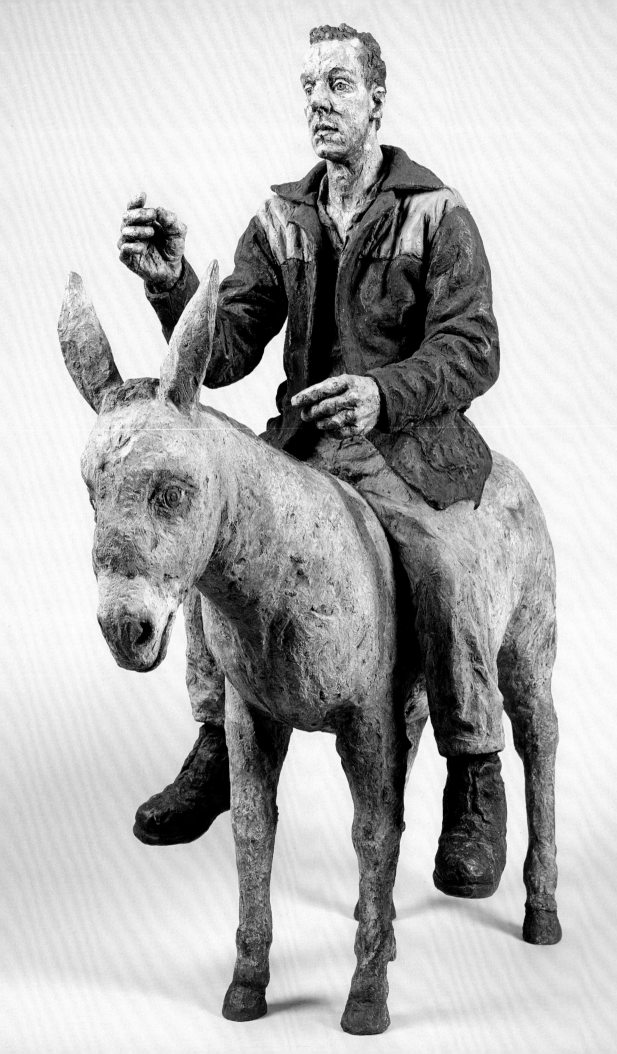

"Well, I've got to paint these things better".' His output slowed, but each individual work was now given more time and attention.

A work made prior to his European tour prefigures some of the influences Henry would absorb while abroad. *Man on a Donkey* of 1997 (fig.45) is derived from a South German figure dating from 1510–20 in painted limewood in the Victoria and Albert Museum collection (fig.46). Depicting Christ riding on an ass, such figures were known as *Palmesel* and were used in Catholic processions on Palm Sunday. Originally the wooden base was fitted with four wheels so that it could be pulled through the streets. Henry's *Man on a Donkey* replaces the figure of Christ with a contemporary working man wearing the sort of orange-shouldered donkey jacket commonly associated with roadworkers and other manual labourers. His right hand is raised in vague imitation of the sign of benediction. The donkey jacket that provides the punning title has long been a favourite part of Henry's nostalgic sculptural wardrobe.

From this point on, Henry's work becomes more subtle and restrained, eschewing the surface rhetoric of his earlier ceramic pieces in favour of a subdued kind of social observation. By conjoining the iconography of religious sculpture with contemporary costume and other attributes, Henry found a means to pay homage to the common working individual – to reveal the heroic in the everyday.

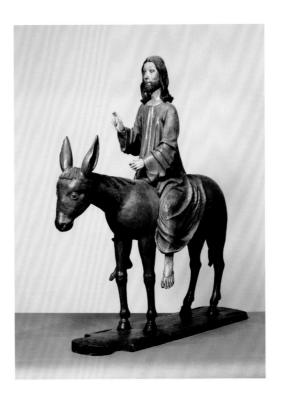

Fig.45 *Man on a Donkey* 1997

Fig.46 German, possibly Ulm
Christ Riding on a Donkey 1470–90
Carved and painted limewood and pine base;
left, three-quarter view.
147.2 × 31.8 × 140 cm / 58 × 12½ × 55⅛ in
Victoria and Albert Museum, London

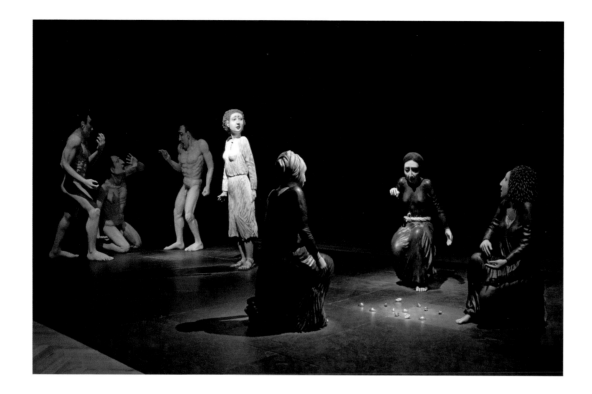

While the Italian tour stimulated in him a more focused awareness of the art-historical canon, Henry has also drawn some inspiration from contemporary artists such as Brazilian-born painter, sculptor and printmaker Ana Maria Pacheco (b.1943).

Pacheco's sculpture draws on the long tradition of polychrome wood statuary which she inflects with a refined sense of the grotesque. Trained at the Slade School of Fine Art, where she worked under the British figurative sculptor Reg Butler, Pacheco is concerned with the darker zones of human behaviour where political, social and religious traditions intersect. The theme of man's inhumanity to man is never far from the surface of her work as she hints at the violent undercurrents flowing beneath Catholic ritual and iconography (fig.47).

Her work is related to Henry's not in terms of their subject matter but rather in a shared awareness of the dramatic potential of the painted three-dimensional figure. Both artists are interested in the psychological impact of large-scale figurative sculpture, but where Pacheco marshals it towards a nightmare world of psychic torment and physical suffering, Henry uses it to hint at the mysteries of the here and now, the implicit strangeness of the quotidian world. The additional shot of restrained realism afforded by the use of colour maximizes his opportunities towards that end.

Fig.47 Ana Maria Pacheco (b. 1943)
Land of No Return 2002
Polychromed wood, gold leaf, slate base
193 × 540 × 660 cm / 73 × 212⅝ × 259⅞ in
Private collection

Fig.48 *Ben (Ideas Unresolved)* 2001

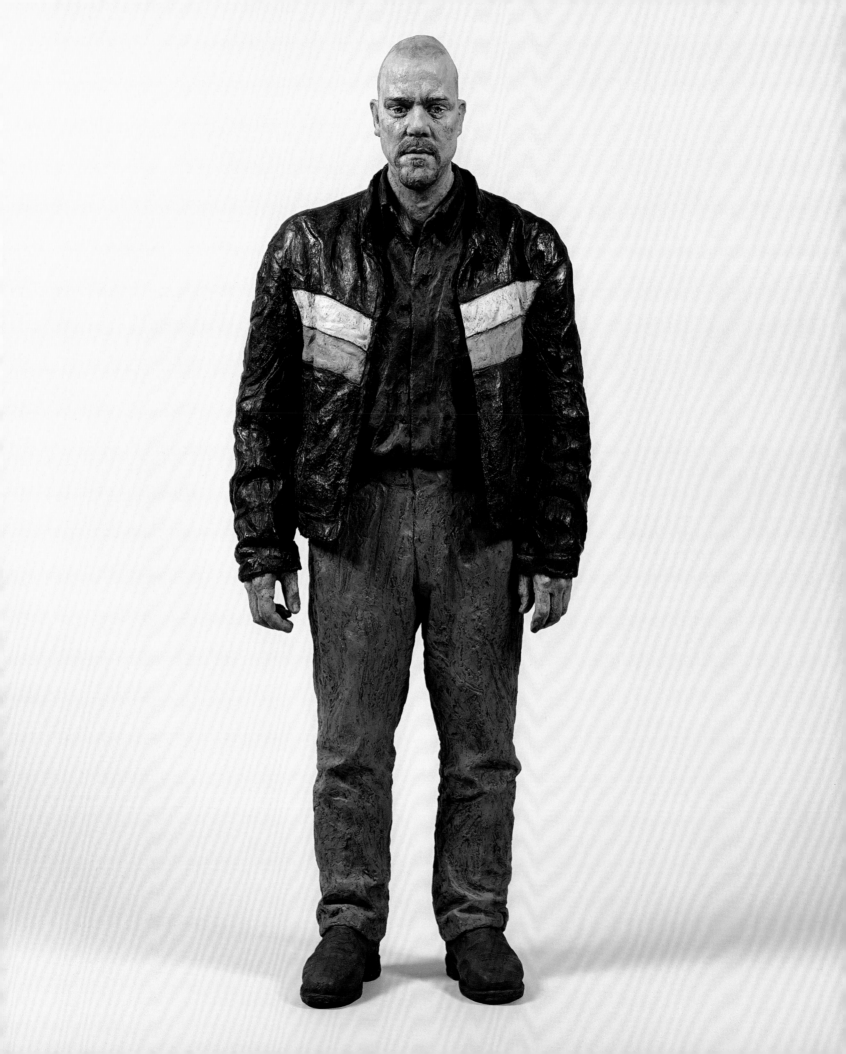

Coincidentally, it was Ana Maria Pacheco's namesake – the Spanish painter and art theorist Francisco Pacheco (1564–1654) – who during the seventeenth century established many of the precepts that influenced the development of polychrome wood sculpture upon which both she and Sean Henry have drawn.

For a time the teacher of Velázquez (who became his son-in-law) and the sculptor Alonso Cano, Francisco Pacheco is today mainly remembered for his treatise *El arte de la Pintura* (The Art of Painting), published in 1649, and for his role as official inspector of art for the Inquisition of Seville. His treatise contains the most important testimony regarding the constraints governing the painting of sculpture in seventeenth-century Spain. It has telling things to say about, among other matters, the application of flesh tones and finishes: 'God in His mercy banished from the earth these glazed flesh tones and caused the more harmonious matte flesh tones to be introduced. This is a more natural kind of painting which permits retouching and allows the beauties we see today.'[6]

Although written some 350 years ago, Francisco Pacheco's concerns about the judicious application of colour are still shared by sculptors today, although happily without the strong arm of a religious Inquisition lurking in the background. Sean Henry has explored a multitude of ways in which colour can be applied and has arrived at what is for him the optimum method of harmonizing flesh tones with the ambient light. His figures are generally matt, in keeping with Pacheco's recommendations, although he has begun using varnish or wax in a restrained way so that a brow or forehead will catch the light. He continues to adapt his technique depending on where the figure is to be displayed, aware that context and location can have an important and profound effect on the reading of the work.

The influence of religious sculpture on Henry's work is not confined to colour; he also draws on aspects of religious iconography which he translates into a secular visual grammar appropriate to his contemporary subjects. Following his Italian trip his figures became quieter and less demonstrative. He dispensed with the floral patterned shirts and the windswept hair of the Californian period. Instead he began to allow other attributes to do the talking – details of dress or objects that carried their own oblique meanings. His figures began to stand like solemn Spanish saints proffering symbolic attributes. For example, *Ben (Ideas Resolved)* of 2001 holds an orange in the palm of his outstretched hand (fig.49). Ben, a friend of the artist, happens to be a talented architect. Henry could have shown him holding a miniature building or some other device indicative of his profession. Instead, the orange offers a gentle tonal balance to Ben's red hair while opening the work to a range of other possible interpretations.

Fig.49 *Ben (Ideas Resolved)* 2001

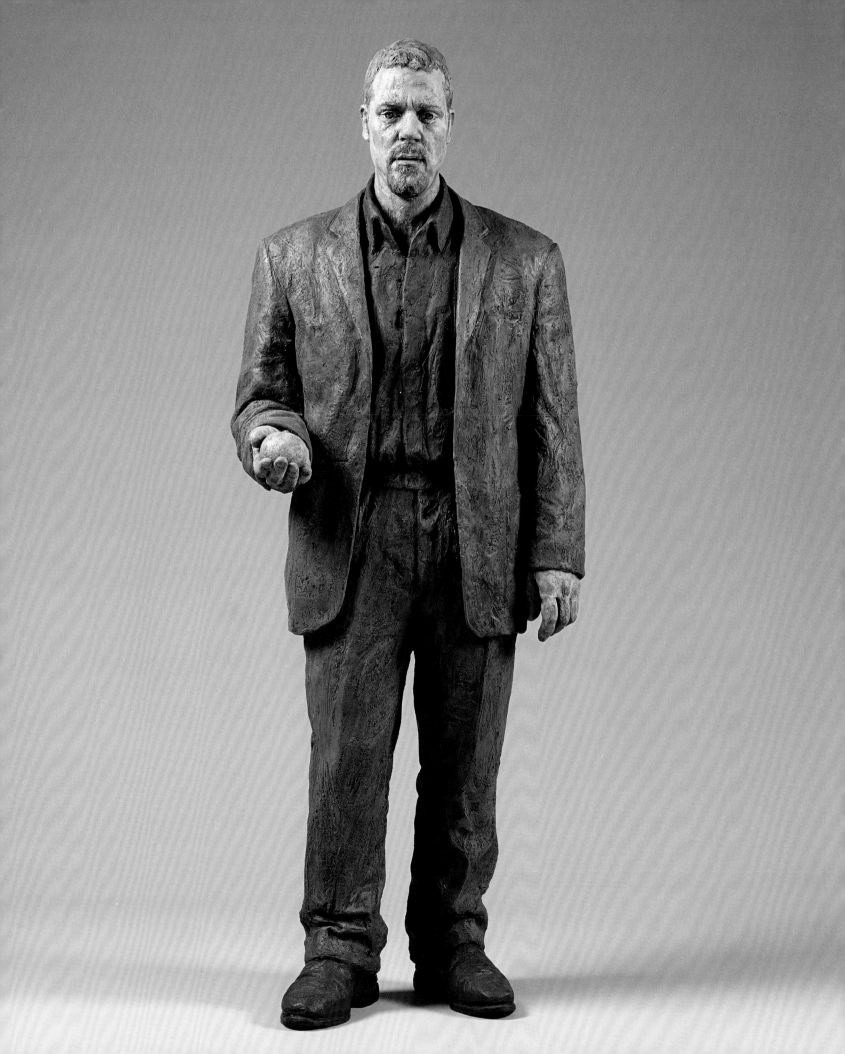

Occasionally Henry's figures stare at the ground, seemingly oblivious to the world around them. This may be influenced in part by the tradition of placing saints high up in niches from where they gaze down on the faithful as though detached from worldly concerns.

The Duke of Milan (1999; fig.51), deploys this strategy to marked effect, the hood of his three-quarter-length quilted puffer coat doubling as a monk's cowl reminiscent of Pedro de Mena's *St Francis of Assisi* (1720–40). The figure's voluminous coat and baggy combat trousers parody the swirling drapery we see on religious statuary. The body is almost entirely subsumed beneath the mass of clothing and yet the melancholy facial expression and careful use of colour elicit something akin to the sense of pathos we associate with religious sculpture. He has the look of an uneasy spirit risen from his grave. The title of the work – a genuflection to Renaissance portraiture – lends high status to an unknown citizen of the world who has been temporarily plucked from anonymity to enter Henry's private Italianate canon. It remains one of the artist's most successful single figures.

1 R. Westmacott, 'On Polychromy in Sculpture, or Colouring Statues' in *Journal of the Society of Arts*, Vol.7, 4 March 1859, p.226.

2 David Batchelor has explored the cultural phobias surrounding colour in his book *Chromophobia* (Reaktion Books, 2000). See also T. Flynn, *The Body in Sculpture* (Weidenfeld and Nicolson, 1997).

3 Conversation with the author, 2005.

4 *ibid.*

5 *ibid.*

6 Francisco Pacheco, 'El arte de la Pintura' (Seville, 1649), quoted in Robert Engass and Jonathan Brown, *Italian and Spanish Art, 1600–1750: Sources and Documents* (Northwestern University Press, 1992 (1970)), p.217.

Fig.50 *Man of Honour* 1999

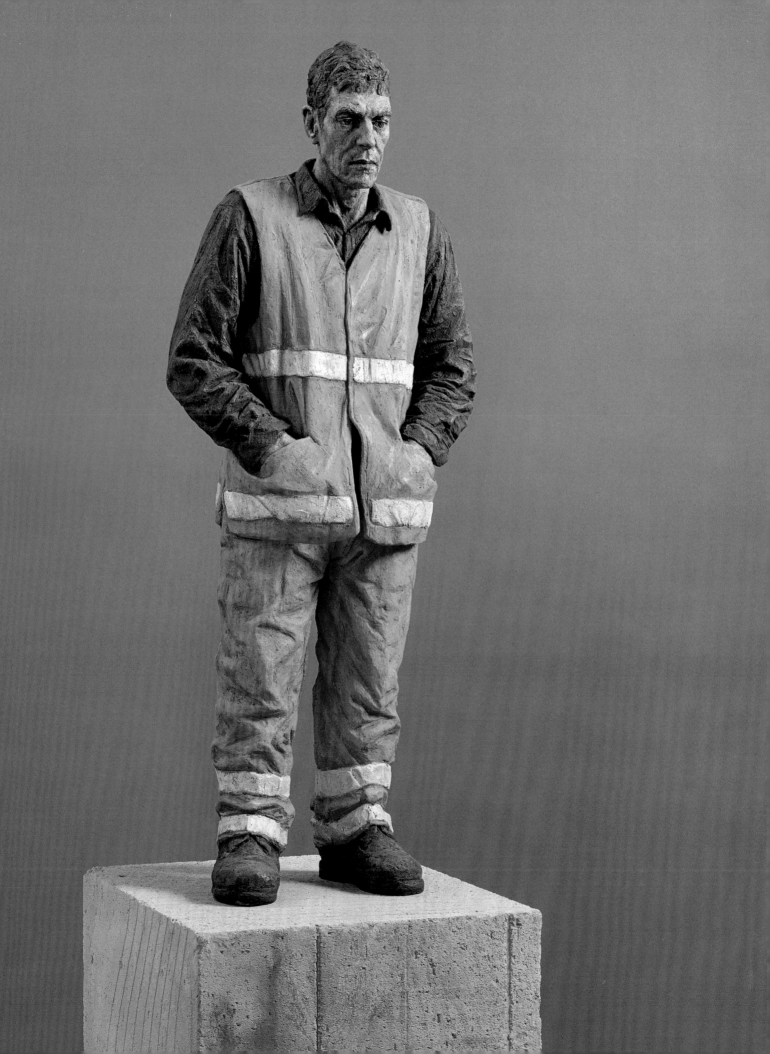

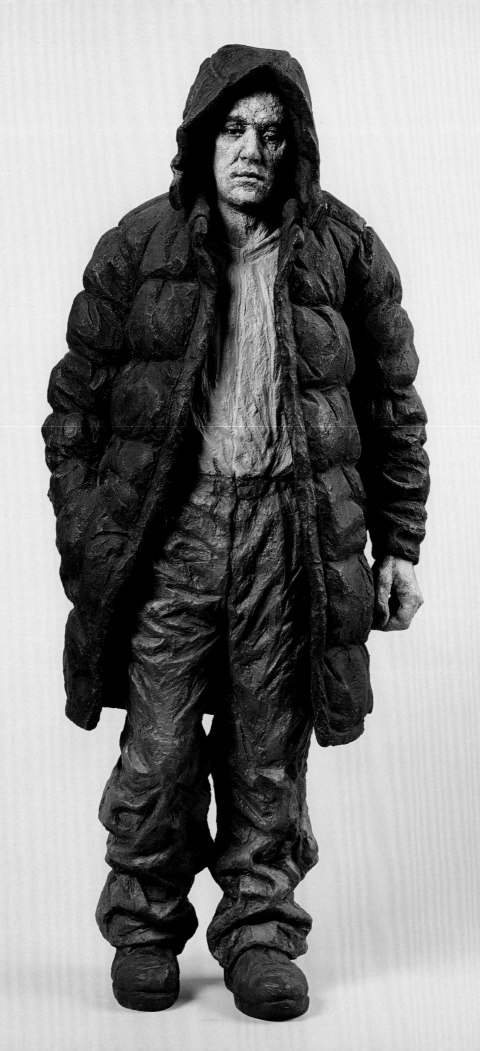

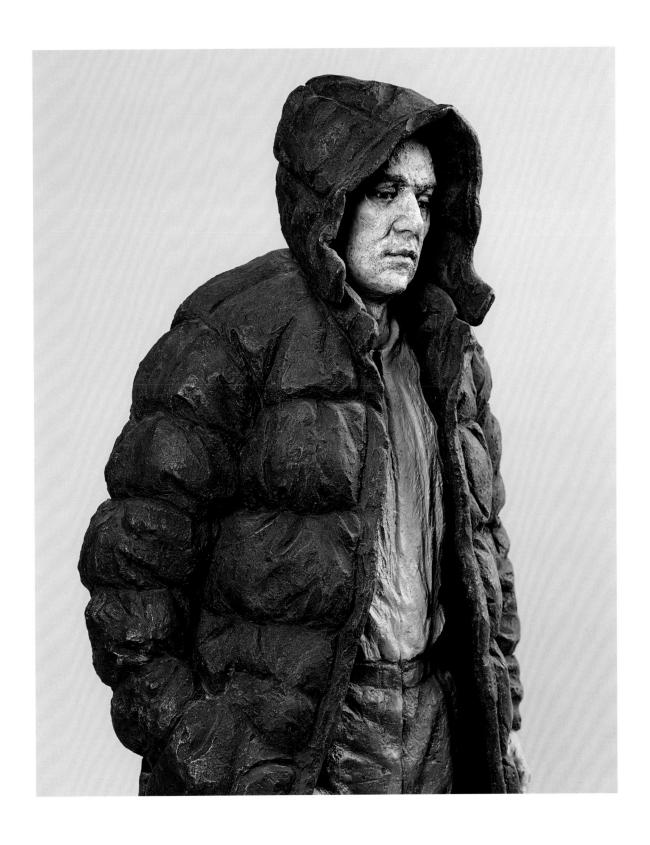

Fig.51 *The Duke of Milan* 1999

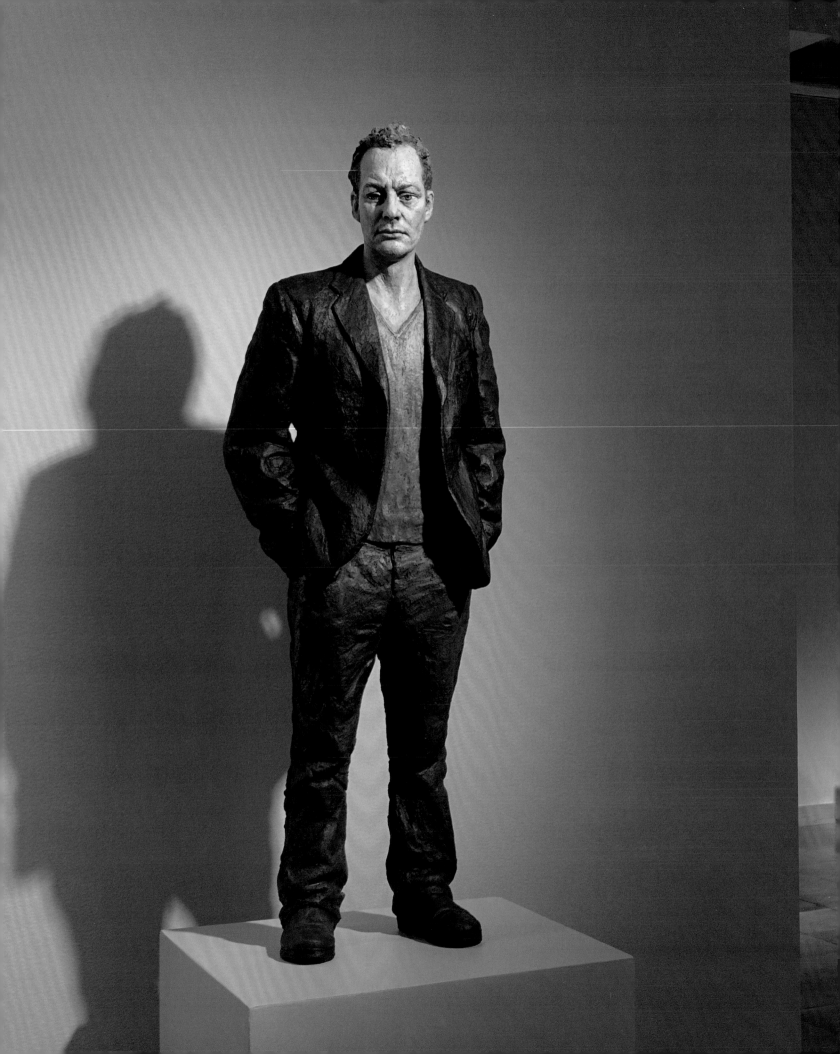

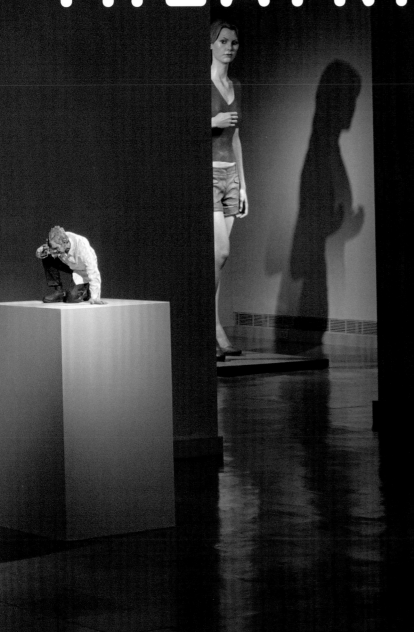

THEATRICALITY

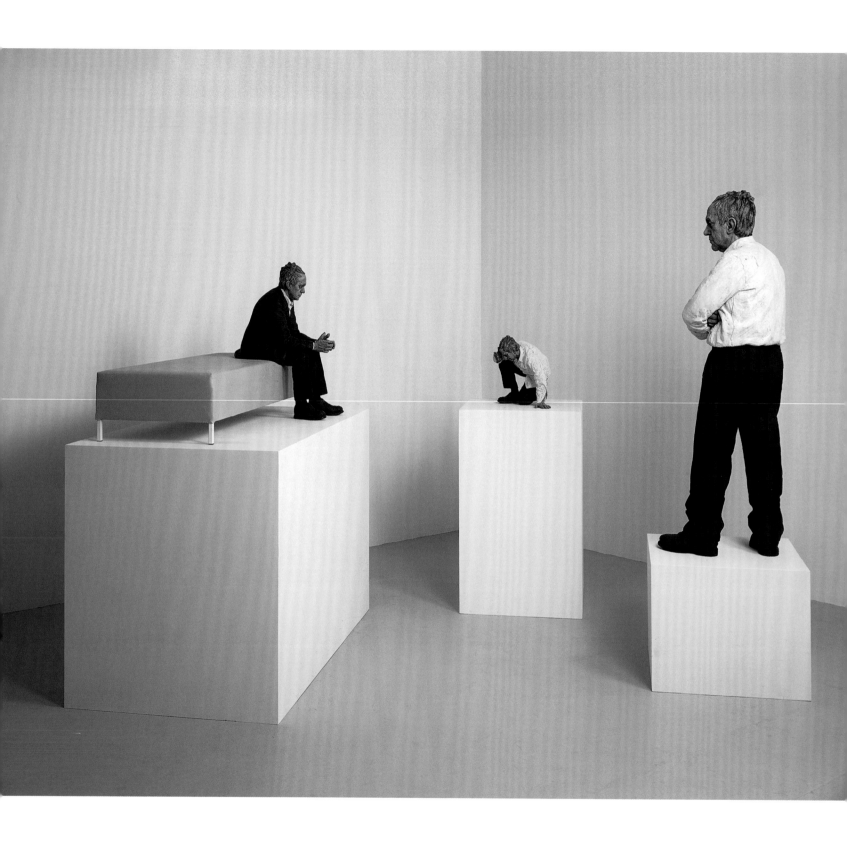

Fig.52 *You're Not the Same* 2005

In 2004, Sean Henry saw Edward Albee's play *The Goat, or Who Is Sylvia?*, about a successful architect who falls in love with a goat.

Anthony Page's Almeida production starred British actor Jonathan Pryce as the central character, Martin, wrestling with both the anguish of his own bizarre sexual infidelity and the revelation that his son is gay. Beneath the play's dark, Absurdist theme of goat sex lies a deeper meditation on tolerance, ambition, human vanity and the nature of love.

Henry saw a strong sculptural quality in the *mise en scène* of Page's production and was particularly impressed by the way Pryce's character communicated inner turmoil through a subtle range of stances and gestures. He promptly approached Pryce and invited him to sit for him. The actor agreed and the result was one of Henry's most successful multi-figure works to date – the three-piece group entitled *You're Not the Same* (fig.52).

Edward Albee is very particular about how his plays are staged, largely avoiding lighting effects and music in the belief that they diminish the sense of realism. Henry takes a similarly proscriptive approach to his own work. For him, reality resides not in incidental details but in the way in which his figures appear to be responding internally to the world around them.

The Goat closes with the four characters forming a *tableau vivant* across the stage. *You're not the same* focuses on a number of sequences throughout the play in which Pryce's Martin struggles to make sense of the events that have torn apart his previously untroubled personal and professional life. Henry shows him in three contemplative poses, each using a different scale to accentuate Martin's mounting disorientation and his diminishing sense of self and social status. The largest figure (1.37m high) stands with his arms folded, shirt tucked in, his eyes fixed on some distant point, lost in thought. A slightly smaller Martin (51cm high), dressed in a dark suit, sits on a large modernist upholstered stool, the fingers of each hand brushing nervously against each other. The loose, tentative pose is strongly suggestive of loss, of bereavement, of a man ruefully pondering the past rather than hopefully looking forward. Finally, in the smallest figure (33cm high) we see Martin compressed into a crouching posture. He has dispensed with his jacket and his shirttails are out. He is down on one knee, one weight-supporting hand flat against the ground, the other poised to cover his eyes in a gesture of incipient psychological collapse.

While each figure represents a separate moment of meditation, it is the relationship between the three – and the sum of the parts – which conveys the unfolding existential crisis at the heart of Albee's play. However, the sculpture was not intended as a portrait of Pryce and nor does it function as such. Henry has succeeded in creating a work whose significance survives beyond its referent. Like all Henry's works, it has pulled free of its original moorings

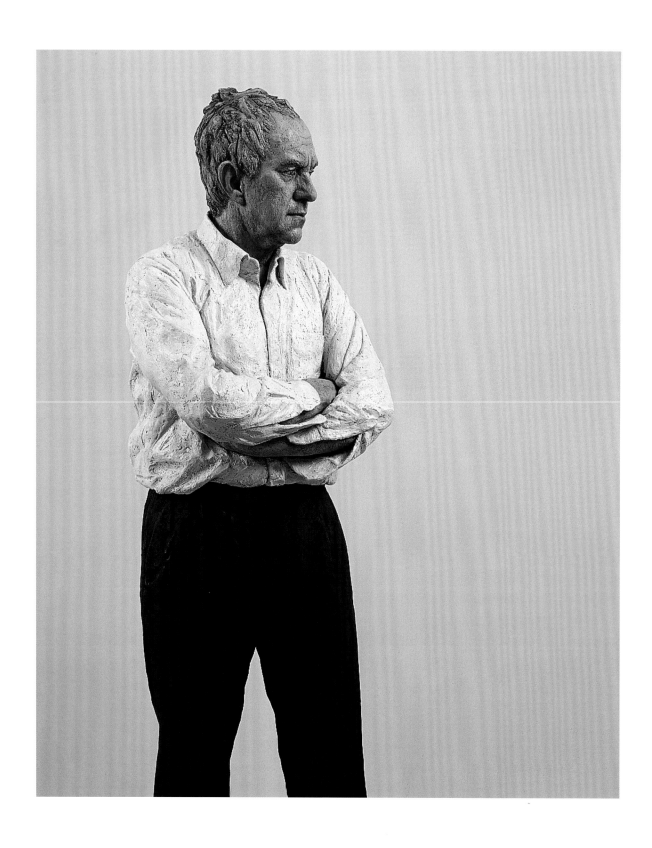

Fig.53 *You're Not the Same* 2005 (detail) Fig.54 *You're Not the Same* 2005 (detail)

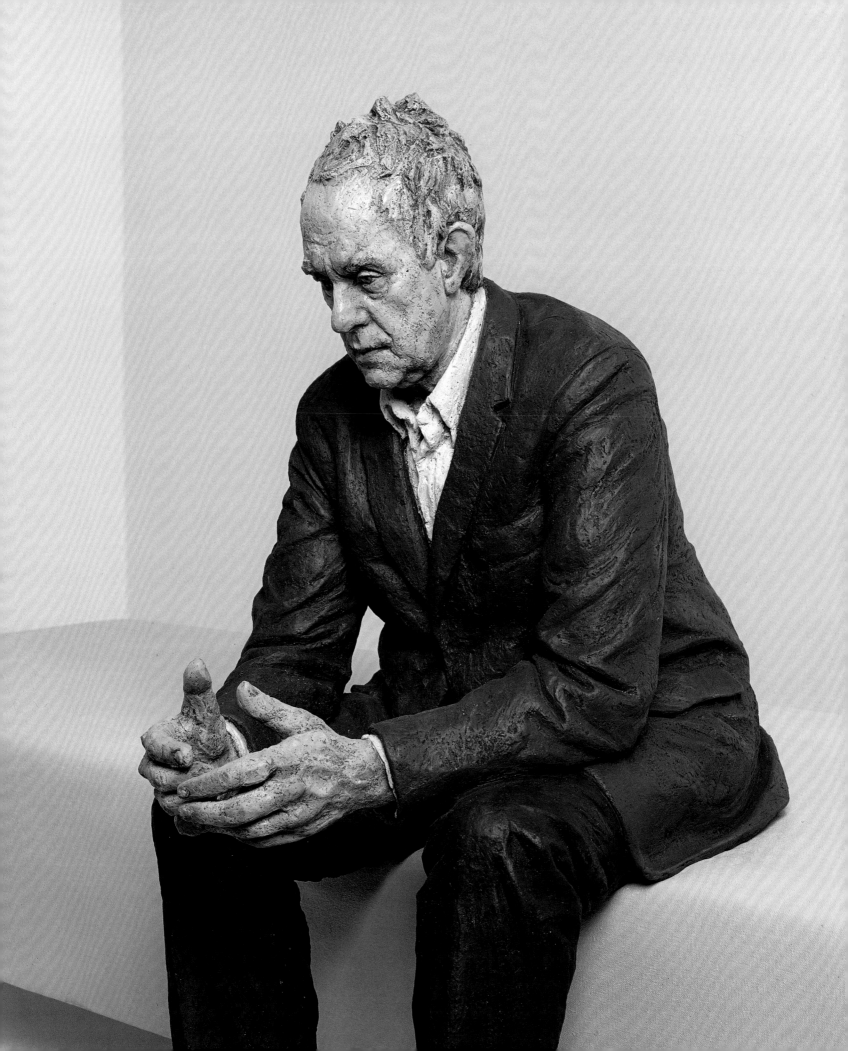

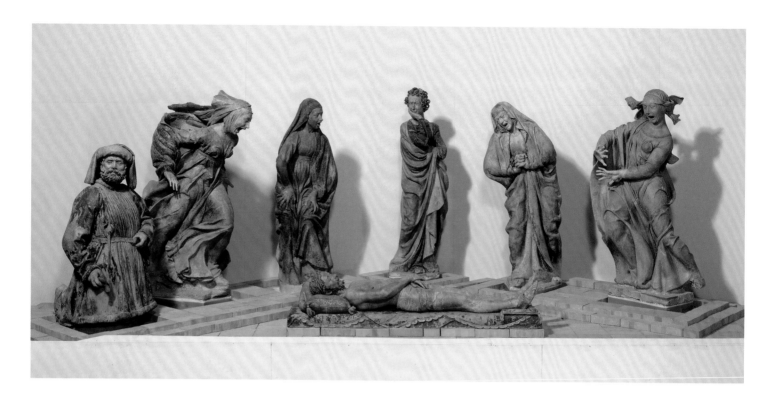

to generate a range of other readings. It does not require an awareness of the source material to resonate in the viewer.

Henry's interest in the relationship between sculpture and theatre has been an important element in his work for some time. It stems from his awareness of their common reliance on the human body to suggest a range of emotions. He recalls seeing Niccolò Dell'Arca's life-size painted terracotta sculpture *Pieta* (1463–85) in Bologna, a curiously frenetic group which uses rhetorical gestures and fluttering draperies to articulate the grief of the mourners (fig.55). His subsequent experience of the Albee play reminded him that profound meanings can be as effectively communicated by stillness as by dramatic gesture.

The particular theatricality Henry is concerned with is by no means limited to the physical space of the theatre but is, for him, intrinsic to everyday life. A defining characteristic is the sense of people observing the world around them while being aware of being observed themselves. This is the realm of the modern day *flâneur* as invented by Baudelaire and glossed by Walter Benjamin – the city dweller who aimlessly strolls the boulevards, absorbed in the visual flux of urban life. 'The life of our city is rich in poetic and marvellous subjects,' wrote Baudelaire. 'We are enveloped and steeped in an atmosphere of the marvellous; but we do not notice it.'[1] Henry draws it to our attention.

Fig.55 Niccolo' Dell'arca (1440–1494) Fig.56 *You're Not the Same* 2005 (detail)
Pieta High Renaissance
Pinacoteca Nazionale, Bologna

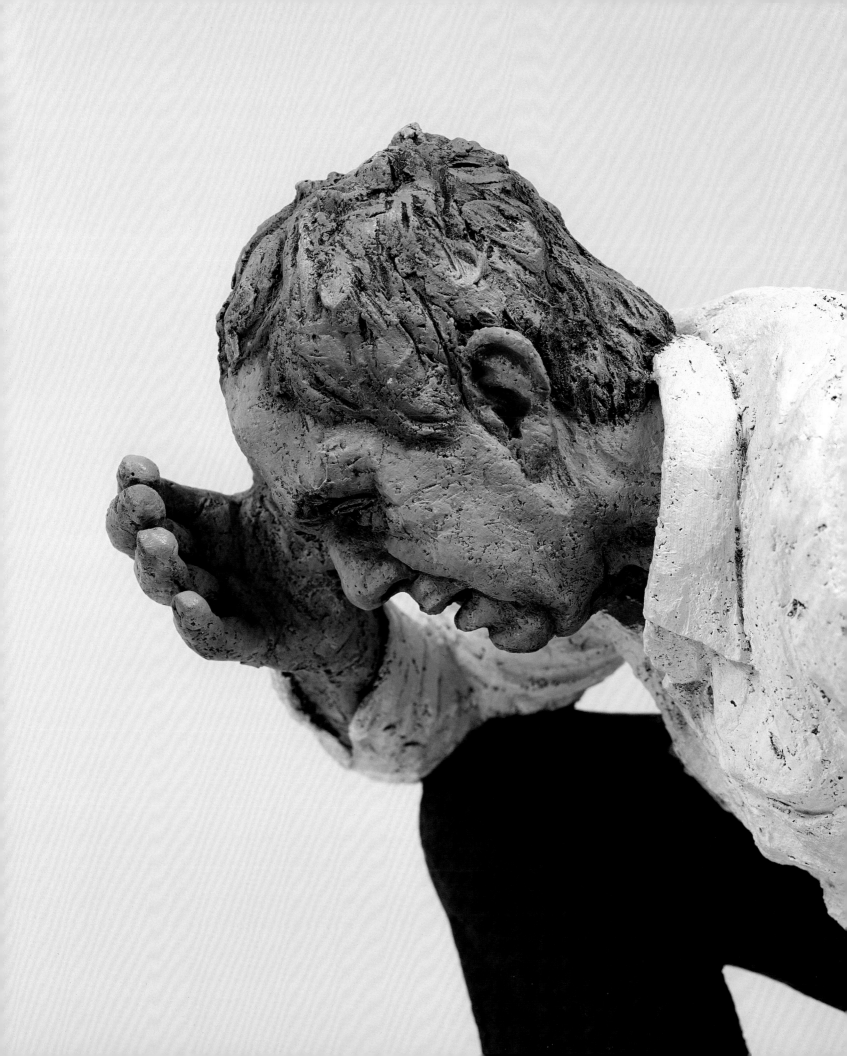

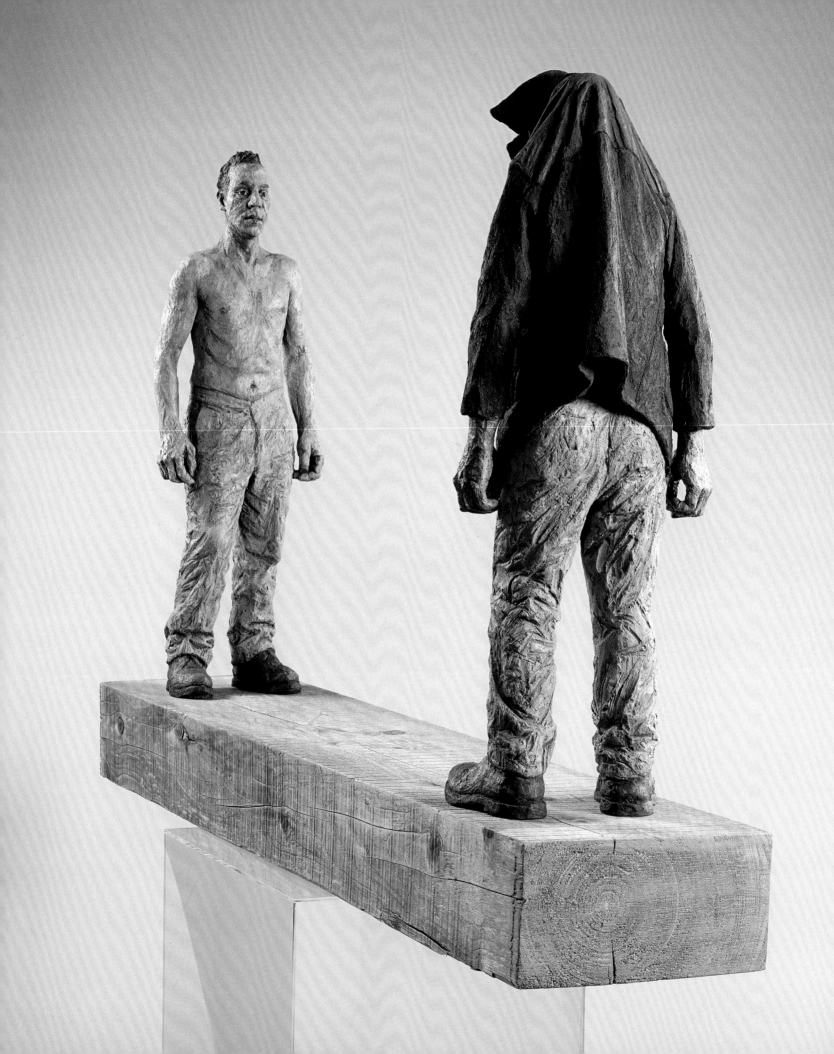

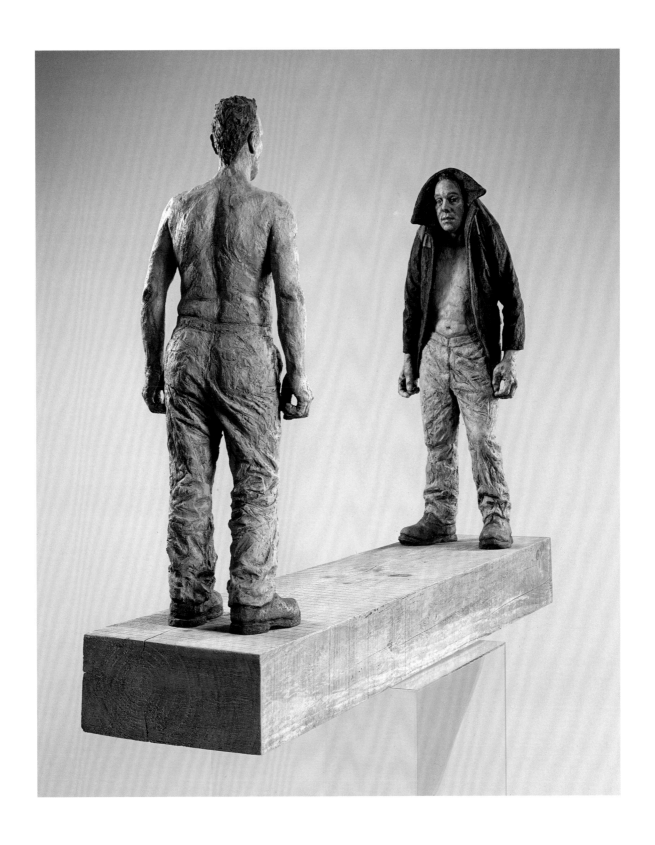

Fig.57 *Man with Alter Ego* 1998

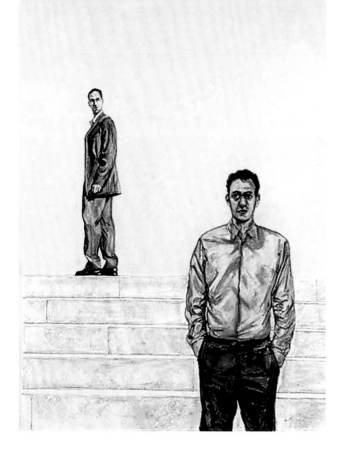

While touring Italy between March and June 1999, Henry executed a drawing of two figures outside a church in Faenza (fig.58). This became a study for the sculpture made later that year known as *Sic Transit Gloria Mundi* showing a man standing at the foot of a set of steps, while another man above him pauses and turns as if momentarily distracted by something (fig.59). 'It was an everyday scene,' Henry says, 'but also "modern Italian" in the way people often involve themselves in looking while being looked at.'

The Latin phrase *Sic Transit Gloria Mundi* – meaning 'Thus passes the glory of the world' – is used in papal coronations, traditionally spoken by a monk holding a length of burning flax as a warning against papal hubris. Henry's use of it creates a subtle interplay between the heroism of everyday subjects dressed in what Baudelaire called 'the necessary costume of our time' and the underlying futility of human existence. The concrete steps function as both a fragment of the real world, adding veristic weight to the composition, and as theatrical artifice, a foil to the human drama enacted by the figures.

Henry has great respect for the work of the Portuguese-born painter Paula Rego. Like Henry, Rego is primarily concerned with the use of human figures as dramatis personae. She often builds elaborate tableaux in her studio featuring a range of theatrical props that help her conceive narrative-based compositions implying social and sexual repression (fig.61).

Fig.58 *Study for Sic Transit Gloria Mundi* 1999 Fig.59 *Sic Transit Gloria Mundi* 1999

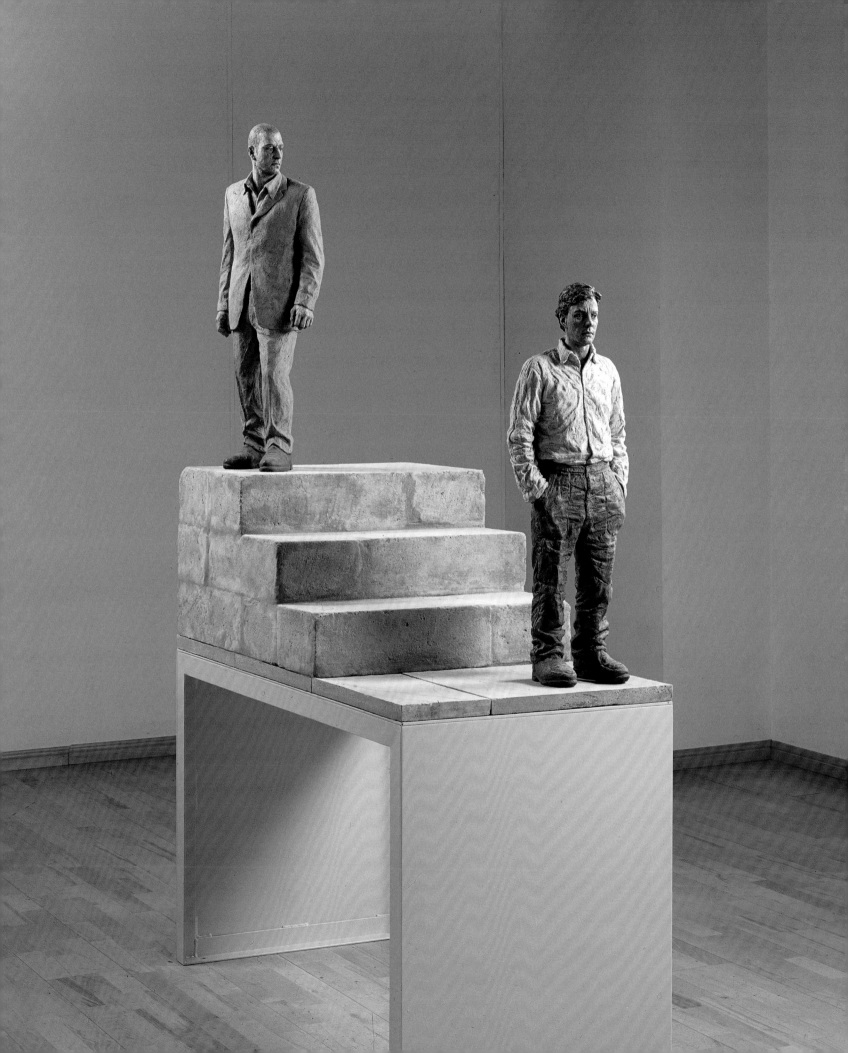

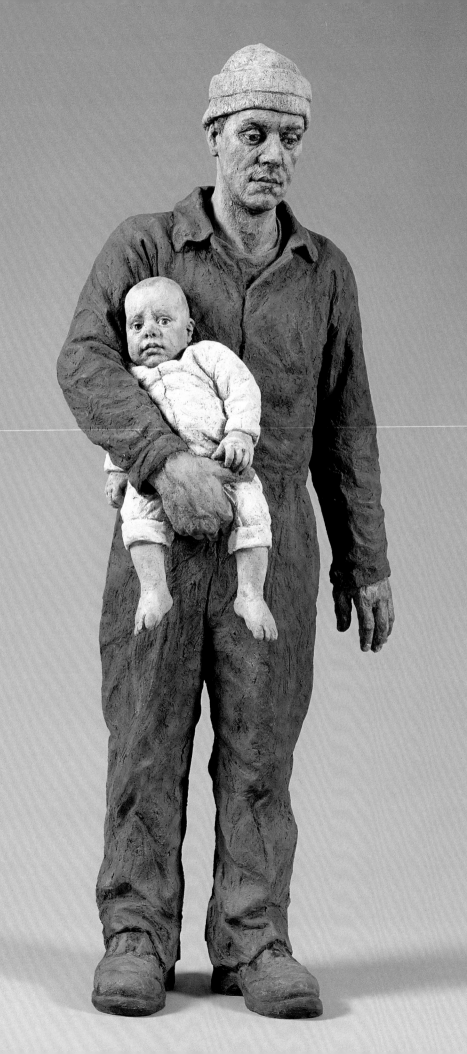

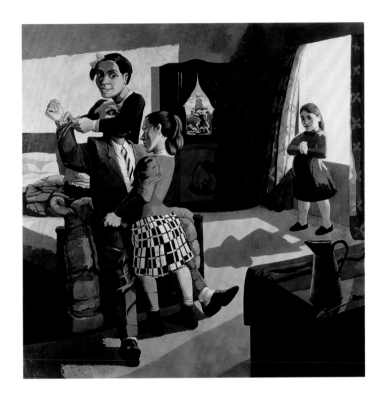

Although she is primarily a painter, Rego's canvases and large-scale pastels feature human figures with a powerful sculptural presence. Furthermore, many of her pictures use disorientating contrasts in scale to suggest hierarchies of power or social status. She draws inspiration from a diverse range of elevated and popular cultural sources, from the theatre of Jean Genet to Spanish folk literature, from Portuguese myth and legend to the films of Walt Disney. She is acutely sensitive to the symbolic power of certain types of historical national dress, which she combines with contemporary clothing to invent her own visual theatre of desire and repression. Henry has always been moved by the forceful theatrical element in Rego's work, and the way she uses it as an armature around which to build compelling narratives.

Like Rego, Henry occasionally uses the fabric of the real world to amplify the sense of realism. This often reinforces a sculpture's semantic charge. The 2004 work *Italia* (figs.62–63) places three figures against a rudimentary architectural structure of two walls set at right angles. Two of the figures, dressed with Brechtian drabness, stand inside the building, one with his hands in his pockets, his companion making a vague conversational hand gesture. The third figure, wearing jeans and a zip-front sports jacket emblazoned with the word 'ITALIA', stands outside the structure on the angle of the building. The ambiguity of interior

Fig.60 *Man and Child* 2001

Fig.61 Paula Rego (b. 1935)
The Family 1998
Acrylic on canvas backed paper
213.4 × 213.4 cm / 84 × 84 in

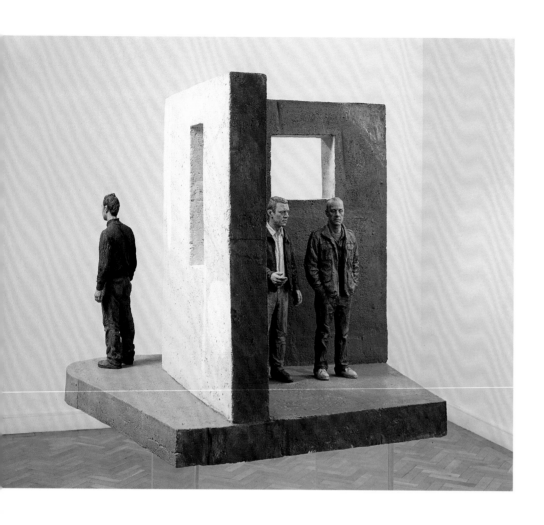

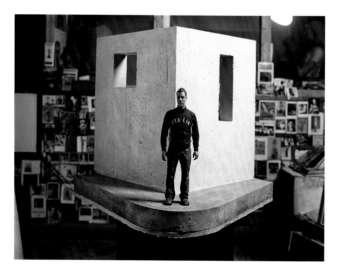

Fig.62 *Italia (Room)* 2004
Above: Side view
Right: Front view

Fig.63 *Italia (Room)* 2004 (detail)
Opposite: Back view

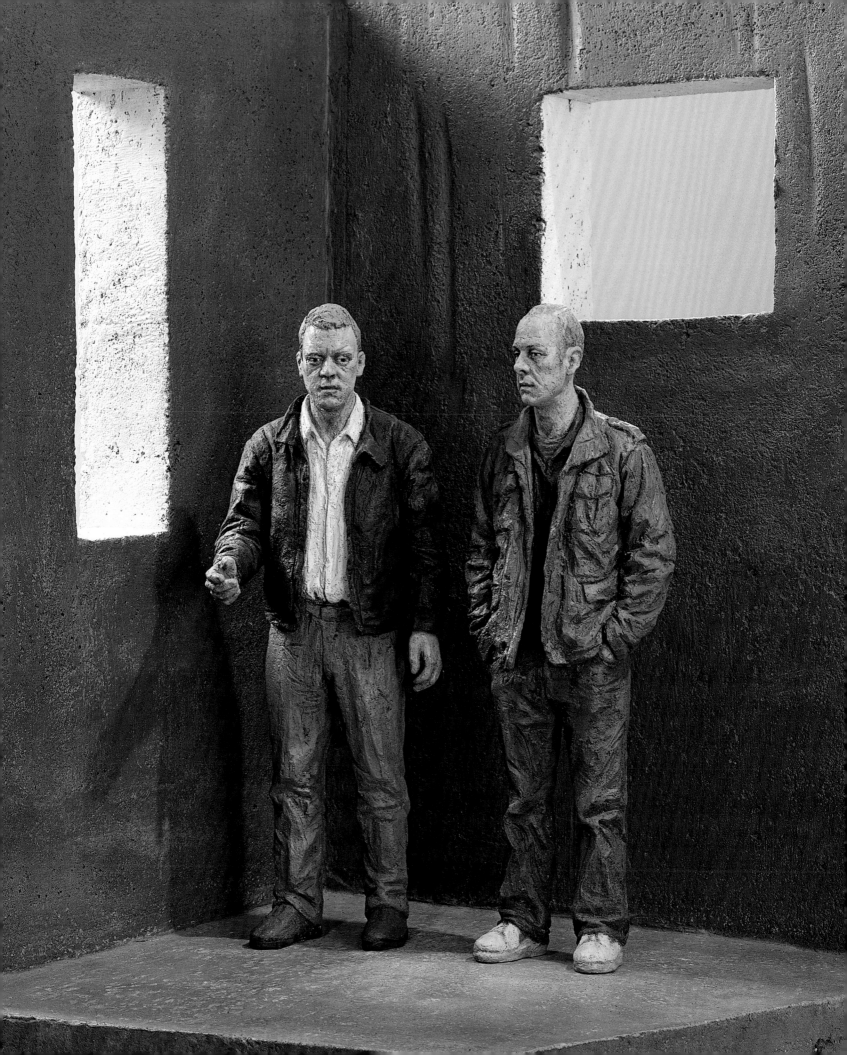

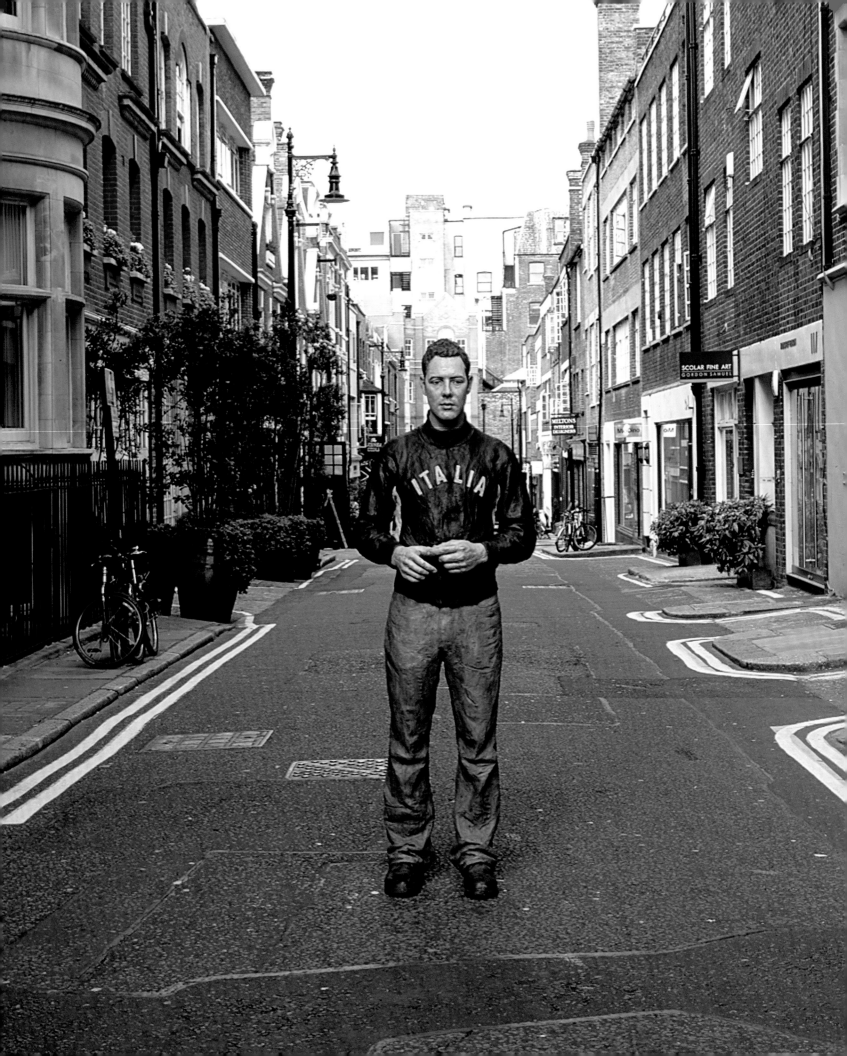

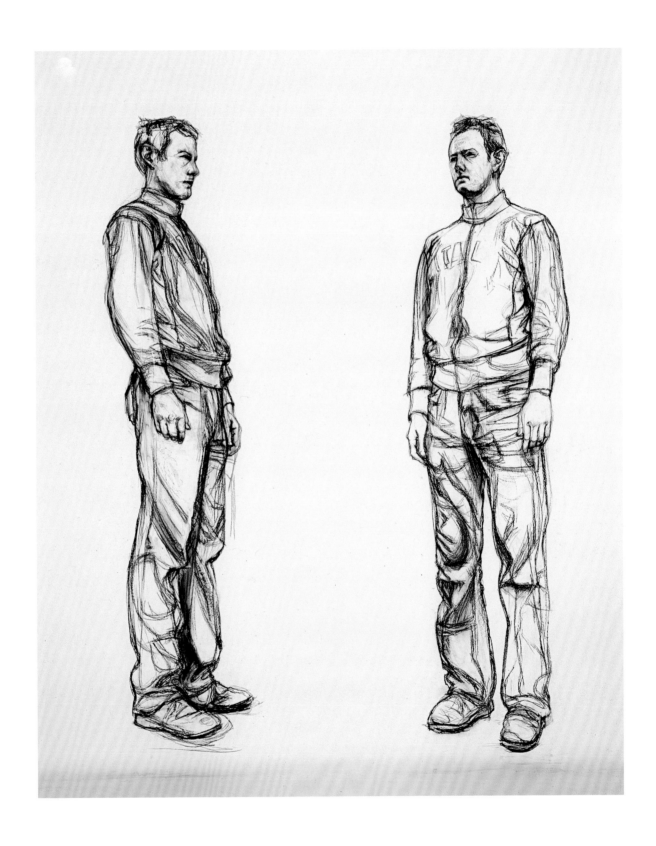

Fig.64 *Italia* in Bruton Place, Mayfair,
London 2004

Fig.65 *Study for Italia (Twice)* 2004

and exterior contributes to the enigmatic quality of the work. In what way, if at all, are the figures related to each other? Are they aware of each other's presence? Depending on our viewpoint, we can see one, two, or all three figures at any one time. However, while no single vantage point offers narrative closure the possibilities expand and contract depending on our position. The table-top scale of the work lends it some of the qualities of a working model for a stage set. From this minimalist three-dimensional conceit we can imagine an entire Beckettian dialogue unfold in which our three protagonists ponder the futility of the human predicament.

An awareness of the not always welcome proximity of other people seems to have inspired the work entitled *Folly* of 2001 (fig.66). The piece comprises a space-frame construction in which we see a couple asleep in bed, the man lying awake beside his sleeping partner. Henry has spoken of the sensation of realising when lying in bed in a London house that one might only be a couple of metres away from someone else asleep on the other side of the wall separating the two dwellings. This repeats itself all the way down the street and is multiplied right across the city, a notion which at the time filled Henry with existential dread. Hence although the title alludes to an architectural folly, it just as pertinently evokes the folly of the human condition. The open architecture of the sculpture – a scale model of Henry's London home at that time – echoes the constructions built on stage when a drama requires the action to take place on separate floors of a building. However, it also doubles as an imprisoning cage not unlike the scaffolding in which Francis Bacon liked to enclose his figures. More importantly, the work dramatises a private thought process, externalizing an interior life and implicitly recasting the individual as alienated loner in an encroaching social world. One is reminded of a perceptive remark by the great silent film star Louise Brooks, quoted by Kenneth Tynan: 'The great art of films does not consist in descriptive movement of face and body, but in the movements of thought and soul transmitted in a kind of intense isolation.'

Another instance in which an architectural element adds theatrical impact is the work known as *Trajan's Shadow* (2001; figs.67–68). A single male figure dressed in a buttoned casual shirt and plain trousers stands with his hands in his pockets beneath an angular steel arch – a scale replica rendered in Cor-ten steel of a Roman doorway at Trajan's Market in the Forum in Rome. Behind the figure his shadow is painted onto the arch to signify the transience of a single human presence when juxtaposed against two thousand years of history. The connotation of a proscenium arch in a theatre is accidental but has the effect of presenting the figure as a stage actor about to commence a soliloquy. Moreover, the arch serves to reconfigure the world framed beyond as a theatrical backdrop. When exhibited outdoors in the public park in London's Berkeley Square in 2001–02 (fig.68), the work triggered a slippage between art and reality, momentarily recasting the natural world as mimetic representation.

Fig.66 *Folly* 2001

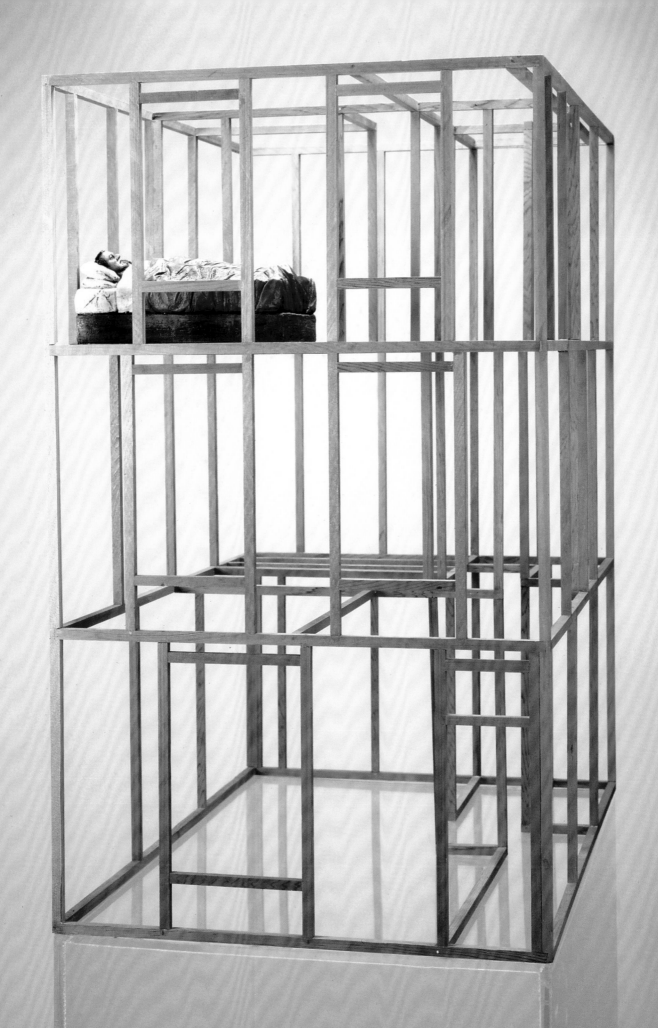

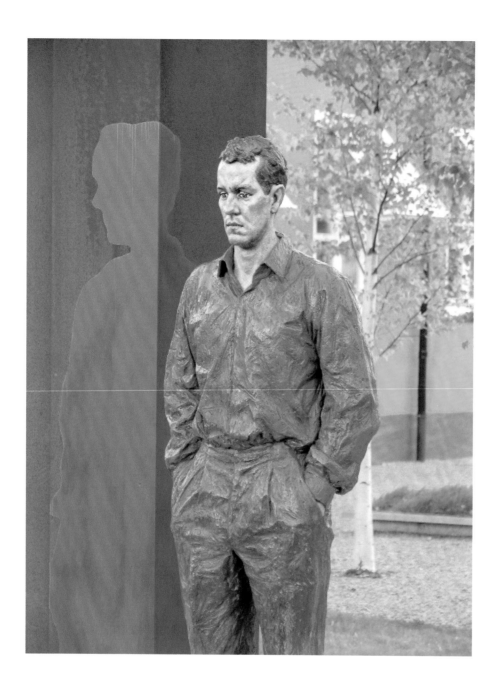

Fig 67. *Trajan's Shadow* 2001 (detail) Fig 68. *Trajan's Shadow* in Berkeley Square, London 2001

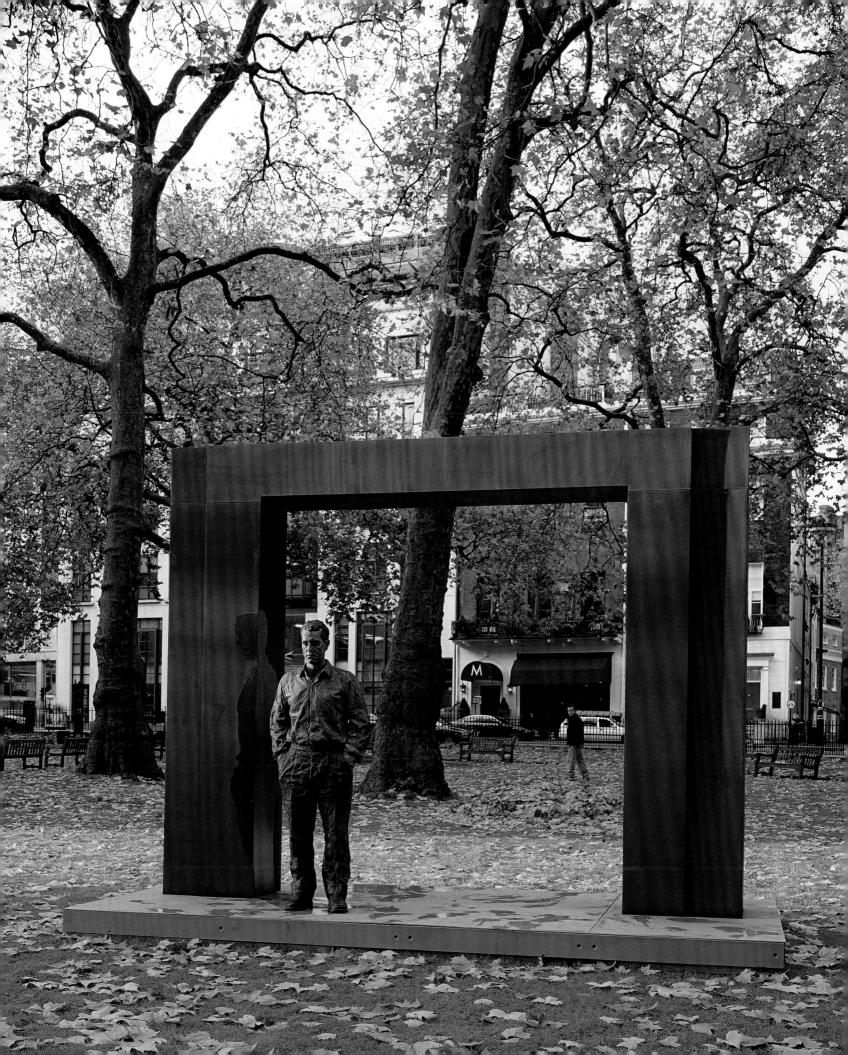

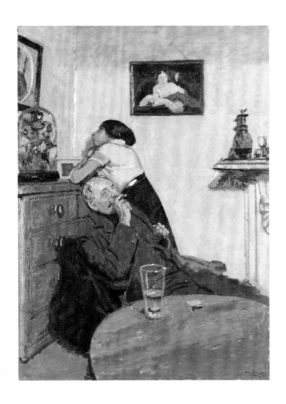

The theatrical element in Henry's work can also be found in his relief sculpture. One of his most accomplished compositions in this format is the painted aluminium work entitled *Hotel Room* (2005; fig.70). A woman lies snoozing on a double bed while her male companion stands with his back to us staring out of the window. In its evocation of the solitude of city life, the mood is decidedly Hopper-like. The scene is reflected twice – in a large mirror at the head of the bed, and in the rectangular screen of a plasma television on the opposite wall. The reflections expand what appears to be a claustrophobic interior typical of budget 'boutique' hotels found in most major cities, although the image is ambiguous. An upholstered settee at the lower right is turned to hint at further space beyond the picture plane. Spatial depth is delivered by the receding orthogonals of the mirror, screen, bed and floorboards. Absorbed in the view from the window, the man is the modern equivalent of the woman in Sickert's *Ennui* (c.1914; fig.69) who leans absent-mindedly against a chest of drawers, staring at a taxidermic bird beneath a glass dome while her companion sits smoking.

Were Henry's modern travellers to come alive and speak, one suspects it would be a Pinteresque dialogue of stark economy fitting the depersonalised hotel room in which they're depicted.

1 Charles Baudelaire, 'The Salon of 1846:
On the Heroism of Modern Life', quoted in
Francis Frascina and Charles Harrison (eds),
Modern Art & Modernism: A Critical Anthology
(London, 1982), p.18.

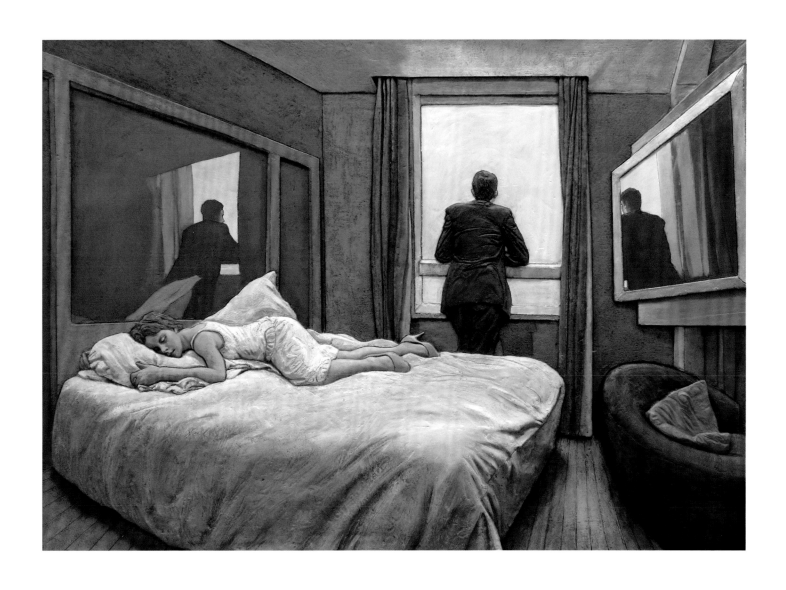

Fig.69 Walter Richard Sickert (1860–1942)
Ennui c.1914
Oil on canvas
152.4 × 112.4 cm / 60 × 44¼ in
Tate London

Fig.70 *Hotel Room* 2005

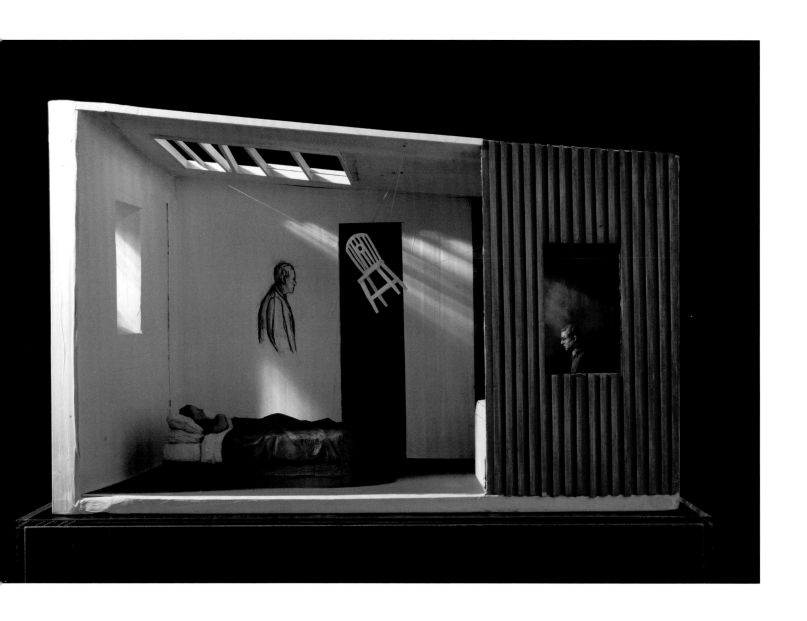

Fig.71 *Maquette for Folly* 2007 Fig.72 *Great Western Man* 2006 (detail)

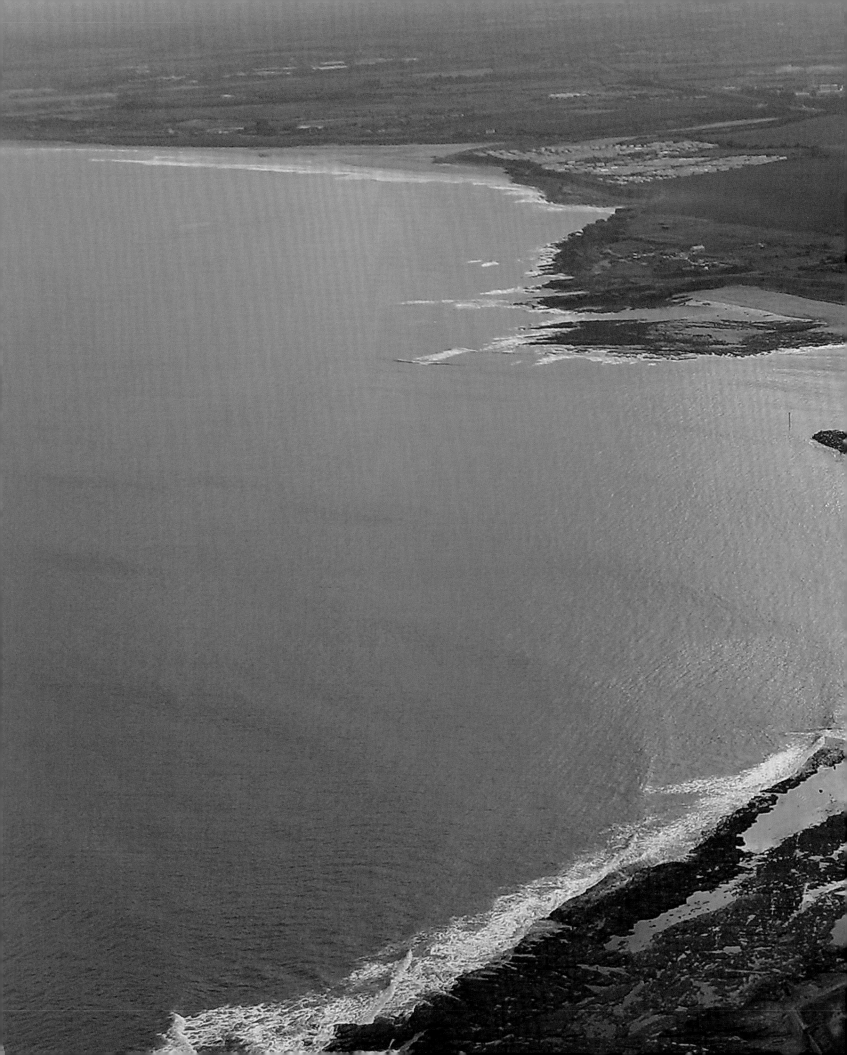

LOCATION AND ENVIRONMENT

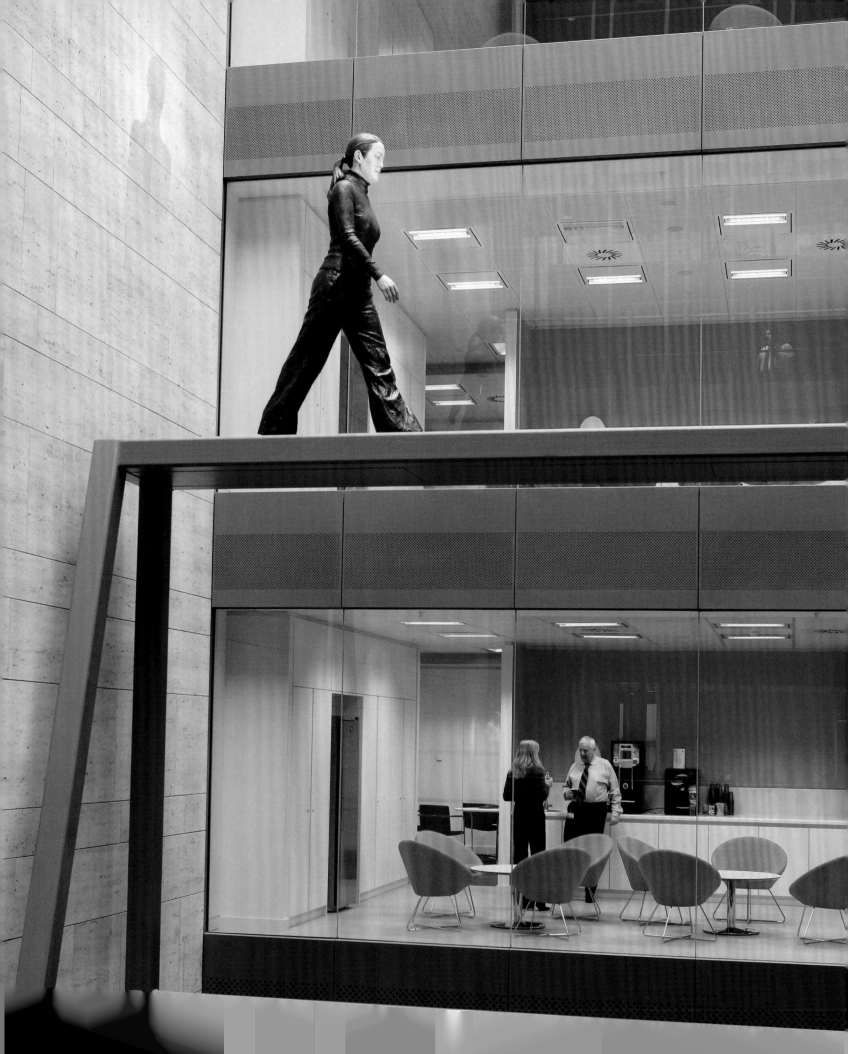

One of Sean Henry's principal concerns as an artist is to heighten the experience of sculpture for the viewer. The Newbiggin installation required acute sensitivity to the North East environment and the social context in which the work was to be located. This prompted him to explore how associated design elements impact on the presentation of sculpture and he became actively involved in those aspects of the installation. While most of his more important public works have been outdoor projects, he has recently begun tackling significant interior installations that present quite different, but equally exciting challenges.

In 2005, Henry was invited by Standard Chartered Bank to submit a design for a sculpture installation for the bank's new head office in Basinghall Avenue in the City of London. The bank already owned one of his works – the bronze *One Step Forward* (2004; fig.93 on pages 138 and 139) – but this recent commission offered him an opportunity to attempt a more ambitious integration of his sculpture into a brand new office building and an important hub of international finance.

Presented with the architectural plans, he was asked to submit a proposal for the 23-metre-high atrium that commences on the fifth floor and extends up through five of the building's ten storeys. Using a 1:20 scale model of the space he spent several months constructing miniature figures, exploring possible permutations and playing with perspective.

Three sides of the atrium are glazed so as to afford unobstructed views across each level and from each floor down into the open atrium itself. The atrium's north wall is clad in a rich honey-coloured Dura limestone panelling, the shade of which changes subtly according to the light filtering through the building's glazed roof above. The open wall of the main access walkway is partially articulated by vertical beams in oak. The space is lit by a combination of natural ambient light and from a series of uplights mounted between the vertical oak beams.

Henry's proposal was for a series of nine sculptures of differing scale to be distributed around and within the various levels of the atrium and its immediately adjacent walkways. Some of the figures are mounted on individually designed plinths made from Dura limestone to harmonise with the rear wall from which they spring. Others are distributed between the linking walkways that unite the main body of the building with the elevators and main access routes. The challenge was to integrate the sculptures into the architectural and social fabric of the building and to relate them to each other while maintaining the individuality of each figure or pair of figures. Henry achieved this by creating subtle links between the separate sculptures as they appear to register each other's presence through a relay of exchanged glances.

Having secured approval for the work, Henry met some of the bank's employees and

Fig.73 *Walking Woman* at One Basinghall Avenue, London 2008

photographed them in their work environment with a view to possibly using them as models for the sculptures. Three works evolved in this way, a fourth was designed specifically for the project (but was modelled by someone unconnected to the bank), while the remainder derive from pre-existing works that take on fresh meanings within this context.

Several aspects of the project were inspired by art historical precedents which Henry has adapted for his own purposes. One point of reference was the fourteenth-century equestrian figure of Cangrande I della Scala (1291–1329) in the Museo Civico di Castelvecchio in Verona, a building redesigned in 1964 by the Italian architect Carlo Scarpa (1906–1978). Scarpa integrated Cangrande into a bold modernist scheme, elevating the Veronese nobleman onto a brutalist slab that appears to have slid silently from the wall behind him. The effect is dramatic, concentrating attention on the sculpture and enhancing the viewer's one-to-one relationship with the work. Other frames of reference were Roman buildings and the disposition of sculpture in Gothic and Renaissance cathedrals where the eye is constantly drawn to different parts of the architecture by sculpted figures in niches, their proportions invariably foreshortened to compensate for a single viewpoint below. The atrium at Standard Chartered Bank is a cathedral-like space with a good deal of natural light. Because the figures can be seen from multiple viewpoints, Henry varied their scale to create a richer and more complex

Fig.74 *Man Holding Jacket* 2008 Fig.75 Installation at One Basinghall Avenue, London 2008

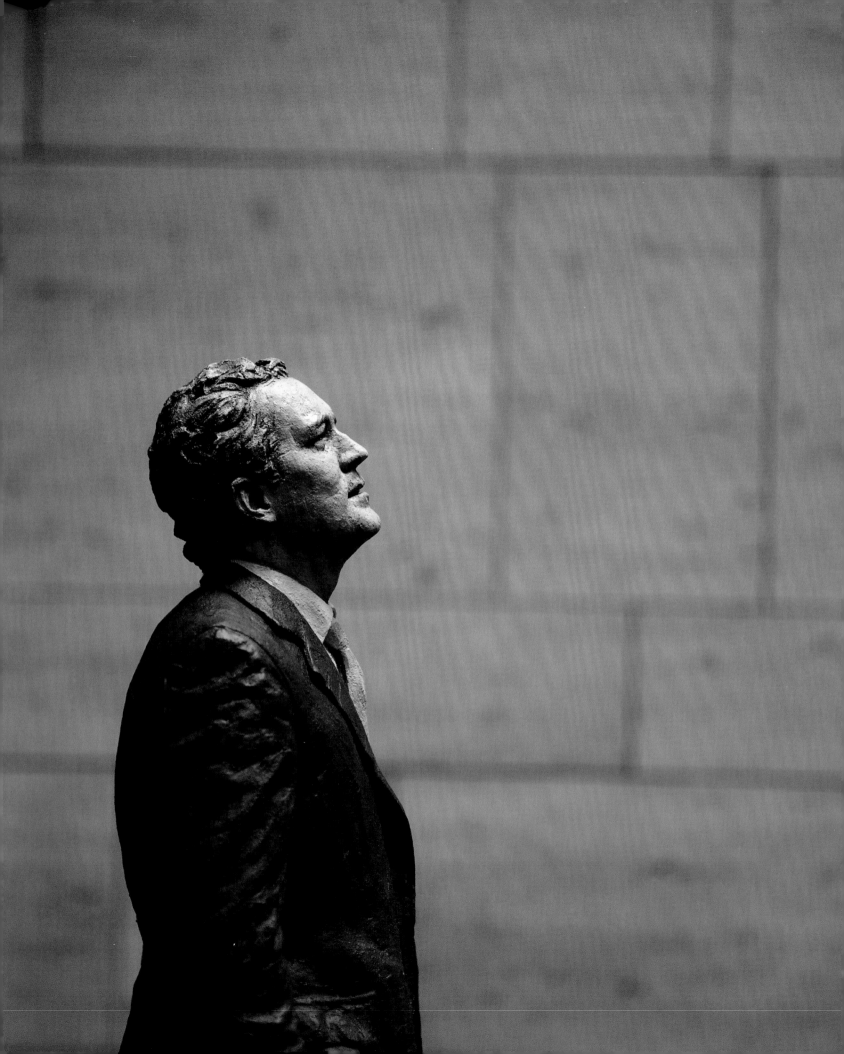

experience. The limestone plinths on which the figures stand are designed to support the sculpture while appearing integral to the building. The overriding aim was to make the figures appear grounded and resonant in their given spaces while creating a dramatic arena marrying sculpture and architecture.

Beginning at the fifth floor, the installation commences in a communal area devoted to rest and relaxation where employees can sit and take coffee. One of the two figures occupying this café zone is a man in a business suit (fig.76) who stands in the centre of the room, looking up into the atrium at one of the figures above him. This encourages us to follow his gaze, connecting us with the space and with the sculptures that populate it. Nearby sits another male, a slightly reduced-scale suited man originating from the triple-figure group *You're Not the Same*. Positioned outside the circuit of glances and absorbed in his own thoughts, this figure provides a more introspective register and offers a quiet counterpoint to the more visible figures above.

The café area also provides the foundation for the most prominent feature of the entire installation – an A-frame steel scaffold that extends up to the seventh floor. Across its top beam, which spans the length of the atrium back to front, strides a young black-clad female figure (fig.73), seemingly oblivious to the plunging drop below. Occupying pole position in the heart of the atrium, this chic, casually dressed figure is the cynosure of all eyes.

This figure was one of those inspired by meeting bank employees. 'I had a very loose notion of wanting to include a walking female figure,' he says, 'and this particular woman happened to be wearing black that day and seemed very bright and determined. Her shoulders were back and she was walking very purposefully from A to B. Looking at the photographs afterwards I realised this could be a 2.2-metre-high figure and it made sense to scale her up.' As she walks across her vertiginous platform, it is hard to resist her symbolic significance as an avatar of a confidently advancing Chinese economy, but doubtless some may also seek to interpret her as symbolising Standard Chartered's role as a bridge between emerging markets in developing nations. The majority of the bank's profits come from the Asia Pacific Region, South Asia, the Middle East and Africa.

The walking woman also provided another opportunity to create an oblique reference to what Henry sees as the heroic nature of contemporary life, a theme that runs through much of his work. 'It seems to me that everyone's life contains an element of the heroic and I want to try to reflect that. Who knows what people's back stories are? It's about finding the heroic in the everyday.'

While this striking sculpture provides a vivid focal point that is entirely at home in its surroundings, Henry has also deliberately included figures that bring with them a life beyond the conservative workplace environment.

Fig.76 *Man Looking Up* 2008

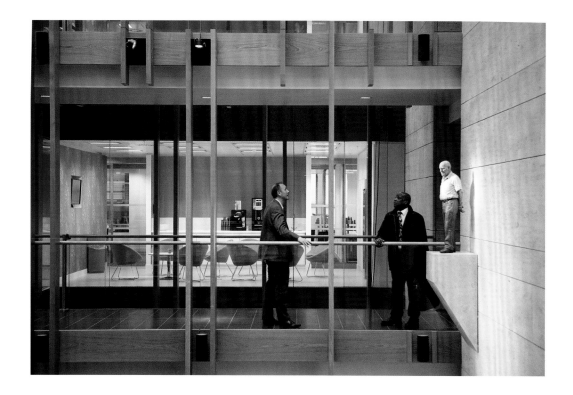

Emerging from a plinth in the rear wall, roughly level with the sixth floor, is *Standing Man*, showing a man in his mature years (fig.77). His hands are clasped behind his back and he stares down into the café area at the executive glancing up. Significantly smaller than life-size (1.09m high), he is clearly the oldest of the figures represented. His casual clothes and air of gravitas suggest a reflective private world distinct from the social maelstrom of business and high finance.

To one side, and again enjoying a vantage point from his own plinth on the north wall, a male executive is shown lost in thought, a take-away cup in hand (fig.80). He is absent-mindedly staring off into the meeting room adjacent to the atrium where he will no doubt provide an interesting conversation piece for the bank's executives. So content did this gentleman seem when Henry met him during preparations for the project, so apparently at peace in his own body, that Henry chose to model him at a smaller scale, confident that his physical presence would still resonate. As with most of the figures, his true size is partly disguised by his position in relation to the other sculptures and seems to change depending on which floor and which angle one sees him from. Similarly, visitors will need to ascend to the seventh floor to discover how big the striding woman really is.

At the other side of the atrium stands another figure, a Sikh man of generous embon-

Fig.77 Installation at One Basinghall Avenue, sixth floor 2008

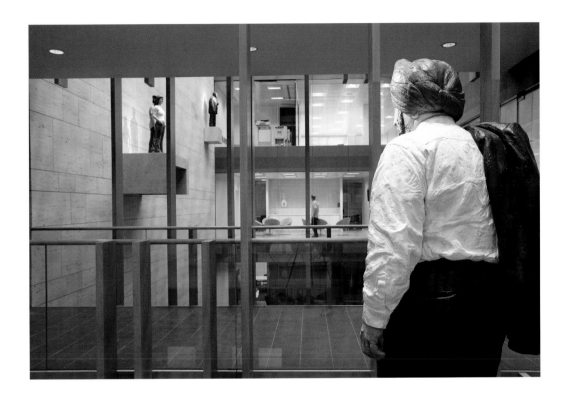

point, his suit jacket slung nonchalantly over one shoulder (figs.74 and 78). Like his female colleague on the other side of the space below him, this figure enjoys his own elevated platform adjacent to the walkway. An aura of authority radiates from him as he scans the visitors who cross the bridge in front of him. Directly in his line of vision beyond the walkway, perched on their own limestone plinth, stand two further figures, reduced-scale versions of the Newbiggin *Couple*. Henry was keen to try and introduce into the bank scheme a series of visual surprises and these emerge principally from contrasts in dress, scale, physical comportment and implied social status between the various figures. No longer transfixed by the North Sea horizon, here the companionable couple appear momentarily hypnotized by the hum of high finance, like a couple of bohemian artists who might have taken a wrong turning over London Bridge.

Finally, discreetly positioned to one side of the main doors leading from the lift on the uppermost floor is the most idiosyncratic figure in the building, *Man Lying on His Side* (fig.79) – a besuited businessman reclining on a rectangular plinth, his head resting on his briefcase, his feet bare. Visiting clients attending meetings at Standard Chartered may easily fail to notice him on arrival, but could not fail to miss him on leaving. He will perhaps inject a note of levity among departing executives as they muse over his shoeless feet that lend him a sense

Fig.78 Installation at One Basinghall Avenue,
viewed from eighth floor 2008

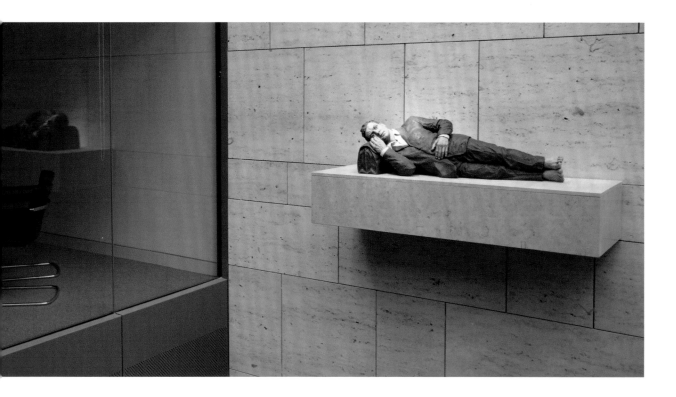

of great vulnerability. As a form of vanitas motif, he may resonate longer than any figure in the building.

As in many of Henry's previous works, the Standard Chartered Bank figures interact with each other and with the architecture to suggest multiple narrative possibilities. These multiply further through sharing the space with the bank's 1500 employees. One of Henry's core aims was to 'create a flow through the building', interrupting the 'floor-specific' psychology of routine office life in which workers tend to gravitate to their own floor, rarely venturing to other parts of the building unless required to do so. The fact that the sculptures are never viewable as a group from any single position will, he hopes, prompt staff to engage with them and the building in creative ways. 'I was very attracted by the idea of tempting people through the building, inviting them to inhabit it in a different way. The relationship between the viewer and sculpture can be radically different depending on where the work is viewed from.'

As we have seen, allusions to religious sculpture abound in Henry's work. He has long harboured ambitions to put figures in a church (some of his sculptures were for a time displayed in St John's Church in London's Notting Hill district). The Standard Chartered installation allowed him to express some of these aspirations in a secular building, creating a series of figures that are grounded but which at the same time seem vaguely metaphysical.

Fig.79 *Man Lying on His Side* 2000/2008 Fig.80 Installation at One Basinghall Avenue, viewed from ninth floor 2008

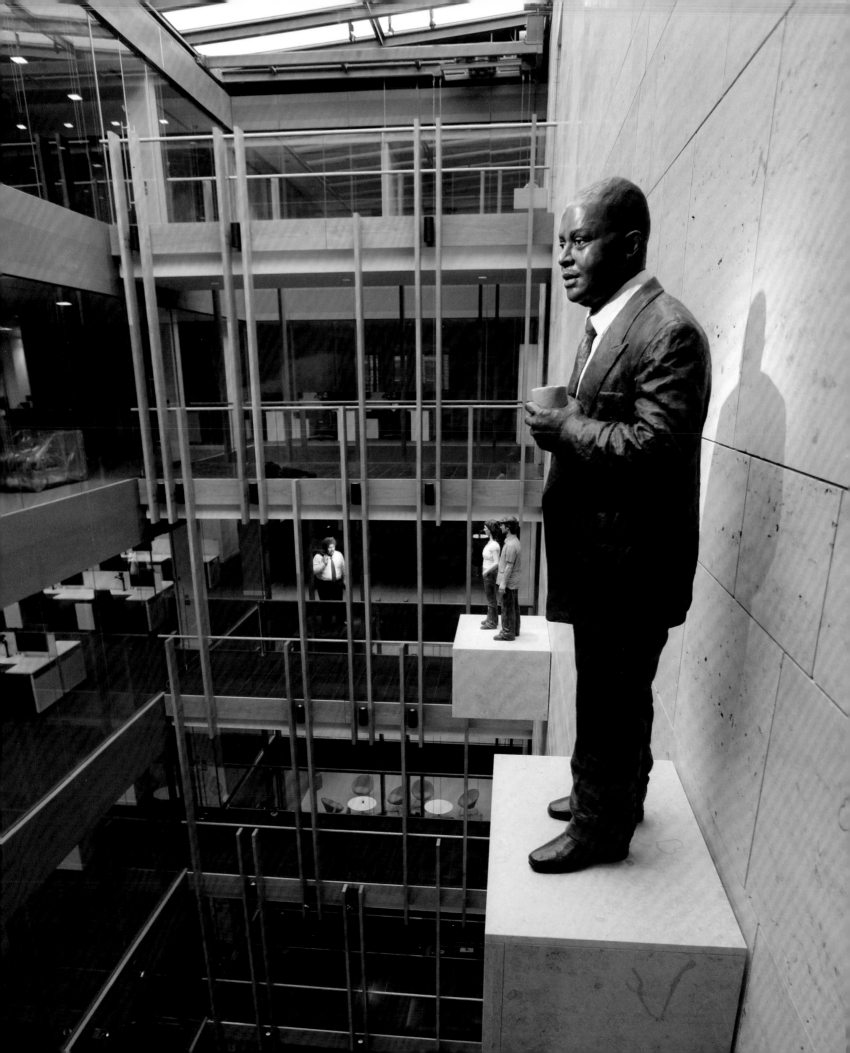

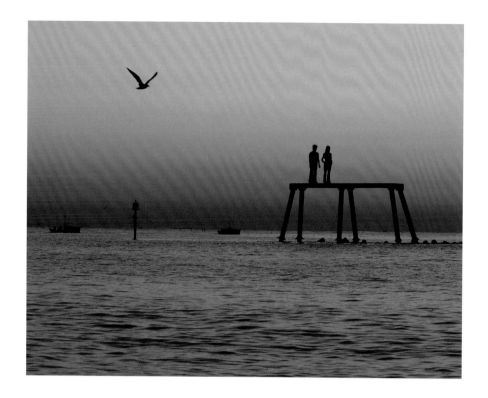

This seems an appropriately ambiguous note to strike in a cathedral of high capital located in the heart of the City of London.

The Standard Chartered project confirms Henry's facility at reading social spaces and devising sculptural schemes appropriate to them. A new multi-figure outdoor scheme for the Scheringa Museum in Spanbroek in the Netherlands will also require a considered approach to context and location. These recent projects represent a relatively new development for Henry as previously most of his figures were conceived as autonomous works that could be located anywhere. They have also encouraged him to think more about location even when making figures with no specific destination in mind. *Woman (Being Looked At)*, for example, was conceived as an indoor work requiring a certain amount of space to be displayed to optimum effect.

Site-specific considerations were also central to the conception and creation of *Couple* (figs.81 and 83). Henry's approach to the Newbiggin installation was grounded in an aware-ness of the broader aims of the government-funded initiative to renovate the bay's eroded sea defences. An important element of the project was the need for a new breakwater, although few envisioned at the outset how this might be combined with a specially commissioned work of art. Henry saw the construction of the breakwater 300 metres off the coast as an

Fig.81 *Couple*, Newbiggin Bay 2007

opportunity to do something more audacious than merely placing a piece of sculpture on the seafront promenade. His design for a graduated pier elevated above the breakwater to support two standing figures was universally endorsed as an innovative solution combining both sculpture and architecture. Like the A-frame support for the walking woman in the Standard Chartered project, it is another instance in which Henry exercised his design instincts to enhance the viewing experience.

The Newbiggin work gains much of its impact from the dramatic light of the coastal location and the continually changing sea conditions. Moreover, the viewing position at Church Point at the north end of the bay offers a markedly different aspect from that at Spital Point in the south. These multiple vantage points and varying distances broaden the work's visual appeal and deepen its social significance to the community.

The Newbiggin figures also offer a contemporary sculptural take on an art-historical tradition in painting that sought to capture the spiritual significance of landscape. One thinks of the work of the nineteenth-century German painter Caspar David Friedrich (1774–1840), whose *Moon Rising Over The Sea* (1821; fig.82) encapsulates the romantic notion of humankind bewitched and humbled by the sublime beauty of the natural world. Henry's work extends that genre into the twenty-first century.

Fig.82 Caspar David Friedrich (1774–1840)
Moon Rising Over The Sea 1821
Oil on canvas
135 × 170 cm / 53⅛ × 67 in
Hermitage, St Petersburg, Russia /
The Bridgeman Art Library

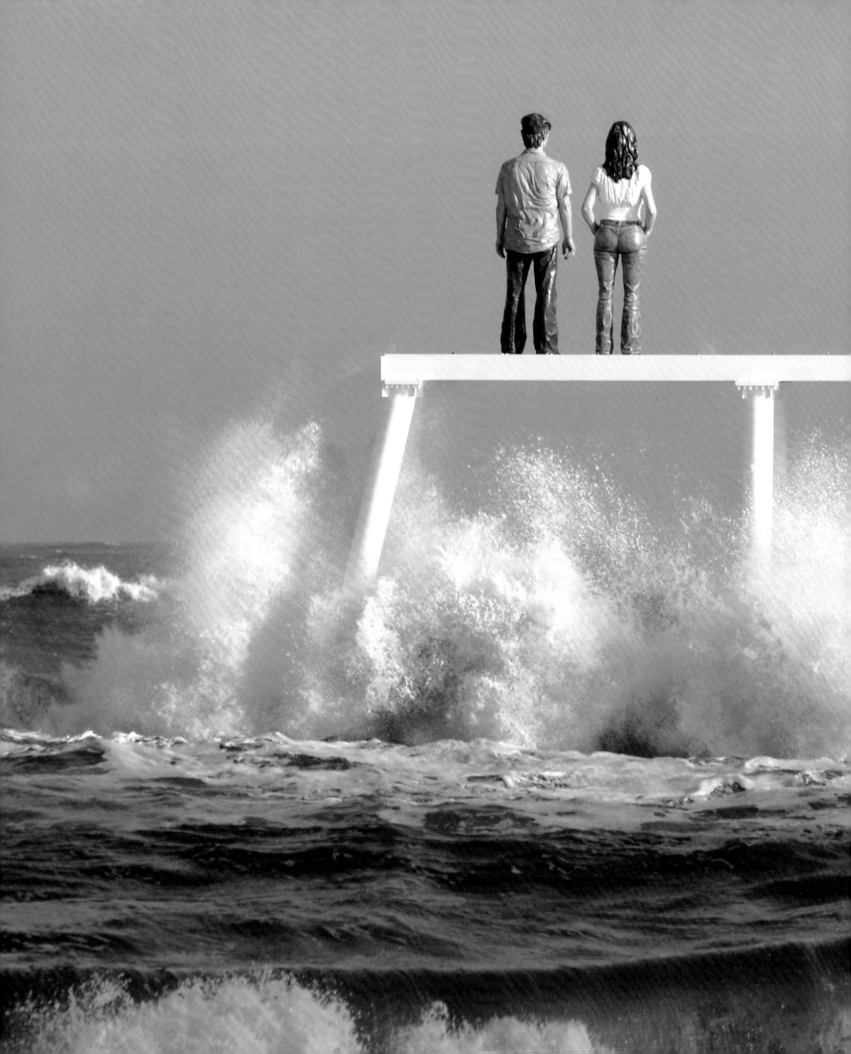

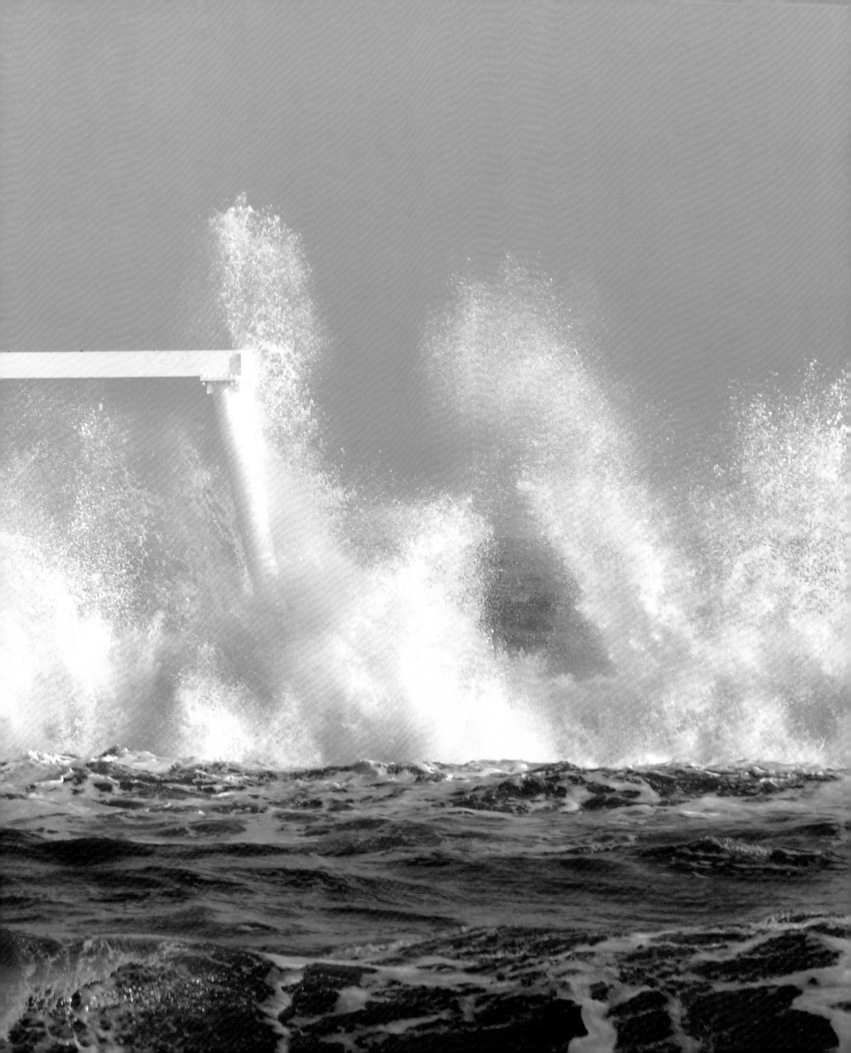

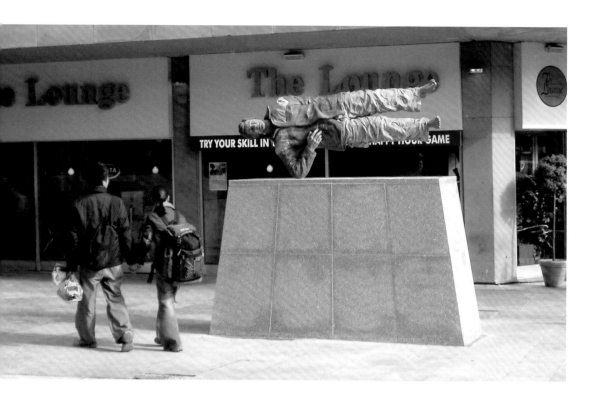

The inspiration for *Couple* sprang from what Henry described at the time as 'a desire to couple land and sea'. Serendipitously, the work has served to re-couple Newbiggin to its immediate hinterland and beyond in a meaningful way, as visitors arrive to view the UK's first permanent offshore work of art.

Couple is part of a broader North Eastern cultural renaissance to which Henry has already made a significant contribution. Twenty miles south of Newbiggin in Newcastle upon Tyne, the artist's three-piece work *Man with Potential Selves* (2000; figs.84–85) enlivens the entrance to the Metro underground station at Lower Grainger Street, one of the city's busiest precincts. One male figure stands motionless on a low plinth, the collars of his black donkey jacket pulled up against the wind; another in short-sleeved shirt and khaki trousers strides purposefully towards the city centre; the third, a barefoot figure also clad in donkey jacket and baggy trousers, appears to levitate horizontally above a tapered plinth. The works are in sufficiently close proximity to each other to be visually connected while maintaining their autonomy as single figures. Every day, the Newcastle public moves between, past and around them, seemingly as oblivious to the sculptures as to each other. This ought not to be taken as public indifference to the work but as confirmation of its positive integration into the life of the city.

(pages 126–127)
Fig.83 *Couple*, Newbiggin Bay
March 2008

Fig.84 *Man with Potential Selves* in Lower
Grainger Street, Newcastle upon Tyne, England
2000 (detail)

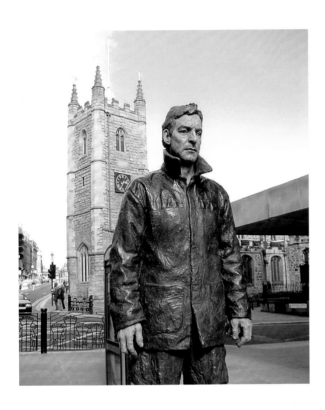

Bought by Newcastle City Council in 2003, *Man with Potential Selves* is now a familiar part of the urban fabric. On a recent visit, while exiting from the Metro station I noticed a cigarette end lying on the pavement at the feet of the standing figure as if he had just stubbed it out. Discarded by a passer-by, this fragment of real human debris offered a reminder that, for all its apparent realism, Henry's sculpture does not mirror reality so much as collaborate with it.

In its Tyneside home, *Man with Potential Selves* communicates a rugged masculinity echoing the region's working-class heritage. Much of Henry's work has an interactive quality, his figures often appearing to both absorb and reflect the ambience of their surroundings. Another cast of *Man with Potential Selves* is located in the spacious lobby of the Le Meridien (The Cumberland) Hotel in London's Marble Arch where the figures assume an architectonic function, punctuating the space (see pages 14–15). Bathed in colourful lighting and juxtaposed against the chic metropolitan décor, the figures' somewhat dishevelled working-class apparel adds an ironic note to the hotel's luxurious interior.

As these examples reveal, location is an increasingly important consideration in Henry's work, not merely in terms of his concern for where his public sculpture is sited, and how context and lighting can affect the way a work is read, but also as a source of inspiration.

Fig.85 *Man with Potential Selves* in Lower Grainger Street, Newcastle upon Tyne, England 2000 (detail)

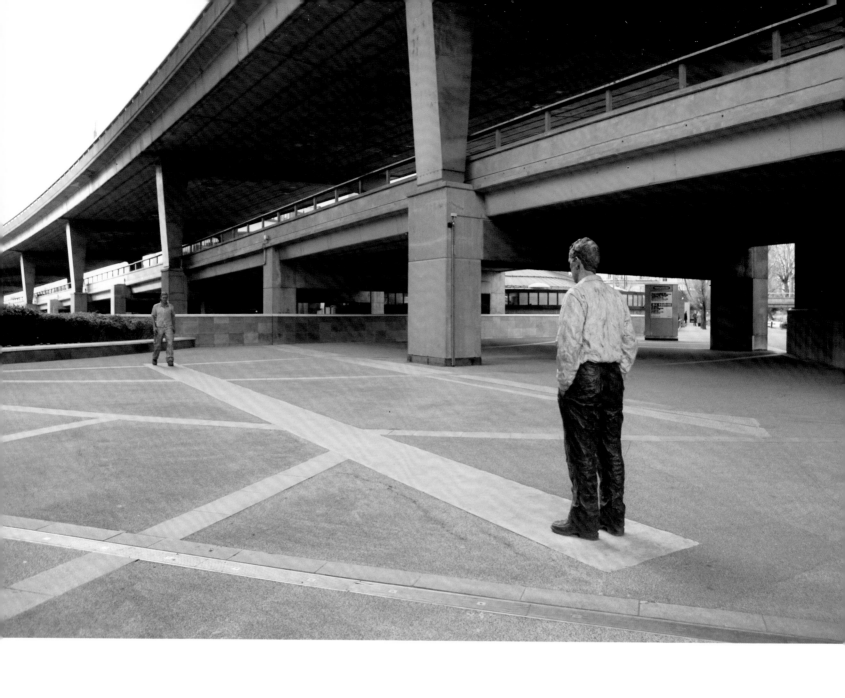

Fig.86 *Meeting Place* at Paddington Central, London 2003

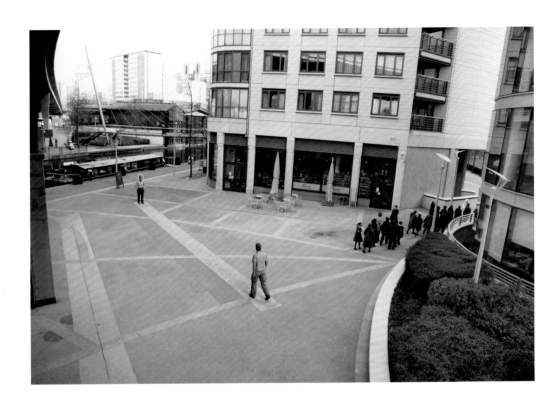

Living and working in London has had a profound influence on both his personal develop-
ment and the character of his work. Although he recently moved his main studio to
Wiltshire, he continues to feel an umbilical connection to the metropolis and its kinetic
energy. This partly explains his admiration for the School of London painters who came to
prominence in the post-war period – Frank Auerbach, Francis Bacon, Lucian Freud, Leon
Kossoff and Michael Andrews being the principal members of that informal group. Their
commitment to a gestural, figurative painting and their fidelity to the human figure in the
face of an avant-garde moving in another direction towards Conceptualism and Minimalism
resonated for Henry, whose own work stands in a similar contrary relation to prevailing
trends today. He also shares their instinct for the theatrical. As Dawn Ades has noted, 'Freud
uses, as does Auerbach, metaphors drawn from the theatre, which imply both empathy and
identification with the subject and also the necessity for some artifice.'[1]

 Henry's London period helped him shape in his work a kind of urban melancholy centring
on the working individual as existential loner mesmerised by the illusory promise of bourg-
eois life (for example, figs.86–87). Clearly Henry feels a strong sense of identification with
this social type. One recalls Francis Bacon's remark about his own painting: 'It's concerned
with my kind of psyche, it's concerned with my kind of… exhilarated despair.'[2]

Fig.87 *Meeting Place* at Paddington Central, London 2003

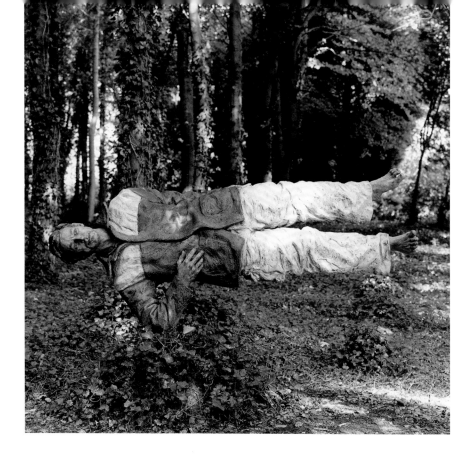

Although Henry often uses himself, friends or acquaintances as his models, the finished sculptures emerge as anonymous representatives of contemporary humankind. He has an eye for what Michael Andrews once described as 'mysterious conventionality'.[3] We see such subjects around us every day – standing waiting for a bus, queuing for tickets, negotiating the ebb and flow of urban thoroughfares, or when we happen upon them in their working environment. By selecting them as subjects for his art, Henry foregrounds certain characteristics about them that we might otherwise have overlooked, distilling those aspects he deems worthy of attention. As Baudelaire put it for his own generation: 'The gesture and bearing of the woman of today give to her dress a life and a special character which are not those of the woman of the past. In short, for any "modernity" to be worthy of one day taking its place as "antiquity", it is necessary for the mysterious beauty which human life accidentally puts into it to be distilled from it.'[4]

One Step Forward (2004; fig.93) shows a man clad in the ubiquitous body-warmer, work trousers and heavy boots. But it is to his circular white kneepads and orthopaedic arm support that our eye gravitates. These pieces of flimsy armour betray the body's vulnerability, adding a layer of pathos to the work and inviting us to provide the missing second part of the title: …Two Steps Back. Like the bare feet of *Man Lying on his Side*, such details place the work

Fig.88 *Man with Potential Selves*
at Cass Sculpture Foundation 2000 (detail)

Fig.89 *Lying Man* (from *Catafalque*)
at Cass Sculpture Foundation 2007

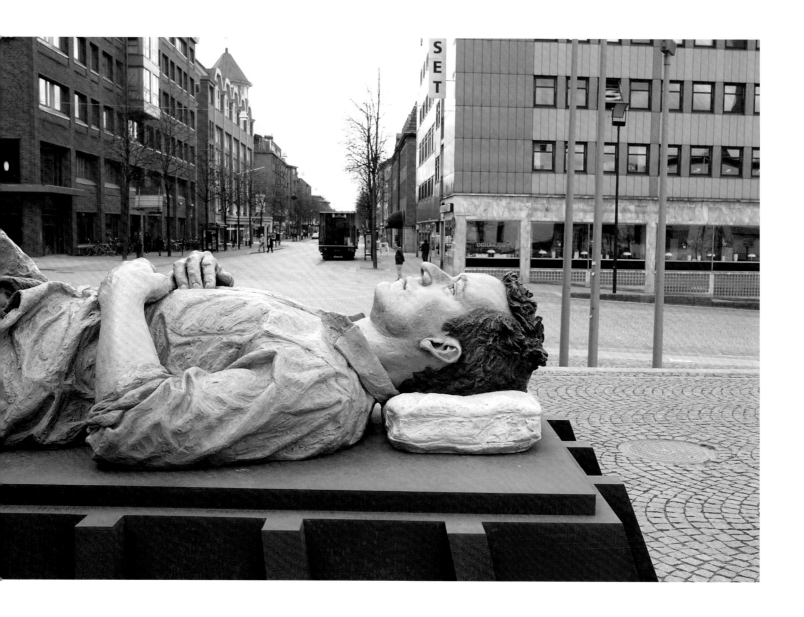

Fig.90 *Catafalque* in Borås, Sweden 2008

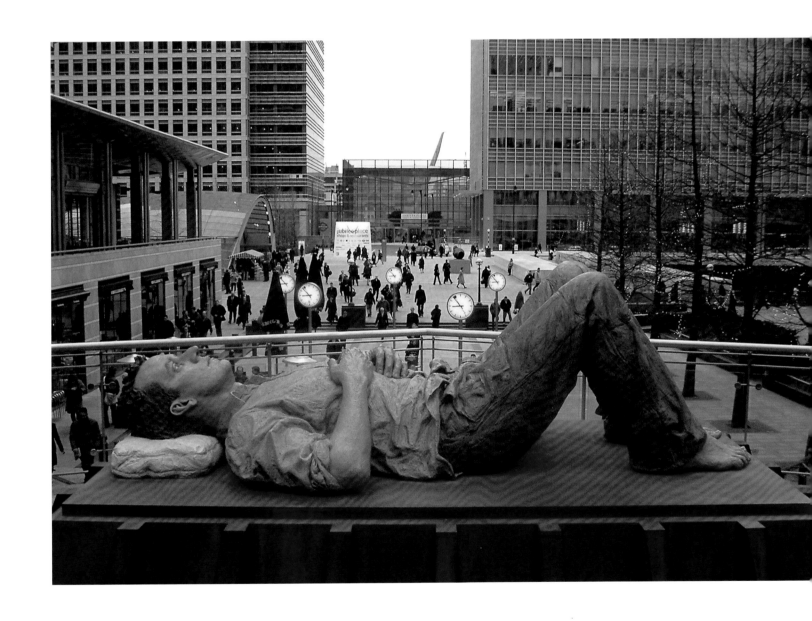

Fig.91 *Catafalque* at One Canada Square,
Canary Wharf, London 2003/4

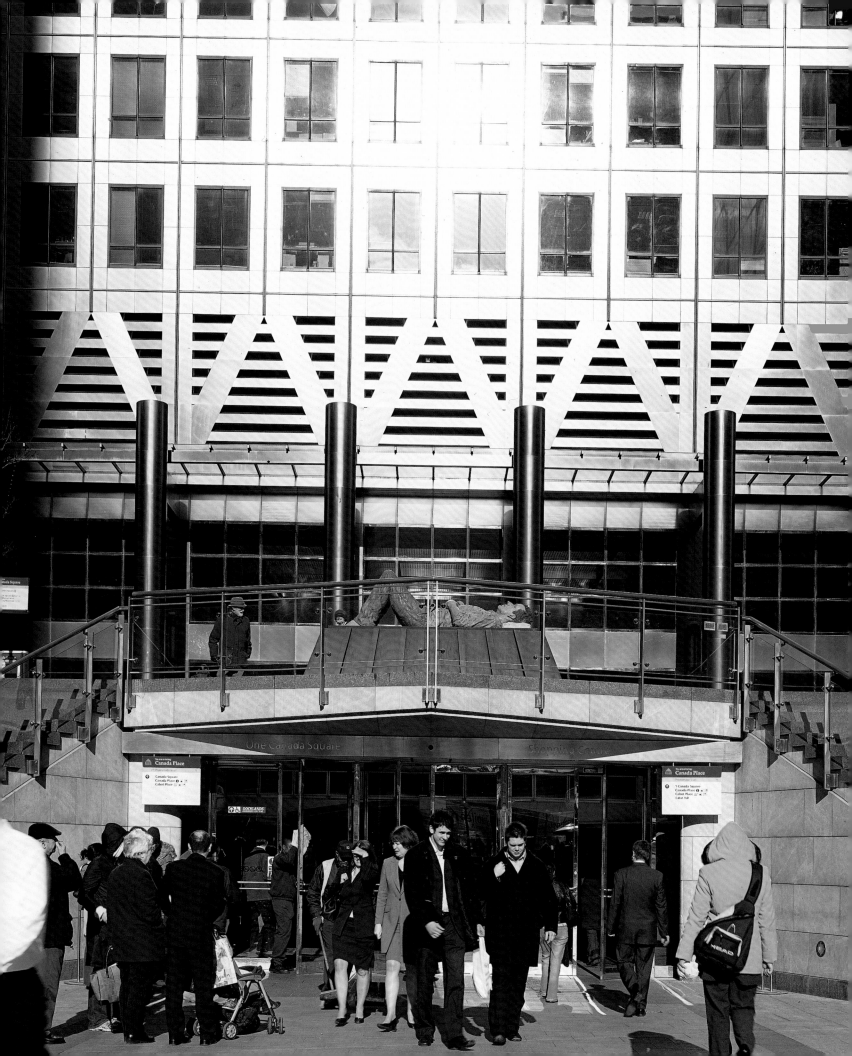

firmly in the art-historical tradition of the memento mori or vanitas motif alluding to the brevity of life on earth.

The theme of life and death is a constant subtext in Henry's sculpture and it is often amplified by the environment in which it is located. In *Catafalque* (2003) it emerges as a tension between the subject of the work – a casually dressed male lying contentedly on his back gazing up at the sky – and the title, referring to the temporary structure upon which a body is laid in state prior to or during a funeral. When situated atop a grassy tumulus in the wooded grounds of the Cass Sculpture Foundation in Goodwood, West Sussex (fig.89), *Catafalque* evoked the Latin phrase *Et in Arcadia Ego*, traditionally spoken by the devil and interpreted as 'I (Death) am even in Arcadia.' Its rural location also brought to mind Joseph Wright of Derby's portrait of Sir Brooke Boothby (1781) which shows the young aristocrat reclining in a wooded glade clutching a book by Jean-Jacques Rousseau, the French philosopher who advocated a more harmonious relationship with the natural world. These latent meanings were reinforced when another in the edition was placed in Canary Wharf in the City of London (figs.91–92). Here amid the swarming crowds of office workers *Catafalque* offered a wry comment on the futility of the career-driven urban treadmill. It became a still point in a turning world, evoking the famous stanza from Eliot's 'The Waste Land':

> Unreal City,
> Under the brown fog of a winter dawn,
> A crowd flowed over London Bridge, so many,
> I had not thought death had undone so many.

Site-specific commissions frequently present something of a minefield for contemporary sculptors, requiring the reconciliation of the artist's creative vision with the often conflicting social and aesthetic agendas of diverse interest groups. Public space thus becomes a symbolic battlefield in which broader political issues are contested. Henry avoids many of these obstacles by placing the emphasis on the figure itself, leaving the environment to adapt to its presence accordingly. His work demonstrates how social space is shifting and malleable, changing over time in response to the visual stimuli placed within it.

1 'I didn't want to get just a likeness like a mimic, but to portray them, like an actor.' – Lucian Freud quoted by Dawn Ades in 'The School of London' in Compton (ed.), *British Art in the 20th Century*, p.309.
2 David Sylvester, *Interviews with Francis Bacon* (London, 1980), p.82.
3 Michael Andrews quoted in Martin Harrison, *Transition: The London Art Scene in the Fifties* (Merrell/Barbican Art Gallery, 2002), p.60.
4 Charles Baudelaire, 'The Painter of Modern Life', in Francis Frascina and Charles Harrison (eds), *Modern Art and Modernism: A Critical Anthology* (Oxford University Press, 1982), p.24.

Fig.92 *Catafalque* at One Canada Square, Canary Wharf, London 2003/4

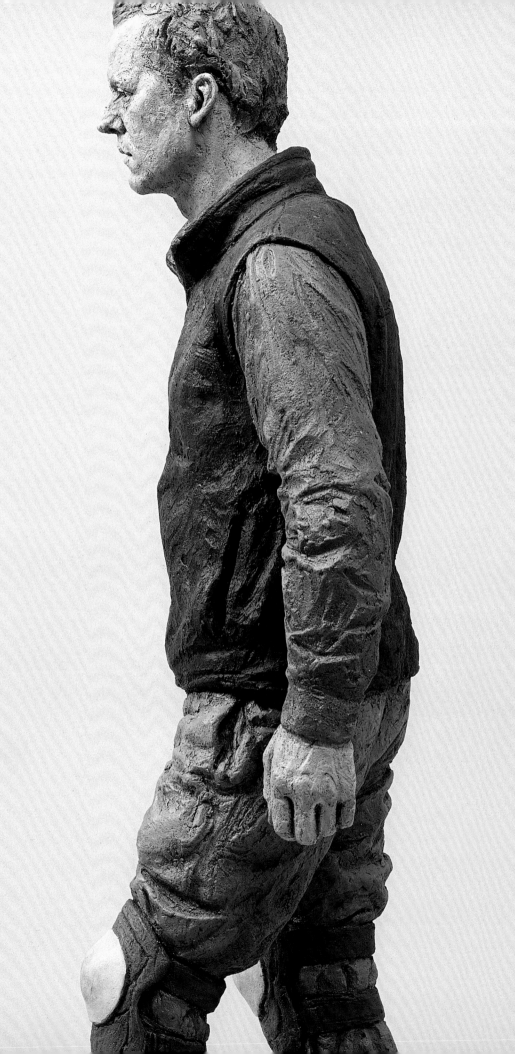

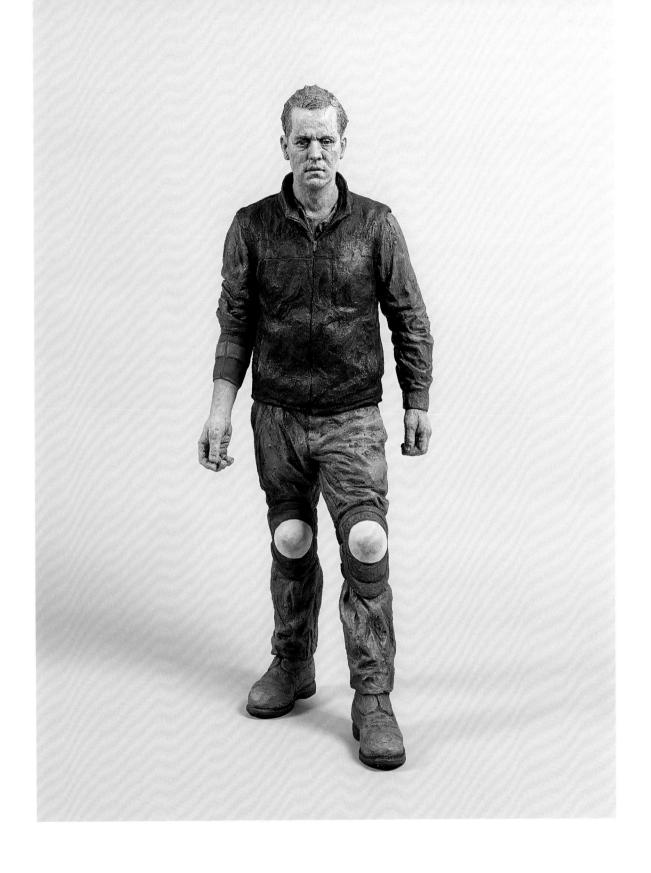

Fig.93 *One Step Forward* 2004

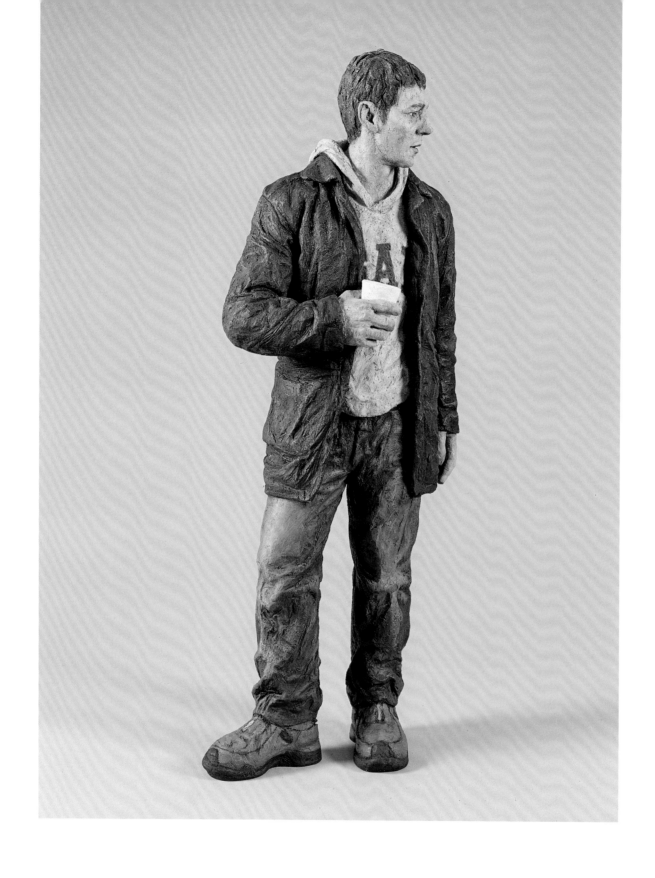

Fig.94 *T.P.O.L.R* 2002

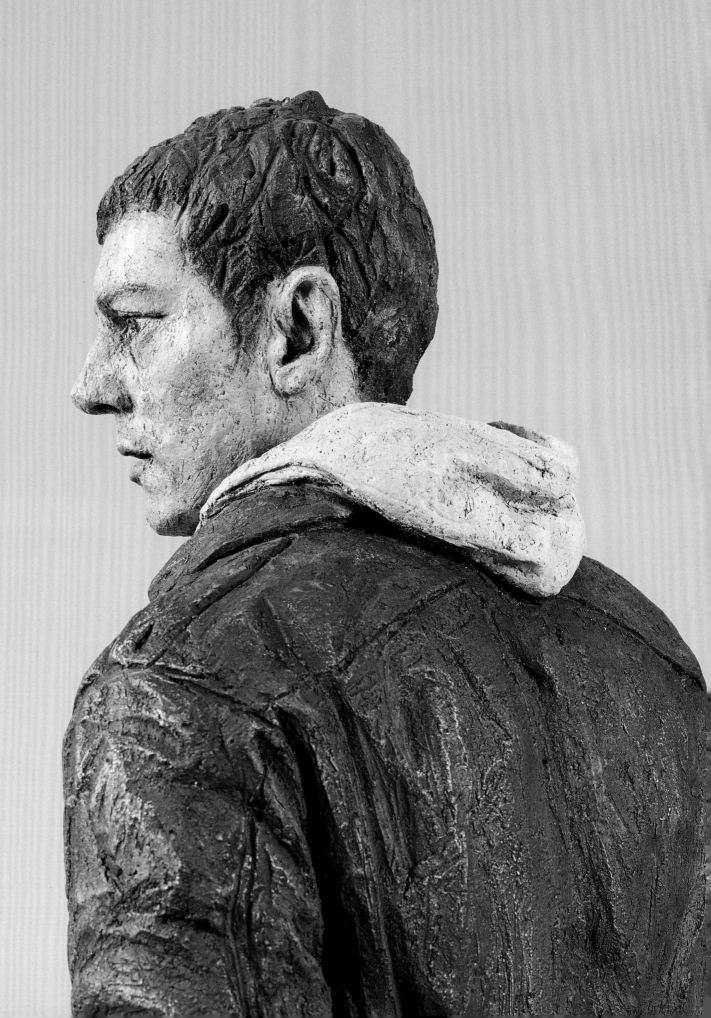

SELECTED
WORKS

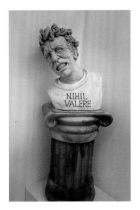

Nihil Valere 1986
Fired clay, glazes
130 × 56 × 41 cm / 51 × 22 × 16 in
Private collection, UK

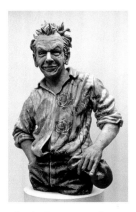

That's the Fact, Jack 1986
Fired clay, glazes
94 × 61 × 48 cm / 37 × 24 × 19 in
Private collection, UK

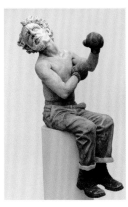

Who Am I? 1987
Fired clay, glazes, wood
183 × 76.2 × 94 cm / 72 × 30 × 37 in
(Destroyed)

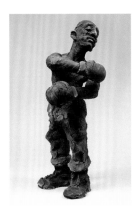

She's Gone 1988
Raku fired clay
71 × 28 × 33 cm / 28 × 11 × 13 in
Private collection, UK

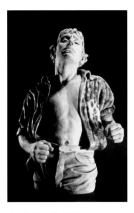

And She Said Yes 1988
Fired clay, glazes
89 × 61 × 38 cm / 35 × 24 × 15 in
Private collection, UK

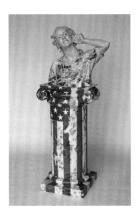

Yank 1990
Fired clay, glazes
182.3 × 68.5 × 53.4 cm / 72½ × 27 × 21 in
Collection Tower Records, California,
USA

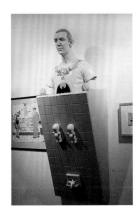

Refugee 1990
Fired clay, wood, tiles, found
ceramic objects
150 × 60 × 38 cm / 59 × 23½ × 15 in
(Destroyed)

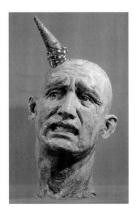

Hard to Swallow 1991
Fired clay, glazes
89 × 51 × 48 cm / 35 × 20 × 19 in
Collection Arizona State University Art
Museum, gift of Jay and Joyce Cooper

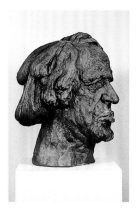

Voulkas 1991
Salt fired clay, oxides
105 × 71 × 81 cm / 41 × 28 × 32 in
Private collection, USA

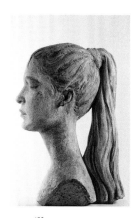

Camille 1991
Sean Henry and Camille Vandenberge
Fired clay, glazes
102 × 48 × 73 cm / 40 × 19 × 29 in
Private collection, USA

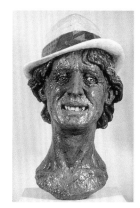

Self Portrait in 20 Years Time 1991
Fired clay, glazes
119 × 69 × 81 cm / 47 × 27 × 32 in
Collection of the artist

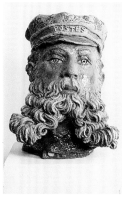

Roulin the Postman 1991
Fired clay, glazes
84 × 64 × 56 cm / 33 × 25 × 22 in
Private collection, USA

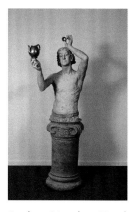

Bonjour Monsieur Henri 1992
Fired clay, found object, lustre glazes
191 × 71 × 81 cm / 75 × 28 × 32 in
Private collection, USA

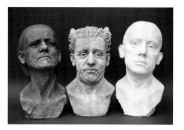

Paris Heads 1992
Raku fired clay, gesso, pigments
Each head approx 55 cm / 22½ in high
Private collection, UK

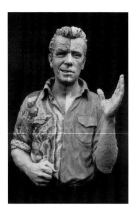

Living with the Past 1993
Fired clay, glazes
81.3 × 67.3 × 40.6 cm / 32 × 26½ × 16 in
Private collection, USA

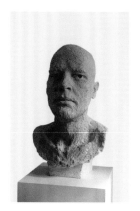

Head of Tom 1993
Fired clay, paint
63 × 38 × 34 cm / 25 × 15 × 13½ in
Private collection, UK

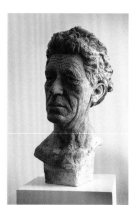

Portrait of Giacometti 1993
Raku fired clay, glazes
68.5 × 35.5 × 41 cm / 27 × 14 × 16 in
Private collection, Australia

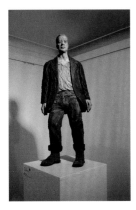

A Little Wine in the Morning,
Some Breakfast at Night 1994
Fired clay, oil paint
86 × 33 × 26 cm / 34 × 13 × 10 in
Private collection, UK

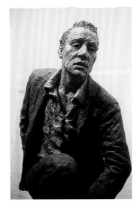

Man on One Foot 1995
Bronze, oil paint
74.5 × 36 × 38 cm / 29 × 14 × 15 in
Private collection, UK

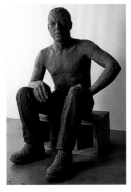

Seated Man 1995
Fired clay, steel
107 × 68.5 × 91 cm / 42 × 27 × 36 in
Private collection, Australia

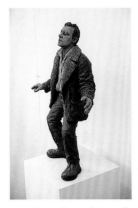

Man in a Sheepskin Jacket 1996
Fired clay, oil paint
74 × 56 × 20 cm / 29 × 22 × 8 in
Private collection, UK

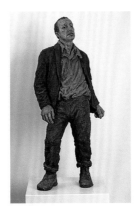

London Fields 1995
Bronze, oil paint
79 × 25 × 18 cm / 31 × 10 × 7 in
Private collection, UK

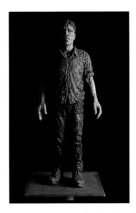

Standing Man (Red Shirt) 1996
Fired clay, oil paint
86.5 × 30.5 × 20 cm / 34 × 12 × 8 in
Private collection, UK

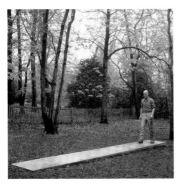

Walking Man 1998
Bronze, oil paint, concrete path
Figure: 203 × 66 × 81 cm / 80 × 26 × 32 in
Private collection, UK
On long-term loan to Royal Borough of
Kensington and Chelsea, Holland Park,
London

Janus 1996/7
Resin, oil paint
206 × 81 × 48 cm / 81 × 32 × 19 in
Collection of the artist

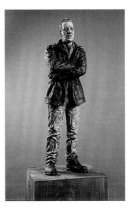

Donkey 1998
Bronze, oil paint
84 × 25 × 20 cm / 33 × 10 × 8 in
Private collection, UK

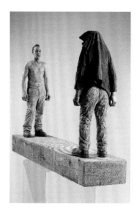

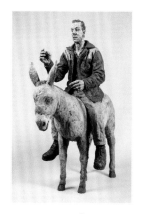

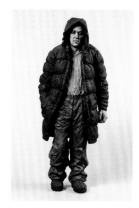

Man with Alter Ego 1998
Fired clay, oil paint, perspex, wood
198 × 152 × 30.5 cm / 78 × 60 × 12 in
Private collection, UK

Man on a Donkey 1997
Bronze, oil paint
95 × 86 × 41 cm / 37½ × 34 × 16 in
Collection St John's Church,
Ladbroke Grove, London

The Duke of Milan 1999
Bronze, oil paint
84 × 35 × 21 cm / 33 × 14 × 8 in
Scheringa Museum of Realist Art,
the Netherlands

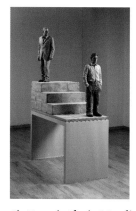

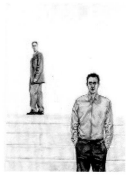

Man of Honour 1999
Fired clay, oil paint
83.8 × 33 × 20.3 cm / 33 × 13 × 8 in
Collection of the artist

Sic Transit Gloria Mundi 1999
Bronze, concrete, steel, oil paint
203 × 130 × 66 cm / 80 × 51 × 26 in
Private collection, UK

Sic Transit Gloria Mundi 1999
Pastel & charcoal on paper
76 × 56 cm / 30 × 22 in
Private collection, UK

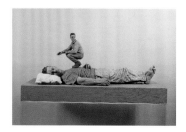

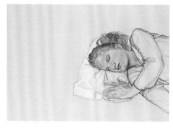

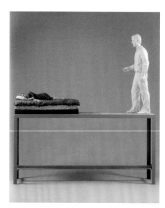

Lying Man 1999
Ceramic, oil paint, wood, perspex
147 × 138 × 62 cm / 59 × 54 × 24½ in
Private collection, UK

Ursula 2001
Pastel and crayon on coloured paper
51 × 71 cm / 20 × 28 in
Private collection, UK

Ursula's Dream 2001
Fired clay, oil paint, steel, plaster, travertine
202 × 140 × 41 cm / 79½ × 55 × 16 in
Private collection, USA

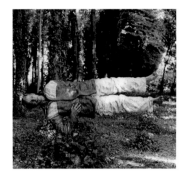

Man with Potential Selves 2000
Bronze, oil paint
198 × 68.5 × 41 cm / 78 × 27 × 16 in
Grainger Street, Newcastle-upon-Tyne,
England

Man with Potential Selves 2000
Bronze, oil paint
198 × 61 × 74 cm / 78 × 24 × 29 in
Grainger Street, Newcastle-upon-Tyne,
England

Man with Potential Selves 2000
Bronze, oil paint
91.5 × 221 × 43 cm / 36 × 87 × 17 in
Cass Sculpture Foundation, Goodwood, England

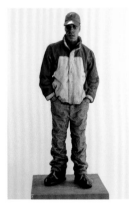

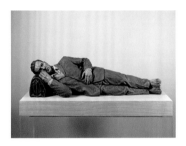

Nobody's Wedding 2000
Fired clay, oil paint
86.5 × 28 × 20 cm / 34 × 11 × 8 in
Private collection, UK

Man Lying on His Side 2000
Bronze, oil paint
124 × 36 × 40 cm / 49 × 14 × 16 in
Collection Standard Chartered
Bank, UK

Trajan's Shadow 2001
Bronze, oil paint, Cor-ten steel, car paint
331 × 500 × 250 cm / 130 × 197 × 98½ in
Collection Umedalen Skulptur,
Balticgruppen, Umeå, Sweden

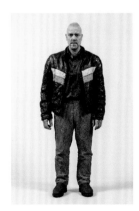

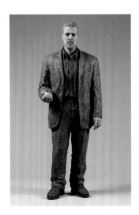

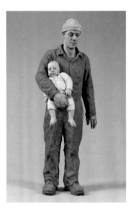

Ben (Ideas Unresolved) 2001
Bronze, oil paint
125 × 47 × 28 cm / 49 × 18½ × 11 in
Private collection, USA

Ben (Ideas Resolved) 2001
Bronze, oil paint
125 × 48 × 40 cm / 49 × 19 × 16 in
Collection University of Virginia
Art Museum, USA

Man and Child 2001
Fired clay, oil paint
84 × 33 × 22 cm / 33 × 13 × 8½ in
Collection of the artist

Folly 2001
Wood, resin, oil paint, perspex
180 × 50 × 80 cm / 71 × 20 × 32 in
Collection of the artist

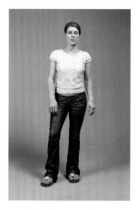

T.P.O.L.R 2002
Fired clay, oil paint
81 × 33 × 20 cm / 32 × 13 × 8 in
Seavest Collection of
Contemporary Realism, USA

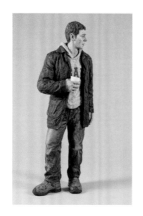

Sandra (Waiting) 2003
Bronze, oil paint
126 × 38 × 24 cm / 49½ × 15 × 9½ in
Private collection, UK

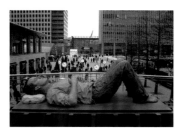

Catafalque 2003
Bronze, oil paint, Cor-ten steel
208 × 394 × 194 cm / 82 × 155 × 76 in
Private collection, USA

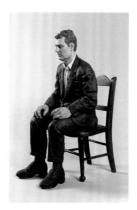

Man on a Chair 2003
Bronze, oil paint
71 × 32 × 49 cm / 28 × 12½ × 19 in
Private collection, USA

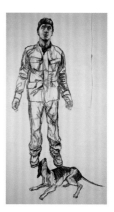

Man and Dog 2003
Charcoal and pastel on coloured paper
220 × 116 cm / 86 × 45 in
Private collection, UK

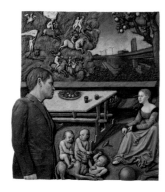

Melancholia 2003
Aluminium, oil paint
125 × 105 × 10 cm / 49 × 41 × 4 in
Private collection, Spain

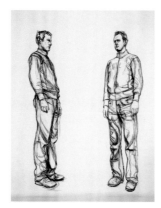

Study for Italia (Twice) 2004
Charcoal on paper
230 × 200 cm / 90½ × 78¾ in
Private collection, Spain

Italia (Room) 2004
Bronze, oil paint, perspex
183 × 111 × 109 cm / 72 × 44 × 43 in
Private collection, UK

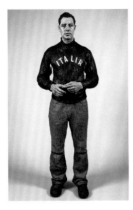

Italia 2004
Bronze, oil paint
201 × 71 × 48 cm / 79 × 30 × 19 in
Private collection, Holland

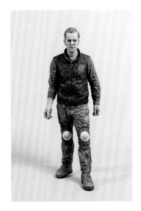

One Step Forward 2004
Bronze, oil paint
84 × 33 × 30.5 cm / 33 × 13 × 12 in
Collection IKSU Sportcenter,
Umeå, Sweden

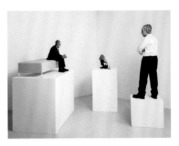

You're Not the Same 2005
Bronze, oil paint, canvas, steel, wood
Standing figure: 137 × 38 × 46 cm / 54 × 15 × 18 in
Seated figure and bench: 66 × 140 × 69 cm / 26 × 55 × 27 in
Crouching figure: 33 × 28 × 30 cm / 13 × 11 × 12 in
Collection Balticgruppen, Umeå, Sweden

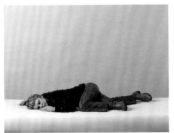

Lying Woman 2005
Fired clay, oil paint, cushion, perspex
81 × 13 × 36 cm / 35 × 5 × 14 in
Private collection, USA

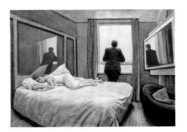

Hotel Room 2005
Aluminium, oil paint, varnish, wax
140 × 97 × 10 cm / 55 × 38 × 4 in
Collection of the artist

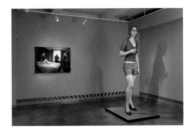

Woman (Being Looked At) 2006
Bronze, oil paint, car paint, wax
260 × 82 × 74 cm / 102 × 32 × 29 in
Collection of the artist

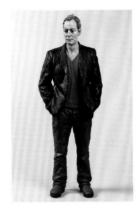

Great Western Man 2006
Bronze, oil paint
84 × 29 × 19 cm / 33 × 11 × 8 in
Private collection, Germany

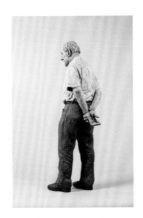

Standing Man 2007
Bronze, oil paint
107 × 39 × 33 cm / 42 × 15 × 13 in
Collection Standard Chartered
Bank, UK

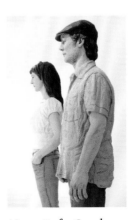

Maquette for Couple 2007
Bronze, oil paint
Male figure 140 × 46 × 30 cm / 55 × 18 × 12 in
Female figure 130 × 42 × 25 cm / 51 × 16½ × 10 in
Newbiggin-by-the-Sea, Northumberland, UK

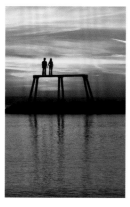

Couple 2007
Bronze, steel, marine paint
12.25 × 21 × 6 m / 40 × 69 × 19½ ft
Newbiggin-by-the-Sea,
Northumberland, UK

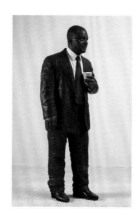

Man with Cup 2008
Bronze, oil paint
137 × 55 × 36.5 cm / 54 × 21½ × 14½ in
Collection Standard Chartered Bank, UK

Man Holding Jacket 2008
Bronze, oil paint
202 × 93 × 74 cm / 79½ × 36½ × 29 in
Collection Standard Chartered Bank, UK

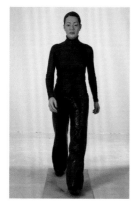

Walking Woman 2008
Bronze, oil paint
217 × 76 × 125 cm / 85½ × 30 × 49 in
Collection Standard Chartered Bank, UK

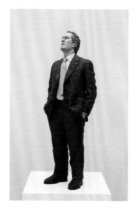

Man Looking Up 2008
Fired clay, oil paint
86 × 28 × 20 cm / 34 × 11 × 8 in
Collection of the artist

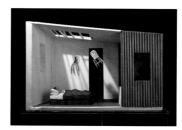

Maquette for Folly 2008
Cardboard, wood, ceramic, bronze, oil paint
56 × 87 × 44 cm / 22 × 34 × 17½ in
Scheringa Museum of Realist Art,
the Netherlands

TIMELINE

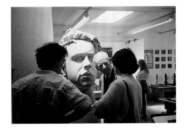

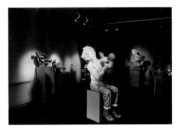

1965 Born 13 May in Guildford, England, youngest of four brothers, to Richard and Lindy Henry.

1978–81 School at Radley College, near Oxford. Takes up pottery and hand-built ceramics around 1979, taught by Sue Haslam.

1982 Finishes A levels at Guildford Technical College, Surrey.

1983–84 Art Foundation course at Farnham School of Art and Design, Surrey.

1984–87 Three-year BA (Hons) degree in Ceramics at Bristol Polytechnic. Degree show travels from Bristol to London, where Henry joins the Anatol Orient Gallery on Portobello Road.

1987 Awarded Gane Charitable Trust Travel Scholarship while at Bristol Polytechnic and travels to New York, Ohio and California, meeting West Coast ceramic artists.

1988 Has first London solo show, *Inner Visions*, at Anatol Orient Gallery, London. Awarded British Crafts Council Grant and uses this to set up a studio space in East Horsley, Surrey.

1989 Travels back to California, working for six months as a studio assistant to artists Lisa Reinertson and Tony Natsoulas. Lectures at University of California, Davis. Meets influential ceramic artist Robert Arneson and has new work *Yank* included in a group show with a number of leading exponents of the West Coast Funk scene. Moves to Putney, London.

1990 Invited back to the USA by Robert Arneson to be Visiting Artist at University of California, Davis. Work included in group shows in Sacramento, California and in London.

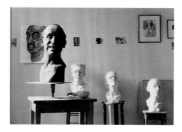

1991 Exhibits work made at University of California, Davis, in solo show *Seven Heads* at John Natsoulas Gallery. Group shows include Galerie Marihube, New York, the Royal Festival Hall, London and South Mountain Center for the Arts, Phoenix, Arizona.

1992 Swaps UK studio with a Syrian artist in the Bastille, Paris. New work from this period exhibited at solo exhibition *Wish You Were Here* in Farnham, England.

1993 Moves to Sydney, Australia. Rents studio space from Sydney-based art dealer Rex Irwin – a specialist in modern British artists. Works as a part-time lecturer at Sydney College of the Arts, Glebe, Sydney and has work shown at the Victoria and Albert Museum, London.

1994 Solo exhibition at the Houldsworth Gallery, Sydney includes first oil-painted ceramic works. Returns to London in May and sets up current studio in the newly established Great Western Studios, Paddington New Yard, West London. First pieces cast in bronze this year.

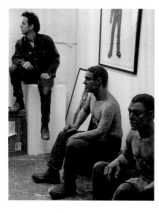

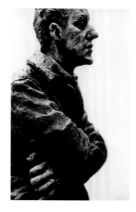

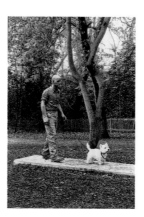

1995 Travels back to California for solo show with John Natsoulas Gallery. Shows new sculpture and drawings at Heathman's Yard, in Fulham, London.

1997 Curates *Up Against It*, a group show of Great Western artists in Mayfair, London, including work by painters Jeremy Dickinson and Machiko Edmondson. Exhibits work in Faenza, Italy and joins London gallery Davies & Tooth. Marries Harriet Marsh in October and moves to Ladbroke Grove, London.

1998 Solo exhibition at the Circolo Degli Artisti in Faenza, Italy. Hardback book *The Centre of the Universe* published by Lamberto Fabbri, including poetry by David Hart and Paul Durcan and photography by Tim Booth. Wins the 1998 Villiers David Prize, enabling an extensive four-month trip studying art across Italy. Exhibits at the Barbican Centre, London.

1999 Villiers David Prize exhibition at Davies & Tooth; work resulting from the trip to Italy includes *Lying Man*, *The Duke of Milan* and *Sic Transit Gloria Mundi*. Group shows include Ann Nathan Gallery, Chicago and the Éigse Carlow Arts Festival, Carlow, Ireland.

2000 Joins the Berkeley Square Gallery, Mayfair, London. Works travel for the first time to art fairs in Palm Beach, Miami and Chicago. *Walking Man* included in *Bronze*, an exhibition curated by Ann Elliot in Holland Park, London, where the sculpture is purchased and donated to the park by a private collector. Exhibits at Il Politicco, Rome, and has three-figure work *Man with Potential Selves* installed at Sculpture at Goodwood, now the Cass Sculpture Foundation.

2001 Son Milo born in July. First solo show at Berkeley Square Gallery, London. *Trajan's Shadow* is installed in Berkeley Square, becoming the first piece of contemporary sculpture ever to be displayed there. Joins the Forum Gallery.

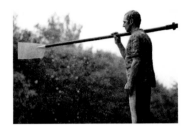

2002 First solo shows at Forum Gallery, New York and Los Angeles. Group shows include the Peggy Guggenheim Foundation, Venice, and *About Face* at the Croydon Clocktower Museum, England. *Man with Potential Selves* purchased by the city of Newcastle-Upon-Tyne, England and sited on Grainger Street. Completes pair of 2.2-metre high sculptures depicting rowers Sir Steve Redgrave and Matthew Pinsent for Mill Meadows at the River and Rowing Museum in Henley-on-Thames, Oxfordshire, England.

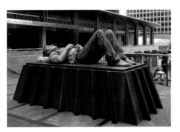

2003 Second edition of *Man with Potential Selves* is installed in the lobby of Le Meridien (The Cumberland) Hotel at Marble Arch, London. *Meeting Place* installed at Paddington Central next to the Regents Canal, London. Daughter Isabella born in July. Family move to Shepherds Bush, London.

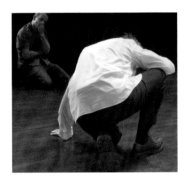

2004 Solo shows at Berkeley Square Gallery, London and One Canada Square, Canary Wharf, London. *Catafalque* installed outside in the plaza and subsequently at the Cass Sculpture Foundation. First edition of *Catafalque* goes permanently to Seven Bridges Foundation in Greenwich, Connecticut. Joins Kunsthandel Frans Jacobs in Amsterdam. Sees Edward Albee's play *The Goat, or Who Is Sylvia?* at the Apollo Theatre, London. Starts work on *You're Not the Same* based on the experiences of the character in the play.

2005 First solo show at Kunsthandel Frans Jacobs, Amsterdam, Netherlands. Invited artist at the Éigse Carlow Arts Festival, Carlow, Ireland and Solomon Gallery, Dublin. *Catafalque* installed in Golden Square, Soho, London. Work starts on proposal for *Couple* project at Newbiggin Bay, Northumberland, England.

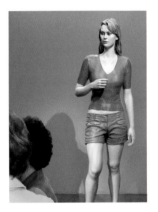

2006 Solo shows at Forum Gallery, New York and Los Angeles as well as Cartwright Hall, in Bradford, England. Second edition of *Trajan's Shadow* installed at Umedalen Sculpture Park, Umeå, Sweden. *Catafalque* sited outside St John's Church, Notting Hill, London. Starts work on design and model for multi-figure installation at Standard Chartered Bank's new headquarters in London.

2007 Solo show *Presence* at Galleri Andersson Sandström, Umeå, Sweden, and Galerie von Braunbehrens, Munich, Germany. *Standing Man* installed in Umeå city centre and *You're Not the Same* sited in Umedalen Sculpture Park. Starts work on proposal for *Folly* project at the Scheringa Museum for Realist Art, Spanbroek, Netherlands. *Couple* completed and installed in August on island breakwater at Newbiggin-by-the-Sea, Northumberland, England. Sets up second studio space in Wilton, Wiltshire. Daughter Matilda born in October.

2008 Completes nine-figure installation at Standard Chartered Bank, One Basinghall Avenue, City of London. Group shows in Ireland, Sweden and France, and solo show at Osborne Samuel, Mayfair, London.

One Person Exhibitions

1988 *Inner Visions*, Anatol Orient Gallery, London

1991 *Seven Heads*, John Natsoulas Gallery, Davis, California

1992 *Wish You Were Here*, St George's Yard, Farnham, England

1994 *The Flip-Side of Dominic Hyde*, Houldsworth Gallery, Sydney, Australia

1995 *New Sculpture and Drawings*, John Natsoulas Gallery, Davis, California

1997 *Up Against It*, Air Gallery, London

1998 *The Centre of the Universe*, Circolo Degli Artisti, Faenza, Italy

1999 *A Pilgrimage*, Davies & Tooth, London

2001 *Sculpture and Drawings*, Berkeley Square Gallery, London

2002 *Sculpture and Drawings*, Forum Gallery, New York

Sculpture and Drawings, Forum Gallery, Los Angeles

2004 *Here and Now*, Berkeley Square Gallery, London

Sculpture in the Workplace, Canary Wharf, London

2005 *Sculpture and Drawings*, Kunsthandel Frans Jacobs, Amsterdam, the Netherlands

2006 *You're Not the Same*, Forum Gallery, New York

You're Not the Same, Forum Gallery, Los Angeles

Sean Henry: Sculpture, Cartwright Hall, Bradford, England

2007 *Presence*, Galleri Andersson Sandström, Umeå, Sweden

Präsenz/Presence, Galerie von Braunbehrens, Munich, Germany

2008 *Folly*, Osborne Samuel, London

Selected Group Exhibitions

1988 *Summer Show*, Hannah Peschar Gallery, Ockley, Surrey, England

Gallery Artists, Lizard Gallery, Farnham, England

1989 *Ceramic Sculptors*, State Capitol Building, Sacramento, California

1990 *Portobello Arts Festival*, Michaelson and Orient Gallery, London

Gallery Artists, Natsoulas/Novoloso Gallery, California

Ceramic Sculptors, Gladding McBean & Co, California

1991 *Three Sculptors*, Royal Festival Hall, London

Bob Marley: An Exhibition, Galerie Marihube, New York

Bob Marley: An Exhibition, Special Photographers Gallery, London

Major Artists/Minor Works, South Mountain Centre for the Arts, Phoenix, Arizona

Sculpture and Paintings, The Collection, Knightsbridge, London

1991–97 *Thirty Ceramic Sculptors Annual Show*, John Natsoulas Gallery, Davis, California

1993 *Group show*, Honolulu Academy of the Arts, Hawaii

Ceramic Contemporaries, Victoria and Albert Museum, London

1994 *Summer Show*, Holdsworth Galleries, Sydney, Australia

Gallery Artists, Robin Gibson Gallery, Sydney, Australia

1995 *IV Mostra Mercato*, Faenza Faience, Faenza, Italy

New Work, Sacramento Club, California

The Figure, John Natsoulas Gallery, Davis, California

1996 *Summer Show*, Blue Gallery, London

Artists of Fame and Promise, Beaux Arts, Bath, England

Robert Arneson Tribute Exhibition, John Berggruen Gallery, San Francisco

1997 *Contemporary British Art*, The Lefevre Gallery, London

34th Exhibition, The Society of Sculptors, London

New Movement in Contemporary Figurative Sculpture, Nevada Institute of Contemporary Art, Nevada, USA

Contemporary Art, The Air Gallery, London

Summer Show, Blue Gallery, London

1998 *Atlantic Crossings*, Barbican Centre, London

Gallery Artists, Beaux Arts, Bath, England

1999 *Éigse Carlow Arts Festival*, Carlow, Ireland

Group Show, Ann Nathan Gallery, Chicago

Artists of Fame and Promise, Beaux Arts, Bath, England

2000 *Classicismi Metropolitani*, Il Politicco, Rome

2002 *About Face*, Croydon Clocktower Museum, London

2003 *Thinking Big*, Peggy Guggenheim Collection, Venice

Sculpture, Rex Irwin Art Dealer, Sydney, Australia

2004 *Sculpture in the Park*, Durham, England

Thinking Big, Sculpture at Goodwood, England

2005 *Figurative Impulse*, Forum Gallery, Los Angeles

Important New Works, Forum Gallery, New York

Éigse Carlow Arts Festival, Carlow, Ireland

Contemporary Sculpture, Berkeley Square Gallery, London

2006 *British Sculpture*, Osborne Samuel, London

Umedalen Skulptur 2006, Umeå, Sweden

2007 *An Eye for Detail*, Forum Gallery, Los Angeles

Sculpture, Kunsthandel Frans Jacobs, Paris

2008 *Borås Internationella Skulpturfestival*, Museum of Modern Art, Borås, Sweden

The Secret Garden, Solomon Gallery, Dublin, Ireland

Umedalen Skulptur 2008, Umeå, Sweden

Selected Bibliography

Books

1998 Beatrice Buscaroli, Edward Lucie-Smith, Paul Durcan and David Hart, *The Centre of the Universe* (Faenza, Italy: Circolo Degli Artisti)

2000 Ann Elliot and Norbert Lynton, *Bronze: Contemporary British Sculpture – Holland Park* (London: The Royal Borough of Kensington and Chelsea Libraries and Arts Service)

2002 Ann Elliot and Sue Hubbard, *Sculpture at Goodwood: a Vision for Twenty-First Century British Sculpture* (Goodwood: Sculpture at Goodwood)
Edward Lucie-Smith, *Art Tomorrow* (Paris: Finest S.A./Editions Pierre Terrail)

2003 *Thinking Big: Concepts for 21st Century British Sculpture* (Goodwood: Sculpture at Goodwood/The Solomon R. Guggenheim Foundation)

2006 Amy Dempsey, *Destination Art* (London: Thames and Hudson)
Schilders van een andere werkelijkheid (Spanbroek, the Netherlands: Waanders/ Scheringa Museum of Realist Art)

2007 Elspeth Moncrieff and Tom Flynn, *Sean Henry: Präsenz/Presence* (Munich: Galerie von Braunbehrens)
Richard D. Segal and Monica M. Segal, *Contemporary Realism: The Seavest Collection* (Portland, Oregon: Collectors Press)

Catalogues

1999 Ann Elliot, *A Pilgrimage: Villiers David Prize Exhibition* (London: Davies & Tooth)

2000 Manuela Alessandra Filippi and Beatrice Buscaroli, *Classicismi Metropolitani* (Rome: Il Politicco)

2002 Norbert Lynton and Barbara S. Krulik, *Sean Henry: Sculpture and Drawings* (London: Berkeley Square Gallery; New York and Los Angeles: Forum Gallery)

2004 Jack Turner and Elspeth Moncrieff, *Here and Now* (London: Berkeley Square Gallery)

2005 Tom Flynn and Sean Henry, *Sean Henry* (Amsterdam: Kunsthandel Frans Jacobs / Judith Bouwknegt Contemporary)
Elspeth Moncrieff, *Éigse Carlow Visual Art Catalogue 2005* (Carlow, Ireland: Éigse Carlow Arts Festival)

2006 Tom Flynn, *You're Not the Same* (New York and Los Angeles: Forum Gallery)

Articles and Media

1988 Tanya Harrod, 'A Form of Funk', *Crafts Magazine*, September
Linda Talbot, 'New Opening', *Hampstead and Highgate News* (London), 13 September
Pamela Johnson, 'Academic Goes to Pot', *The Observer* (London), 17 September
Abigail Frost, 'Inner Visions', *Art Review*, October
Owen Hughes, 'Artist's Huge Feat', *Evening Standard* (London), 2 October

1989 'Art '89', *Evening Standard* (London)
'Art for Art's Sake', *Nine to Five* (London)

1990 'Sean Henry' and 'Fourth Sculpture Annual', *Ceramics Monthly*, April
Victoria Dalkey, 'Feats of Clay', *The Sacramento Bee* (Sacramento, CA), 9 June

1991 'Bob Marley: An Exhibition', *Evening Standard* (London), 12 April
'Carnival Arrived Early', *Sunday Times* (London), 14 April
Marilyn Moyle, 'Young Artists', *The Davis Enterprise* (Davis, CA), 22 April
'Californian Conference for the Advancement of Ceramic Art', *San Francisco Magazine*, May
Penelope Shackleford, 'Joyous Ceramics at Natsoulas', *The Davis Enterprise* (Davis, CA), 25 July

1993 'Ceramic Contemporaries at the V&A', *Sunday Times* (London) and *Evening Standard* (London)

1994 'An Exhibition of New Sculptures', *Sydney News* (Australia), 18 May

'Best Weekend', *Sydney Morning Herald* (Australia), 21 May
Virginia Hollister, 'Sean Henry: Figuring It Out', *Ceramic Art and Perception*, No. 18
Anna Kythreotis, 'The Sculptor', *The London Magazine*, December

1996 'Sean Henry: Up Front', *Ceramics Monthly*, February

1997 Alistair McAlpine, 'Spyglass', *Country Life*, 23 January
Emmanuel Cooper, 'Sean Henry: Up Against It', *Crafts Magazine*, August

1998 Marina Benjamin, 'We Can All Become Saatchis Now', *Evening Standard* (London), 21 January
'New Arrival in Glasgow that Stands Out Among the Crowd', *The Scotsman*, 16 April
Huon Mallalieu, 'Sense Sensation', *Country Life*, 18 June
John Windsor, 'The Independent Collector', *The Independent* (London), 20 July
Tessa Peters, 'Atlantic Crossings', *Keramik magazin* (Germany), October
Antonio Gramentieri, 'Ecco "l'uomocomune" di Henry', *Sette Sere* (Italy), 5 December

1999 Dario Trento, 'Sculture di Sean Henry qui c'è un tocco di sacro', *La Repubblica* (Rome), 7 January
Enzo Dall'Ara, 'Un uomo commune', *Romagna Corriere* (Rome), 16 January
Antonio Gramentieri, 'L'uomo dell'indecisione cammina verso il futuro', *Sette Sere* (Italy), 6 February
Aidan Dunne, 'Figuring Eigse Out', *Irish Times*, 17 June
Edward Lucie-Smith, 'The Ambiguity of Sculpture', *Espace* 48, summer edition
Elspeth Moncrieff, 'Sean Henry's Figures', *The Art Newspaper*, September
'Donkey Do', *Royal Academy Magazine* (London), September
'Sean Takes Religious Art for a Ride', *V&A Museum* magazine (London), September / December

2000 *Walking With Sculptors*, 60-minute documentary made for Sky TV's *Artsworld* channel, shown at various times
Alison Roberts, 'It's So Thoroughly Modern', *Evening Standard* (London), 18 January
'Going Out: A Guide to Art 2000', *The Independent* (London), 20 January
Geoffrey Barker, 'The Dying Art of Suicide', *Evening Standard* (London), 24 January
John McEwen, 'The Great Outdoors', *Sunday Telegraph* (London), 9 April
'Bronze Man's Just Walking the Dog', *Kensington and Chelsea Times*, 16 June

2001 'Bronze Tributes to Golden Heroes', *Henley Standard*, 22 June
'Standing Tall', *Daily Telegraph* (London), 12 November
Elspeth Moncrieff, 'Life-like Figures at Berkeley Square', *The Art Newspaper*, No. 120, December
'Extra-ordinary people', *The Artist's Magazine*, December
Dominic Murphy, 'Men About the House', *The Guardian Weekend* (London), 1 December

2002 L. P. Streitfeld, 'The Real, Surreal and Metareal in New York', *NY Arts*, January
Mary Hrbacek, 'Sean Henry: Forum Gallery', *New York Art World*, Vol 5, No. 6, February
'For the record', *Daily Telegraph* (London), 8 June
David Dawson, 'Statues Go on Display', *Henley Standard*, 28 June
John Spurling, 'Sculpture's Message', *The Spectator*, 28 July
Peter Frank, 'Sean Henry: Forum', *Art News*, September
Neal Brown, 'The great outdoors', *Art Review*, September

2003 David Whetstone, 'Tall and Bronzed', *The Journal* (Newcastle), 6 February
'Visual Treats Mark Out an Artistic Trail', *The Chronicle* (Newcastle), 26 March
David Whetstone, 'Man Has Potential', *The Journal* (Newcastle), 18 September

Paul McMillan, 'In The Art of Town', *The Evening Chronicle* (Newcastle), 23 September
David Whetstone, 'Street Artwork shows Mettle', *The Journal* (Newcastle), 25 September
'Statues on the Streets', *The Evening Chronicle* (Newcastle), 25 September

2004 Alan Lodge, 'Amazing Art that's Got Us Looking Twice', *The Wharf*, 15 January
Tim Teeman, 'Strangely Familial', *The Times* (London) 15 May
Jo McDermott, 'The Lie of the Land', *Westminster Times*, 20 May
Stephen Bleach, 'So Cool it Hurts', *Sunday Times* (London), 24 October

2005 Gemma Tipton, 'Stepping Off the Plinth', *Irish Arts*, summer edition
'Elite at Eigse', *Irish Arts*, summer edition
Bick Wright, '20 City Squares', *Time Out* (London), 8 June
Aidan Dunne, 'Something for Everyone at Eigse', *Irish Times*, 15 June
Paul Mansfield, 'Stranger in a Secret Garden', *Daily Telegraph* (London), 18 June

2006 David Gewirtzman, 'Not the Same', *Playbill* (New York), 19 April
Robert Ayers, 'Jonathan Pryce, in Triplicate', *Art Info*, 19 April
Randy Kennedy, 'Star of Stage, Figure of Bronze', *New York Times*, 20 April
Virginia Bonito, 'Get Real', *Art & Antiques*, October

2007 Clare Clayton, 'Sculpture Offers A New Beginning', *Culture Magazine*, February
'In the Frame', *The Art Newspaper* (London), April
Beppe Starbrink, *Interview with the Artist*, SVT (Sweden television), 13 April
Emer McCourt, 'First Glimpse of Sea Gazing Giants', *The Journal* (Newcastle), 14 April
Anders Sjögren, 'Vanliga människor i ovanlig storlek', *Västerbottens-Kuriren* (Sweden), 14 April

Katrin Holmqvist Sten, 'Omöjligt att undkomma', *Kultur & Nöje* (Sweden), 12 May
'Northerners Ahoy', *Art Monthly*, 1 June
Louise Jury, 'Russians Turn Regent's Park into Home for Sculpture', *Evening Standard* (London), 26 June
Report on *Channel 4 News*, Channel 4 (UK television), 3 July
Vince Gledhill, 'Giant Couple will Guard our Coastline', *The Journal* (Newcastle), 9 July
Feature by John Wilson, *Front Row*, BBC Radio 4, 10 August
'Wave Hello to North's Most Striking Couple', *Sunday Sun* (Newcastle), 12 August
Ian Herbert, 'Giant Sculpture Brings Art to the Middle of the North Sea', *The Independent* (London), 16 August
Mark Lawson, 'The Lure of UFO Spookiness and Sheer Improbability', *The Guardian* (London), 17 August
Report by Nicholas Glass on *Channel 4 News* (UK television), 17 August
'We're a Couple of Sea Swells', *Sunday Mirror* (London), 19 August
'Giant Sculpture Installed in the Sea', *The Times* (London), 20 August
The One Show, BBC1 (television), 27 August
'Bless You!', *Art of England*, December
Mark Lawson, 'Public Sculpture Special', *Front Row*, BBC Radio 4, 27 December

2008 'Borås Internationella Skulpturfestival', *Dagens Nyheter* (Sweden), 19 April
Henrik Strömgren, 'Folket mötte Pinnochio', *Göteborgs Posten* (Sweden), 17 May

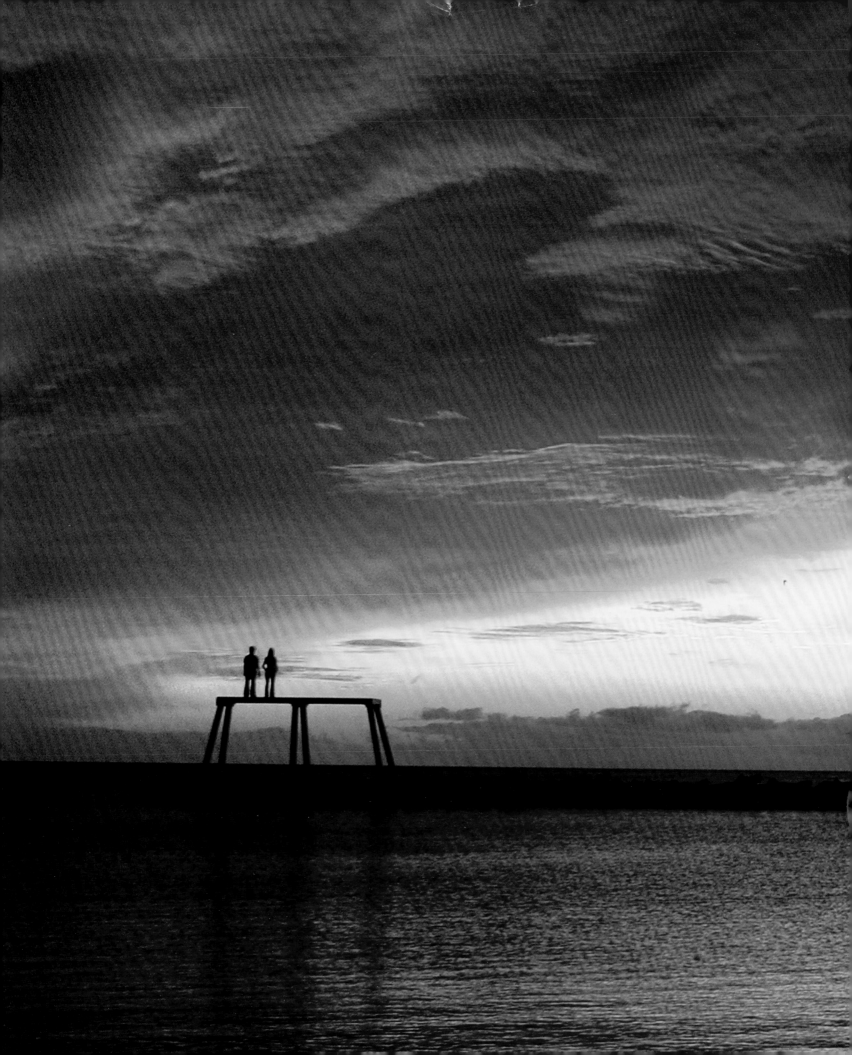